CAVEAT EMPTOR

CAVEAT EMPTOR

The Secret Life of an American Art Forger

KEN PERENYI

PEGASUS BOOKS
NEW YORK LONDON

10·13·12

CAVEAT EMPTOR

Pegasus Books LLC
80 Broad Street, 5th Floor
New York, NY 10004

Copyright © 2012 by Ken Perenyi

First Pegasus Books cloth edition August 2012

Interior design by Maria Fernandez

ISBN: 978-1-60598-360-8

10 9 8 7 6 5 4 3 2

Printed in the United States of America
Distributed by W. W. Norton & Company, Inc.

In memory of
José

London 1993

Twenty minutes passed as I waited in the oak-paneled consultation room. Well into my second day of a vicious bout with the flu, I was burning with fever and getting nervous. I just wanted to get this over with, get back to my hotel room, and sleep.

The day before, I'd visited the posh bank at Harrods and handed the head teller a withdrawal slip for the equivalent of ninety thousand US dollars in cash. They requested a day for the transaction.

When the door finally opened, I lifted my weary head to see three sour-looking bank officials stride in. One solemnly placed

a package the size of a New York City telephone directory on the table and asked dryly, "Do you want to count it?"

The plastic package bearing the emblem of Barclays Bank looked hermetically sealed. Inside, I could see stacks of twenty-pound banknotes bound with neat paper bands. "No thanks," I replied, as a pen and paper were slid in front of me to sign. The three sourpusses looked on in silent alarm as I unceremoniously jammed the package into the canvas safari shoulder bag I'd brought for the occasion. As I rose to leave, an attractive woman poked her head around the door and gently said, "Be careful with that now!"

Desperate to get back into a warm bed, I left Harrods and headed down into the Knightsbridge tube station with part of the package sticking out of my bag. An announcement came over the PA system alerting passengers to pickpockets. I did my best to pull the flap of the bag over my precious cargo, but the strap and buckle wouldn't reach. I clutched it to me and ran.

Back in my hotel room, I took two aspirin and fell into bed. My throat was so sore, it was agony to swallow. A chill had set into my bones and I wished I was back home in Florida soaking in the sun. As I lay in bed, my eyes were fixed upon the package on the dresser: money wired into my account at Harrods a few days before from Christie's auction house, the proceeds from a painting of a pair of hummingbirds that I had left with them some time ago. I fell asleep thinking about my career, how lucky I was, and how it all had started years ago.

CHAPTER ONE

The Castle

J ust across the George Washington Bridge from Manhattan lies Bergen County, New Jersey, composed of towns such as Fort Lee, Englewood, Palisades Park, and Edgewater, to name a few. Today Fort Lee, whose splendid location stretches along the Palisades Cliffs, is a mass of high-rises, a spillover from Manhattan, but the Hudson River and the Palisades Cliffs are still as beautiful as I remember them when I was a kid. In the 1950s there wasn't a high-rise to be seen. The towns were more like villages, old-fashioned and unchanged for decades.

I grew up in Palisades Park, a town next door to Fort Lee, in a typical middle-class neighborhood. Dad worked as a machinist and tool-and-die maker at the American Can Company in Jersey City. His fellow workers said he was a genius and could do the impossible. When everybody else was stumped with a mechanical problem and the situation was considered hopeless, that's when they called on Dad.

I attended an ancient schoolhouse that resembled a Gothic fortress. It had wainscoted classrooms, green slate boards, and old wooden desks with inkwells. The initials carved on their surfaces by generations of bad boys dated back to the turn of the century. I hated every single day of school and was chronically in trouble for daydreaming and drawing pictures. I managed to pass from grade to grade by devising ingenious methods of cheating on tests with like-minded classmates.

Life in a town like Palisades Park in the 1950s was like living in the country today. As provincial as it was, though, one could cross the bridge to Manhattan and land on another planet, one of taxicabs, skyscrapers, and millions of people moving at a hundred miles per hour. I grew up aware that New York City was the center of the entire world, a place where you could get anything or be anything you chose to be—a place where everybody who was "somebody" lived.

During the holidays, my Sicilian relatives would visit from Jersey City for an Italian feast. After my grandmother entertained my cousins and me with stories of growing up in Palermo, she'd give us pieces of *torrone*. Each piece of the Italian nougat came packaged in a small, exquisitely decorated box. On the back of each box was a picture of a painting by one of the Italian masters. Each picture was set in a printed gold-leaf frame that highlighted

the painting like a miniature masterpiece in a museum. I lined up my empty boxes on my bedroom bureau and was mesmerized by the beauty of these pictures.

No holiday was complete without a hike to Fort Lee, where we spent the day exploring the cliffs. This included a visit to something quite remarkable that would one day change my life and set the stage for my future career. At the very edge of town, perched on a cliff overlooking the river, was an old estate set in its own parklands that cascaded down the side of the cliffs and ended at River Road below. In a clearing near the cliffs' edge stood a mysterious-looking house in solitary relief against the sky.

The structure resembled a medieval tower. It stood a full three stories high and had a sinister aspect. As kids, we played on the grounds that descended the side of the cliff. They were filled with strange ruins overgrown with ivy and shrubs. Crumbling walls, lookout towers, and a series of open caves or grottoes were carved into the face of the stone cliff.

Appropriately enough, the locals called the place " the Castle." Every imaginable story circulated about it. One held that a Nazi spy had lived there, photographed battleships on the river during World War II, and was caught and shot.

Time passed. I graduated from the ninth grade barely able to recite the alphabet. It was a foregone conclusion I'd never make it through high school, so I decided to enter a trade school to learn to be a printer. During this period of my midteens, I finally saw the inside of the mysterious house.

After visiting a friend in Fort Lee one day, I was passing through the grounds of the Castle when I was startled to come face-to-face with an eccentric-looking man. He wore a baggy tweed jacket and an old derby perched atop bushy, graying

hair. He cheerfully called out a greeting and engaged me in conversation.

"Do you live in the Castle?" I asked him.

"No, I live in the city," he said, "but I stay here when I'm working for the artist who does." He then introduced himself as Don Rubow, "artist's assistant and technician," and surprised me with an irresistible invitation to see inside the house. Don led the way to the entrance at the side and up a stairwell to the second floor. We then entered a large, airy room with high ceilings and walls framed in antique paneling. Well-worn pieces of vintage furniture graced the room. My eye was drawn to an alcove with a big picture window that offered a spectacular view of the Hudson River and Manhattan.

The trappings of an artist's studio caught my attention. Paints, palettes, and coffee cans filled with brushes were arranged on worktables that stood next to a drafting table splattered with paint. Half-finished sketches and drawings were tacked haphazardly on the walls. A pair of French doors that opened onto a balcony served as a source of light. Across the room, an entire wall was taken up by a magnificently carved antique breakfront that housed a sound system. Another wall was covered with built-in bookshelves filled with volumes. I was enthralled with my surroundings but wondered what anyone could want with so many books.

My host disappeared into the kitchen and returned with two glasses of soda. Don Rubow was forty-two, a soft-spoken beatnik-artist-philosopher who lived in Greenwich Village. He explained that the house was inhabited by people from the city who had come here to establish a design studio. He mentioned that they were in the city on business, and he rambled on about art and the equipment used in their work, but I wasn't paying much attention.

Instead, I was looking around and thinking how cool it must be to live in this place.

When it came time to leave, I thanked Don, and he invited me to drop by again. I didn't need any coaxing. A week later, I approached the Castle through a path in the woods, intending to visit, but just then a car pulled up and parked near the house. I was stunned when the car door opened and a well-tanned, exceptionally handsome man got out stark naked. He proceeded to pull a large towel from the car, drape it around his body, and stride toward the house like Caesar. I remained unobserved and thought it best to come by another time.

I was very bored with my life. The school I went to, Bergen Tech, aka Bourbon Tech, turned out to be nothing more than a repository for every flunky and JD in the county. The place was a madhouse with kids straight out of reformatories and was the perfect incubator for the criminal mind. The standard curriculum for incoming students was:

A) Gambling
B) Smoking
C) Drinking

The good part about the school was that hardly anyone failed— and those who did were held in the highest esteem by the entire student body. The bad part was that you might as well have wiped your ass with the diploma they gave you. Few businesses were fool-hardy enough to hire graduates from that school. After two years of technical education, I still had no inkling of how a printing press operated, except to press the button that said ON. There was some semblance of a classroom schedule, but before long kids started

throwing things at each other and the place exploded into mass hysteria. Desks went flying right out of windows, and teachers had nervous breakdowns.

In 1966, the only thing on my mind was buying broken-down vintage cars, fixing them up with my buddies, and picking up girls. I turned seventeen and got my first jalopy, a backfiring, clutch-slipping Rover, right in time for the Revolution. The hippie phenomenon had been gathering strength and I couldn't wait to "Turn on, tune in, and drop out." British rock groups swept the nation, and events dubbed "be-ins" materialized in Central Park's Sheep Meadow. Thousands of hippies and flower children turned out to make music, smoke pot, and express themselves through their new philosophical movement, embracing peace, love, and freedom.

That fall, I was driving down Main Street in Fort Lee, ready to turn down the steep hill to River Road, which ran below the Castle. As I did so, I noticed two interesting-looking men walking along the sidewalk in the same direction. One was Don Rubow, wearing his derby. I pulled up to the curb, rolled down the window, and called out Don's name. He came over and looked in the car. I hadn't seen him for a while, and, after asking how I'd been, he inquired if I was driving past the Castle.

Before I could answer, both men jumped in, and I renewed my acquaintance with Don as I drove down the street. I didn't have time to notice Don's friend, who was in the backseat, but once inside the car, Don introduced him as Tony Masaccio, who lived on the top floor of the Castle. When I looked in the mirror and focused in on him, I was taken aback. He was in his midtwenties and amazingly handsome. I thought he was a movie star and knew I'd seen him before. Then it hit me that he was the one I'd seen

from the path outside the Castle earlier that year, the one who had jumped out of the car naked and gone into the house.

We drove down the hill from Fort Lee and turned into the narrow hidden drive that led to the Castle. When we pulled up to the house, Tony surprised me with an invitation to come in. I followed him to the charmingly dilapidated suite of rooms where he lived on the third floor. I passed a bedroom, noticed women's lingerie flung about and pieces of modern art hung on the walls. Tony went out of his way to make me feel comfortable and offered me a seat on the living-room sofa. He was curious to learn how I'd come to know Don. I told him the story of my uneventful life, how I'd played on the Castle grounds as a kid, that I was currently attending a trade school, and that I would soon be free of it forever. When I asked him what he did, he casually mentioned that he was a partner in a "Madison Avenue advertising agency." As we talked, Tony walked around doing odds and ends. We eventually wound up in the kitchen, where, under the intense gaze of Mussolini pictured on an old World War II poster on the wall above the table, he proceeded to chop up some peppers and sausage for dinner.

Anthony Masaccio didn't have to tell anyone that he was Italian. His sensuous Mediterranean look said it all. His olive complexion was the color of wine at his cheekbones. A thick, lustrous mane of black hair framed a broad face with dark liquid eyes, eyes that seemed to swallow you up if he turned his gaze on you. Everything about him suggested wealth and privilege. When he'd light a cigarette, the matchbook invariably bore the logo of the Plaza Oak Room or Café Carlyle.

Despite his charming mystique, his raw glamour, and the fact that he was a descendant of the fifteenth-century artist Masaccio, Tony, aka Tony "Cha-Cha," was born and raised in Red Hook,

Brooklyn, a neighborhood known as a Mafia spawning ground, and he was right at home in bars where everyone had names like Joey, Tommy, Bobby, and Vinny.

Tony grew up steeped in Mob culture and old Italian traditions. His father, a "made" man and gambler, owned a fleet of cabs in Brooklyn. Neighborhood clubhouses and corner bars run by wise guys were a part of everyday life. His family also had ties to the Mafia through his uncle Salvatore, aka "Sally the Sheik," Mussachio (they were indeed related, but they spelled their names differently). This background had a profound effect on Tony's personality and manifested itself at times in his speech and mannerisms, which bore the subtle yet unmistakable stamp of the mobster.

Tony explained that the house was a studio for Tom Daly, the artist downstairs. The story was that Tom Daly and Peter Max, the famous poster artist, had met at the Art Students League and were among its brightest talents as commercial artists. They established the Daly & Max Studio and quickly made a hit on Madison Avenue, taking the original art nouveau style, adding a psychedelic twist, and applying it to their illustrations and lettering for the contemporary market.

Tom was first with another brilliant idea, body painting. He painted designs, pictures, and words in beautiful lettering on naked female bodies. He executed a poster of a beautiful blonde with her entire body painted. *Wanda*, as the poster came to be known, lounges on her side in total darkness. A light from above dramatically illuminates her body, revealing the artwork. Not only did Tom win the prestigious Art Directors' Award for it, but *Wanda* became one of the most famous posters in the world.

However, the partnership was short-lived. Peter habitually grabbed all the credit for their success, and it wasn't long before

Tom had had enough. There was a horrendous fight, followed by the end of the partnership. After the split, Tom became established on his own and was one of the most successful commercial artists in the business, his talents in demand by Fortune 500 companies.

In the meantime, Peter Max was busy fabricating his fame by paying publicity agents to get his name in society columns, portraying him as the guru of the hippie art scene. Although he was a poster and commercial artist, Peter wanted to be recognized as a *real* artist.

"Like Frank Stella or Larry Rivers," Tony explained.

"And what do those guys think of Peter?" I naïvely asked.

"Are you kidding?" Tony laughed. "They wouldn't piss on him."

Tony asked if I spent much time in the city. When I told him I liked to go to Greenwich Village with my friends, he surprised me again by suggesting that *we* go to the Village together the following evening.

Friday night I returned, picked up Tony, and headed for Manhattan. It was a beautiful fall night in the Village. The streets were filled with people going into the restaurants and clubs that lined the narrow streets.

Tony was cool and sophisticated. He knew all about the contemporary art in the galleries we passed. He knew the artists' names and where their studios were. It was impossible for me to hold a conversation with him on these subjects, but I was thrilled to just listen to him. His world was exciting, and I wanted to be part of it.

I was puzzled when Tony eventually led me to a dark, deserted area that bordered the Village and steered me toward a single spotlight above a bar named Max's at Park Avenue South and Seventeenth Street. "Tony!" rang out from people standing at the bar

the second we entered. Tony was obviously well known here. I'd been to a few Village joints with school friends before, but nothing that resembled this place!

Max's Kansas City was *the* art bar and restaurant where artists, agents, and dealers mingled and made deals. A magical place where aspiring nobodies flocked to meet the somebodies. It was the place to be and be seen in. A collection of contemporary art was always displayed on the walls above the bar or suspended from the ceiling. On almost any given night, Max's attracted an assortment of celebrities, rock stars, "beautiful people," and jet-setters, not to mention Andy Warhol and his superstars, who hung out in the back room.

I followed Tony, and we joined his friends at the crowded bar. He knew everybody, from artists with paint all over their jeans to big-shot advertising executives in three-piece suits, and beautiful women, one after the other, came to him for a chat, a whispered secret, or a discreet squeeze of his ass. Everybody loved Tony.

Although I was underage, it was no problem for Tony. He ordered me a drink and we headed toward a booth. Then he leaned over and casually asked me if I had gotten laid lately. Drawing a blank on that score, Tony then asked, "Well, have you turned on yet?" I had to confess that I hadn't. Tony smiled and gazed nonchalantly around the bar. Then he excused himself to make a phone call.

Twenty minutes later, after a string of very strange-looking people made their entrances, passed our booth, and went straight into a room at the back of the restaurant, a beautiful, willowy girl with sandy blonde hair and droopy blue eyes joined us.

Kathy was Tony's girlfriend and often stayed at the Castle. I had only seen girls like this on the glossy pages of fashion magazines

and was speechless in her presence. When she took her coat off, she revealed long, graceful limbs extending from a slinky minidress. Kathy worked in a Village boutique, had her own apartment on Perry Street, and did some modeling on the side. In answer to her somewhat puzzled look when she sat down with us, Tony explained that I was a local kid from Jersey.

After a Kansas City steak dinner, we left and headed up the West Side Highway to Fort Lee. Back at the Castle, we relaxed in the living room. Kathy put on a Tim Hardin record and opened a bottle of wine. I was totally dazzled by both of them and by our night at Max's. When Tony suggested that I return the next day for a dinner party to meet Tom Daly and spend the weekend, I could hardly believe my ears. Kathy also insisted that I come and sleep over on the sofa.

I was a silly kid who barely weighed a hundred pounds. I had absolutely no business being with these people. It was inconceivable that sophisticates like Kathy and Tony would be interested in the company of a screwball like me.

When I arrived the next day, Tony welcomed me like a long-lost friend. An Edith Piaf record played as Tony, barefoot and in jeans, showed me to the kitchen, where he was preparing a pot of lasagna. Bottles of wine, wedges of cheese, and a box of pastries were scattered about. The aroma of homemade tomato sauce filled the rooms.

Kathy invited me into the living room. She was wearing one of Tony's shirts and a pair of panties in which her long slender legs were beautifully displayed. Books on art, fashion, and photography were lying on the coffee table. Kathy curled up on the sofa while I made myself comfortable in an easy chair. We chatted, and she showed me the first book on art I had ever looked at in my life, a

book about Aubrey Beardsley, who lived in the nineteenth century and was famous for his erotic drawings.

At sunset, the view outside turned shades of blue as lights were coming on across the river. Kathy lit the candles on the table, and it was time to call Tom Daly. Soon there was a knock on the door, and in walked a man with a head of wild red hair that shot out in all directions. He was draped in a full-length black velvet cape and looked more like a rock star than an artist. With him was Jean, a superthin sexy model with a boyish haircut. She was wearing a yellow minidress with large black polka dots and holes cut in it.

Introductions were made, and Tony proceeded to serve one of his superb Italian dinners. I was completely out of my element. Their conversation about the art world and New York City was way over my head. I pretended to understand and smiled a lot. When the evening ended and Tom and Jean went downstairs, Kathy brought me a pillow and a blanket and then opened her robe and flashed me her beautiful naked body before disappearing into the bedroom with Tony.

The next day Tony invited me to come back during the week and stay over again, when he and Tom would turn on with pot. I still hadn't ever smoked grass and couldn't wait to try.

On the appointed night, I was there. Tony and I went down to Tom's floor. The room was lit with candles and I felt as if this was a secret ceremony, my official initiation to the Castle. Daly was splendidly arrayed in a magnificent antique embroidered silk robe, and he lounged back in his old easy chair with the air of an oriental potentate. With him was Joyce, a pretty, blonde art student and poet who worked for Tom in the afternoons, and another girl who was her friend.

Tony officiated by lighting some joints and passing them around. Joyce put on a record and sat next to me. She explained that the idea was to take a long drag and hold it in as long as possible. It wasn't long before a sense of complete and exquisite pleasure like nothing I'd ever experienced pervaded my being. We listened to music, laughed, and passed joints late into the night.

I lay back on the sofa to enjoy the sensation of being high for the first time. I remained awake as long as possible, gazing through the window at the stars, wanting the feeling to never end. I imagined the house was a rocket ship shooting us through the universe.

A whole new world was opening up to me through Tony. He circulated in the downtown art scene. He took me to SoHo, an area of lower Manhattan filled with streets of neglected turn-of-the-century warehouses. Artists had recently discovered it as a new place to live and work. Galleries, cafés, and boutiques were moving into the area. It was very exciting, and one could feel the energy on the streets. Tony knew many of the gallery owners and took me to the studios of his artist friends. I loved spending every minute with Tony, and for the first time I saw creative people making things happen for themselves, the way *they* wanted it and not depending on the Establishment for a career.

Until this time, I barely knew Tom Daly, and I wanted to see some of his artwork. One day, while on my way up the staircase to visit Tony, I heard music and noticed Tom's door ajar. I stuck my head in to say hi. Tom was lying on the sofa, smoking a cigarette and listing to the soundtrack from the movie *A Man and a Woman*. He waved me in and, when I expressed my wish, he began to show me a few of the posters he'd created. Then Tom casually asked if I cared to smoke a joint.

"Sure," I enthusiastically replied. "Do you turn on a lot?"

"Now and then," he answered. "And what about you? Was that your first time the other night?"

"Yeah," I said. "I thought it was great." At that Tom laughed, went to the breakfront, and produced a brick-shaped, foil-wrapped stash. I watched in astonished delight as he proceeded to break off a chunk and hand it to me as a gift.

"Well, what are your plans after you finish school?" Tom asked. "What are you going to be?"

"Nothing," I said. "I don't have any plans to be anything. Besides, who needs a job anyway? We're on the verge of a revolution."

That was fine with Tom, but he suggested I at least learn the rudiments of joint-rolling to be prepared for the future. He got papers from a drawer and demonstrated his method, showing me how much grass to use and how to roll it. After I made my first prototypes, Tom suggested we test them out to see how they worked. Thus began my first insights into one of the most unusual individuals I ever met.

Tom Daly was above all a sensualist. His main goals in life were getting laid and getting stoned. Despite his twenty-seven years, Tom was really a teenager who could masquerade as an adult when the situation demanded. Otherwise he enjoyed going out in public dressed up in outrageous getups and freaking people out. At his zenith, Tom drove a new convertible Mustang, a moving mass of dents and scrapes, the result of sideswiping the trees lining the narrow road that led up to the Castle.

He was unmaterialistic, with no desire for the sorts of things most people want. His only indulgences, apart from sex and pot, which he bought by the kilo, and scotch by the case, were his installation of a thirty-foot phone wire that allowed him to pace

around the room in frantic conversations with his agent, and the acquisition of books for his treasured library.

When Tony came downstairs, Tom and I were sharing a joint and laughing. He had pulled out a book and was showing me the work of his favorite artist, James Ensor. Ensor was an early twentieth-century Belgian painter who was obsessed with depicting people in bizarre carnival costumes—not unlike the ones Tom wore himself. Tony was heading to the city to collect Kathy and asked if I wanted to go along. As we pulled out of the driveway, Tony asked me what I thought of Tom.

"He's really far-out!" I exclaimed, showing him the pot Tom had given me.

"Yeah," said Tony. "Tom's a complete maniac."

As we were pulling up to the tollbooth on the George Washington Bridge, Tony extended his hand as if to pay the toll clerk, but instead slammed the accelerator to the floor while he flung his empty fingers in her stupefied face. As we raced away laughing, I could hear the woman's screams halfway across the bridge.

I never actually saw Tony go to work at his "Madison Avenue advertising agency." Indeed, his business in the city rarely seemed to extend beyond picking up Kathy (using Tom's new Mustang) and occasionally dropping Tom's portfolio off at an agency.

When I accompanied him, the three of us usually wound up in Little Italy, eating scungilli at the bar in Vincent's on Hester Street with Tony's hoodlum friends. Kathy was amused by the crush I had on her and sometimes, without the least warning, she'd put her arms around me and start kissing me right in front of Tony. He didn't mind at all. In fact, he enjoyed watching the blood rush to my head as I'd almost pass out in a swoon.

If Tony wasn't enough, I reached a new level of cultural enlightenment when I began spending time with Tom. Up until this point, I hadn't read a book in my life, and the only time I'd been to a museum was on a school trip. I assumed that the appreciation of such things as art and literature was for people of superior intellect who dressed in tuxedoes, went to the opera, and ate caviar.

Tom changed all that. Almost every night I was at his place smoking dope with him and listening to his stories. Tom was a storehouse of knowledge. He knew everything about art, history, and literature. I thought he was brilliant. He had the answers to everything—and if he didn't, he'd make them up. He was just the kind of person I wanted to meet. Before long, he had me reading books by Voltaire, Balzac, and Dostoyevsky, and appreciating art by masters with heroic names like Titian, Rembrandt, and Michelangelo.

Stumbling on the Castle was the most exciting thing that ever happened to me. It was a center of cosmic energy. I was deliriously happy. I couldn't sleep nights, thinking about the Castle and my new friends. My mother couldn't understand what had happened to me. Every weekend, there was another party made up of guests that Tony invited from Max's. These always included a few top fashion models, artists, actors, and even rock stars. As a practical contribution, I showed Tom and Tony around Jersey and served as chauffeur, especially at night coming home from Max's when they were too drunk to even walk to the car.

And Tom was the best friend anyone could ever want. Not only did he let me smoke all the pot I wanted, and not only did he give me a copy of the Marquis de Sade's *Juliette* for my birthday, but

he was positively dedicated to getting me laid as well! What more could any teenager wish for?

Nineteen sixty-seven promised to be an exciting year. The Vietnam War was tearing the country apart; that spring, protests, rallies, and be-ins were held in Central Park. I finally graduated from school and was good for absolutely nothing. Tony, Joyce, and Tom, black cape and all, surprised me and came to my graduation. They sat right in the first row of the auditorium and cheered when I got my diploma. Afterward, they took me to Max's for dinner.

The prospect of going out and finding a job with a bogus diploma in order to run a printing press for the rest of my life was never even a consideration. For the time being, I had no intention of doing anything except hanging out at the Castle and studying art. And what better place to advance the curriculum than the Metropolitan Museum of Art? For Tom and Tony, it served as the ideal pickup joint. I tagged along on their field trips every Sunday afternoon. Not only did I finally see paintings like those I remembered from the *torrone* boxes, but, curiously enough—and what would prove to be an important factor in my life—I developed an interest in the early European furniture I saw on display there.

I had no idea how I was going to use all this new knowledge about art, but through these expeditions I lost my fear of museums and galleries and was now able to hold a conversation on the subject. In addition, Tom allowed me to watch him paint as much as I wanted. He showed me how an ever-developing series of drawings became a finished work of art. It was fascinating for me to watch the creative process unfold before my eyes. I had always assumed that paintings were created by an artist guided by some

supernatural inspiration, instead of by a process of simple progressive steps.

—⁓—

In the late sixties, the Vietnam War was America's worst nightmare. No sooner had I graduated than the draft was ready and waiting with an order to report to Newark, New Jersey, for classification. If I passed the mental and physical examinations, I would be inducted on the spot, shipped to boot camp, and on my way to Vietnam.

I needed a plan fast, and Tom had the answer. He gave me a satirical instruction book titled *101 Ways to Beat the Draft*, which he'd bought for me in a head shop in Greenwich Village. It was filled with ridiculous suggestions designed to convince the doctors at the induction center that you were unfit for service. It suggested you talk to yourself, roll your eyes, prick holes in your arms, wear a dress, etc. However, the book warned that a rejection on these grounds came with a derogatory classification on your draft card. According to the book, 1-Ys were handed out to "physical wrecks and psychological misfits." And the 4-F was reserved for the "incorrigibly wicked." The book also warned that potential employers were required to check your draft status, and that a derogatory classification made your chances of getting hired very slim.

I read the book but had no idea of what I would do when the time came. I racked my brain trying to figure out a way to be undesirable. It was obvious that 99 percent of the suggestions were absurd, but it was the principle that was important.

It was a dreary gray morning when I and the other inductees were loaded onto an army recruiting bus in Hackensack, New

Jersey, for the ride to Newark. It was a depressing journey through an endless industrial landscape of rusting factories, oil refineries, and garbage dumps.

The bus pulled up to a dirty nondescript building in a run-down part of town. We were ordered out. Once inside, we were directed to a classroom where an old windbag in a military uniform treated us to a patriotic sermon. Then they handed out an aptitude test. It was about four pages long, containing math, science, and history questions.

I decided this would be my starting point and deliberately scored low. In fact, I scored so low that I was ushered into an office for a chat with the shrink.

The doctor began by asking me a few questions about the extent of my schooling and background. Finally he wormed his way around to the aptitude test and said he thought it rather unusual that anybody could score so low.

"I thought I did pretty good!" I answered.

Satisfied with that, the shrink turned his attention to questions of a more personal nature.

"Have you ever taken any drugs?" he asked.

"Yeah," I replied.

"What kind?" he wanted to know.

"Pot, acid, and speed," I confessed.

"How often?" he inquired.

"Every day," I assured him.

The psychiatrist studiously noted all my responses on a pad and then asked me in a frank manner, "Have you ever received psychiatric help or been admitted to an institution?" At this point, I exploded with indignation. "Whadda I look like?" I yelled. "Some kinda degenerate?!"

He calmly recorded my response in his growing report. He thanked me with a smile and directed me to a waiting room, where I sat for an hour with two other interviewees. They looked like zombies and were oblivious to their surroundings. If they were acting, they were doing a beautiful job.

Finally my name was called, and I was ordered into a room down the hall where I found a serious-looking officer seated behind a desk. He looked up at me and picked up a piece of paper. "I'm sorry, Ken," he said, after glancing at the sheet, "but the Armed Services aren't interested in your service at this time. You'll be receiving your classification in the mail in a few weeks." I tried to look disappointed and left. I couldn't wait to get out of that building.

Weeks later, when my draft card came in the mail, the classification 1-Y was stamped on it in bold letters. It was the perfect complement to a diploma from Bourbon Tech. Together they virtually guaranteed I'd be thrown out on my ass if I even approached an employer for a job. I knew I had struck out big-time and had no idea where I was heading in life. But during this period I also came to realize that the more I studied paintings, whether in Tom's books or at the museums, the more I understood how they were painted. It was as if they were breaking down into their simplest elements right before my eyes.

At this point, looking at paintings was the only thing that made sense in my life. Somehow I understood the logic behind their creation. I felt an irresistible force driving me, telling me that I could paint them too.

My artistic career began that summer when I explained my feelings to Tom. He went around the studio and gathered up some old tubes of paint and a few brushes. He suggested that I follow the example of the old masters and begin by painting copies of

masterpieces. Hunting around through some books, Tom came up with a portrait of Christ by Rembrandt.

It was my first try, but I executed the Rembrandt with a genuine understanding of color, tone, and texture, as though I had always understood how to handle paint and brushes. I was very excited and couldn't wait to show it to Tom. I raced to the Castle. Tom was amazed when he saw it and called my mother to tell her how impressed he was. My mother was delighted that I had found such nice people at the Castle, people who were finally giving me some direction in life.

Tom lost no time finding more prints for me to copy, and with each consecutive painting I learned more. Soon painting became a compulsion and I couldn't wait to start another one. For me, this was a major turning point. Painting gave me a purpose in life. Now I didn't feel so bad about my 1-Y and promptly burned my draft card at the next antiwar rally in Central Park.

Next, Tom gave me books on two artists whose work we had enjoyed looking at under LSD. Hieronymus Bosch and Pieter Bruegel were two early Flemish artists who specialized in bizarre allegorical paintings. In fact, I don't think it would be an exaggeration to say that Bosch was probably on an acid trip himself when he painted his pictures. As for me, I didn't need any prompting at all to begin copying their work as well.

One day Tony showed up at the house with two girls he knew from the back room at Max's. The girls were Andrea Feldman and Geraldine Smith, two of Warhol's superstars from his films *Trash*, *Imitation of Christ*, and *Bad*. Andrea, spaced out on drugs twenty-four hours a day, lived in a state of complete fantasy. She claimed to have taken LSD over four hundred times. Geraldine, in contrast, was cool and in complete control. Beautiful, thin, and

sexy, she had dark red hair and a sculptured face, and she arrived in a fishnet minidress that left nothing to the imagination.

The girls needed a break from the city. They promptly moved into an empty room at the Castle and I made friends with them right away. They were great fun—and soon we were cruising around in an old Mercedes-Benz I had just restored, getting stoned and going to the Dairy Queen for milkshakes, little realizing that my fate was being sealed and life would never be "normal" again.

CHAPTER TWO

Ciao! Manhattan

Providence could not have put Tom Daly in a better place at a better time. He was the psychedelic king of the Castle. Brilliant, rich, and talented, he lived in a paradise of booze, sex, and pot. And the world came to his door.

Tom called one afternoon while I was at home tuning up the old Mercedes. He wanted me to come over as soon as possible. He had some important news to share, and Andrea and Geraldine would be there too.

After dinner and under the suspicious eye of my mother, who was beginning to suspect that more was going on at the Castle than intellectual forums, I left for Fort Lee.

When I entered Tom's room, I found him seated with Geraldine at the table in the alcove. He seemed mesmerized by a coffee can placed on the table. When I approached, he motioned for me to take a seat across from him.

"What's that?" I asked, pointing to the can, on which his attention was focused.

"Open it," he commanded. To my astonishment, the can was filled to the brim with a fine green powder.

"What is it?" I asked.

"Kief, one of the best grades of smoke," Tom said. "It was a gift!"

Instinctively we began rolling joints, as Tom explained that the Castle was going to be used for the shooting of an epic underground flick entitled *Ciao! Manhattan*. The star, Edie Sedgwick, was the Marilyn Monroe of the underground movie scene. Tony had brought the Castle to the attention of the producers, and the kief was a goodwill offering presented to Tom for his permission to use the house.

Andrea called out from Tom's bathroom. She wanted me to keep her company as she tried a hundred different things on and asked me what I thought. She also wanted to know if I had any acid. I unwrapped a piece of foil extracted from my jeans, and we split a piece of filter paper. When she was finally ready, we joined Tom and Geraldine in the main room. Tom, who was already stoned on God knows what, was amusing Geraldine with stories as she lay back on the sofa, gazing up at the ceiling.

Andrea was going to entertain us with a record of the original soundtrack from *Peter Pan* sung by Mary Martin. She

loved playing the album, especially the songs "I'm Flying" and "I Won't Grow Up."

The acid kicked in, and Andrea sang and played along with the record again and again until she believed she *was* Peter Pan. Andrea was apparently having a reality crisis in the midst of a drug-induced, hallucinogenic trip. It seemed that the problem she was experiencing in distinguishing reality from whatever metaphysical meteor she'd mounted was leading to a transcendental meltdown.

At one point, we put Tom in his studio chair, which had casters. Every time Mary Martin sang out "I'm Flying," we'd hurl him across the room. The evening wore on, and the acid magnified awareness a thousandfold. I could see every pore in Tom's face and count the hairs on Andrea's head. I could hardly bear to look at the expressions of others. Everything was grotesquely distorted, hilariously funny one moment and then horribly frightening the next. It all seemed more like a dream than reality.

The following day, I was sitting down with Tom. We were having a chat about the images and impressions of the night before. Tom thought it would be an excellent artistic project if I tried to capture them in a painting—and furthermore suggested that I paint a surreal, psychedelic impression of the Castle, a painting that would depict how people and events looked to me under LSD, part Hieronymus Bosch and part Marquis de Sade. This was the first real artistic challenge I had faced, for now I had to invent a picture rather than just copy one. For the rest of the summer, I sketched people and scenes, real and imaginary, to incorporate into one all-encompassing masterpiece.

Ciao! Manhattan was to become an underground movie classic. It was based on the life of Edie Sedgwick, who by 1967 had already

assumed mythical proportions in the underground society of New York City. Young, glamorous, and beautiful, she came from an old Boston family. She had moved to New York in the sixties and met Andy Warhol, and together their chemistry sparked the beginning of the pop-art underground culture. Their ideas in fashion and art set a trend for decades to come, and *Ciao! Manhattan* was to be Edie's apotheosis.

Andy Warhol was not involved in *Ciao!* and was said to have been quite sore about it. It was shot by Chuck Wein and John Palmer, friends of Andy's who worked with him on movies made at his factory.

As word of the filming spread, half of the Warhol Factory, including Viva, Eric Emerson, and Paul America, invaded the Castle. Andrea and Geraldine were already ensconced. Lionel Goldbart, a poet from the Beat generation, came with his guitar, sunglasses, and bongo drums. He was tall, handsome, extremely intelligent, and hopelessly addicted to heroin. He was working on a new calendar that he claimed would "completely change the world as we know it."

Chuck Wein and John Palmer arrived in a caravan of limousines bearing Edie Sedgwick, the cast, the camera crew, and an entourage of friends. Two trucks hauling equipment followed behind. Lights, cameras, and boxes full of costumes were carried into rooms below Tom's that opened up onto the lawn.

After Edie and her friends settled into various rooms in the Castle, a party that would last for days got under way. Music blared from Tom's studio, and caterers delivered trays of food and wine by the case. When Tom introduced me to Edie, I thought she was very cool and very hot. She was wearing a lime-green minidress with a large gold zipper right up the middle of it. Her eyes were

big and soft, enchanting to look into. She possessed an uncanny hypnotic attraction. Edie was very sweet, but she spoke so softly and so low I thought she was about to fall asleep. I noticed there were pills scattered on the floor. Tom and I headed for a table set up with a buffet of sandwiches and salads.

"What are all those pills doing all over the floor?" I asked him.

"Oh, those," Tom said. "Well, Edie just threw a handful of them at somebody who didn't bring her the kind of Danish she likes."

After the crew set up the cameras and equipment for the shoot, people began to appear around the Castle in very strange costumes. The reason was made clear when John Palmer explained the story line to me. According to the script, Edie had been ordered by some mysterious member of the underground to leave Manhattan and go to the Castle, which was designated as a "contact point." There she would meet the "saucer people"—i.e., friendly beings from outer space who would show her how to save the planet from destruction. That was all logical enough, I thought. But what I found puzzling was that the saucer people weren't limited to just plain old Martians, but included cowboys, drag queens, circus acrobats, soldiers, fashion models, and several who simply defied description. They even had Allen Ginsberg dressed in the beads and robes of an Eastern mystic to greet her.

After a lengthy shoot in Tom's studio, the climax of the filming occurred when Chuck Wein asked everyone to follow Ginsberg, who had shed his robes and was completely naked, down into the caves in the cliffs for a shoot of Allen leading us in a hedonistic chant.

Tony was missing all the excitement, but he wasn't interested in watching the film shoot. Instead, he was making a movie of his

own with two young models, even Edie herself, in his bedroom upstairs. "And besides," he said when I knocked on his door to see if he wanted to come downstairs and get something to eat, "I'm sick of looking at Allen Ginsberg walking around with his dick hangin' out!"

To cap the summer off, Tony got opening-night invitations to the Electric Circus. Heralded as the ultimate psychedelic disco, it was purportedly designed to employ a light show that would mentally induce its patrons into a hallucinogenic trip without the use of drugs.

Despite the promoters' claims, we weren't taking any chances, and on the night of the event Tom, Tony, Joyce, and I dropped acid, jumped in the car, and headed for St. Mark's Place. Inside, the place was packed with celebrities and the underground elite in outlandish "otherworldly" fashions. As soon as we entered the main room, we met Allen Ginsberg, beads, robes, and all. To the deafening sound of "Eight Miles High" and "Light My Fire," we worked our way to the second floor and joined a group of people from *Ciao!* sitting on the floor in a corner. Outtakes from the movie were being projected on the walls. Edie was there, looking spectacularly beautiful. She was made up like a dewy, owl-eyed doll. She wore jeans and a slinky top cut low down the back, revealing her entire spine. Across the expanse of her exposed back, she had scrawled her telephone number in flaming red lipstick.

—∞—

In 1968, Tony's current girlfriend, Barbara, was tall, sophisticated, and beautiful with long, straight red hair and freckles. She was a model and had been married to a designer for the ultrahip boutique

Paraphernalia. One night at Max's, after they had just returned from a trip to upstate New York, Tony and Barbara told Tom and me about a museum they had visited in Lake George. The museum had been the summer residence of Marcella Sembrich, a famous opera singer in the 1930s. It was filled with antiques and artwork she had collected during her life. Many of the pieces had been given to her by wealthy admirers. Tony was desperate for a big score and came up with the idea of cleaning the museum out. Not long after that, I got a call from Tom. He had received a call from "you-know-who," and he told me to be at the Castle that evening.

That night, Tom and I held a vigil. At 1:00 A.M., we spotted a pair of headlights at the end of the road inching slowly up toward the house. We went out on the balcony and held our breath as the car pulled up beneath us. Tony emerged from the car, grinning from ear to ear. He spread his arms wide and took a grand theatrical bow.

Barbara, coolly dressed in skin-tight black leather jeans and a turtleneck, disembarked from the car and sauntered up the steps to the entrance of the house. Hollywood could not have cast a more glamorous pair of art thieves. "You did it!" Tom cried when Tony entered the room. Barbara, the ultimate picture of composure, sank into an easy chair and lit a cigarette.

Tom, Tony, and I went down to the car. It was packed to the headliner with boxes containing all the loot. We lugged everything up to the house and began to unwrap the items and spread them out on Tom's worktables. Our eyes were met with a dazzling array of treasures. There were beautiful Russian cigarette cases by Fabergé, a Tiffany desk lamp, art glass by Lalique, and a complete set of antique Sèvres china, each piece wrapped in newspaper by Barbara's lovely hands. There were eighteenth-century

French clocks and Russian icons, even a collection of early bronze figurines. The most breathtaking sight of all came when Barbara unpacked a priceless collection of eighteenth-century ladies' fans of indescribable beauty.

"There was nothing to it," Tony said, as Tom lit up a joint. Tony explained how they'd checked into a Lake George motel and waited until nightfall to visit the museum. They'd parked in a hidden spot and broken in through a window at the side. Once in, they broke into display cases, grabbing everything in sight and packing the loot into boxes brought in with them. They loaded up the car and sped away into the night.

We were thunderstruck. Tony was really wired and in a dangerous mood. I kept clear of him and spent my time with Barbara, who was serene as a Persian cat.

Unfortunately, Tony hadn't made as clean a job of it as he thought, and the next couple of weeks were frightening. He hadn't used a stolen car as planned, but rather one owned by his brother. Then he created suspicion at the Lake George motel by asking the management a million questions about the museum, before robbing it. They had taken down his license plate number. The FBI traced it and paid a visit to his family in Brooklyn. Then the feds showed up at Max's. It was only a matter of time before they'd reach the Castle. We were all in a state of paranoid shock. Tom urged Tony to leave the area at once, but Tony insisted that he needed to sell some of the goods first. Sure enough, the feds showed up at the Castle. They scared the hell out of Tom, but he managed to stonewall them and claim he hadn't seen Tony for a while.

Amazingly, at that very moment, Tony was coming to terms with a dealer along Third Avenue in the Fifties. The dealer

correctly surmised that he was looking at hot merchandise. The whole lot must have been worth a couple of hundred thousand or more. Tony took a lousy ten grand, but at the time it seemed a fortune. Now with the FBI swarming around and crisscrossing paths with Tony, there was no returning to the Castle. He and Barbara decided to take a trip to Mexico and lie low for a while.

Things quieted down, and I finally finished my masterpiece impression of the Castle that I had started months earlier. Although I did most of the drawings at the Castle, I did my painting at home in the garage where I worked on my cars. Tom was very anxious to see it, especially since he'd come up with the idea and this was my first effort that wasn't a copy of an existing painting. On the evening that I was ready to bring it over, Tom assembled the "Castle People," they lit up joints, and we had an unveiling. The painting, which was to become the first of a series, was a bizarre phantasmagoric scene depicting people, objects, and symbols in a surreal Boschlike landscape of rivers, cliffs, and imaginary buildings. Everyone was stunned. Nobody had thought I was capable of doing anything like that. Tom was at a loss for words. Andrea said it sent her on a "trip." Lionel Goldbart took me off to the side and said that he had just one question for me. "And what's that?" I asked.

"What planet did you come from?" he inquired.

—⁂—

Meanwhile, a steady stream of postcards and letters arrived from Mexico, describing the idyllic circumstances south of the border where Tony and Barbara were soaking up the sun, living the good life, and sipping margaritas. It sounded to good to be true, and

indeed, only a couple of months after they had gone on the lam, trouble in paradise was announced in the form of a collect call from Tony. The story was that they were stranded high and dry, stone-broke, and out of tequila, in a hotel in Mazatlán.

Three days before they rolled into Mazatlán, Tony and Barbara had driven to a lovely secluded beach. They put their bankroll in the glove compartment and went to swim in the nude. While they were frolicking, everything in the car was stolen. The bandits left them fifty bucks on the driver's seat, presumably to help them "make it through the night." They needed money immediately. Tom and I wired them a few hundred dollars, and they were on their way back home.

When they returned to New York, they settled into a five-story walk-up apartment on East Fifteenth Street. The FBI paid periodic social calls on Tony's family, hoping to nail him there. Gradually their interest dwindled. It was a piece of irony that the agent investigating the Lake George robbery had his office only a couple of blocks from their apartment. Tony actually called the guy from a pay phone once, trying to convince him that he hadn't done it!

—⁂—

One day in 1969, I was at an Upper East Side café with Tony when he suggested that we go to the Parke-Bernet Galleries (which later became Sotheby's) and take a look at a collection of European artworks on display, where he suspected he might see some of his stolen loot for sale.

Outside, a number of chauffeured limousines, some double-parked, marked the entrance to the galleries. I hadn't even been aware that it was an auction house. I followed Tony, and we took

the elevator to the second floor. The doors opened, revealing rooms filled with dazzling artwork.

This was my first glimpse of the moneyed of the art world. They were out in force, leisurely cruising the salesrooms. Women dressed in haute couture spoke in hushed tones. One, with a York-shire terrier draped over her arm, chatted with a friend who was considering an eighteenth-century game table, while impressive-looking men, impeccably dressed, studied beautiful paintings hanging on the walls.

Thanks to Tony, this experience proved to be a breakthrough for me. I bought some expensive clothes and returned frequently to study antiques and paintings, mingle with the art snobs, observe their mannerisms, and watch the sales. Most of all, I was fascinated by the atmosphere of the salesrooms. The silver-haired auctioneer in his pin-striped suit, flanked by his spotters, reminded me of a croupier at Monte Carlo. The room was invari-ably charged with excitement and glamour, as fashionable young ladies took bids over the telephones. I was struck by the ease with which items selling for tens of thousands, even hundreds of thousands, passed before my eyes. What I wouldn't give to be the owner of a couple of those pieces, I thought, and wished I could be part of this rarefied world.

My interest in early European furniture, which had begun as a result of visits to the Met with Tom and Tony, had by now developed into a genuine passion. And, better yet, it would pay off as well. I discovered from my visits to Parke-Bernet that they held sales featuring examples of this furniture. I bought catalogs, attended the sales, and learned as much as I could about the market for these items. I also made the acquaintance of several dealers who specialized in this area. Soon, I was scouting the country antique

shops, hunting for early furniture. When I found a good piece, I'd buy it and make a profit by selling it to one of the dealers in the city.

However, the real pivotal event in my life occurred when my obsessive love of vintage cars impelled me to swap a beautiful 1955 MG-TF I had painstakingly restored for a dilapidated 1936 Bentley Sports Saloon. I was enthralled with its walnut-veneer dashboard studded with neatly arranged toggle switches and gauges, and its posh leather interior. Some of my sports-car buddies helped me tow it home.

When we pulled into the driveway with it, Dad ran out of the house, flipped open the hood, and blew his stack. Half of its enormous straight-six-cylinder engine was pulled apart and in pieces. Months of work under the direction of my father and every penny I had were poured into the restoration of the beast, but it was well worth it. Friends were thrilled with rides into the city, cruising Greenwich Village and pulling up to Max's in style.

The car was terrific fun, but I soon discovered I was in way over my head. Apart from its voracious appetite for gas, the cost of parts was astronomical. A set of distributor points, which cost five dollars for my MG, cost seventy-five for the Bentley, a muffler ran six hundred, and God forbid something major blew, like a generator or transmission: it would be curtains.

Nevertheless, I managed to keep it on the road, and one fine day as I turned onto a street leading to the George Washington Bridge, I had the unparalleled good fortune to see the hottest girl in Fort Lee High hitching a ride to the city. Swerving to a stop, I could hardly believe my eyes as I looked into my rearview mirror. The beauty in skintight jeans and an old sweatshirt was running toward my car, her mass of wild dark hair tossed out behind her in the wind.

Linda was a stunning seventeen-year-old stringbean of a girl. She was five foot nine and all legs. Tony and I had occasionally glimpsed her walking around Fort Lee. Once Tony had swung a U-turn right in the middle of Palisades Avenue just to pull up and attempt to dazzle her with his Italian charm. He tried every trick in his seductive repertoire, but to no avail: she just smiled and kept on walking.

Now here we were, happily driving across the bridge bound for Fifty-Ninth Street. She told me she was headed to Central Park to attend a bra-burning. I confessed that *I* too found underwear abhorrent and never wore the stuff. With so *much* in common, and mutually confident that our meeting was much more than chance, Linda and I exchanged phone numbers, and a whirlwind romance ensued.

Linda lived with her father in a luxury high-rise in Fort Lee and planned to be a model. I'd pick her up after school in the Bentley and we'd cruise to Callahan's Drive-In for hot dogs and fries. Then we'd go to the Castle or one of the scenic parks overlooking the river, jump into the backseat, and make out for hours.

A month of bliss passed in the backseat of the Bentley. Life would have been perfect if it hadn't been for the perpetual state of poverty in which the car kept me. Any profit I made on a piece of antique furniture quickly vanished into that money pit. Desperate to finance the next round of repairs on the car and desperate to keep my romance alive, I was ready to do anything for some money. Once again Tom, my Svengali, had the answer.

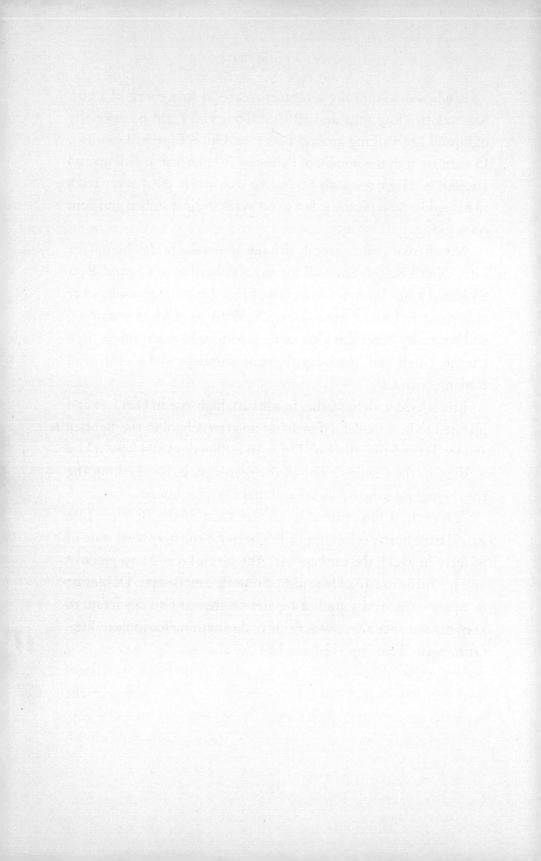

CHAPTER THREE

Art Forgery 101

Tom liked to prowl around bookstores in an endless search for something new and interesting for his library. One evening while I was ruminating about my financial condition, Tom showed me a book he'd just picked up at the Strand bookshop. "Now, this guy knew how to make money!" he said. The book was about Han van Meegeren, a Dutch art forger who operated in the 1930s and '40s. He specialized in faking Vermeer, the seventeenth-century Dutch master. Van Meegeren had done very well for himself living in a villa on the Riviera, but apparently his

success had affected his thinking, for he began selling his pictures to the Nazis when they occupied France during the war. And he didn't fool around with the riffraff, but sold his work to Hermann Göring, one of Hitler's closest chums.

Van Meegeren's downfall came after the war, when Nazi art treasures were seized by the Allies, who found some Vermeers along with transaction receipts listing van Meegeren as the seller. The poor man was brought up on charges as a traitor for selling national treasures to the enemy. In a supreme twist of irony, van Meegeren's only defense was to declare himself the artist. The court refused to believe him. Only when van Meegeren painted a masterpiece in his prison cell were the authorities convinced.

The van Meegeren book made a big impression on us. In addition to revealing the Dutch artist as a mastermind, the book delved into the technical details of how van Meegeren created his fakes. It explained basic principles such as using the canvas and stretcher or wood panel from a genuine antique painting of minor value as the support or surface for the forger's masterpiece. It also revealed techniques for producing cracks and hardened paint.

After I read the book, a plan began to take shape due to a combination of factors. First, the basic technical principles explained in the book seemed simple enough and well within my reach. In fact, a lot of it was just common sense plus some imagination. The second element was that every time I visited the Met and studied the work of Brueghel to get ideas for my surrealistic paintings, I noticed a collection of sixteenth-century Flemish portraits nearby. Measuring approximately ten by twelve inches each, they looked simple, and I was sure I could paint them.

The third and determining factor emerged as a result of my visits to Parke-Bernet. There, I was able to physically handle old

master paintings, something I could never do in a museum. I studied several examples of Flemish portraits similar to the ones in the Met. I was able to lift them from the wall and view the all-important backside to see exactly on what they had been painted. I noticed that most were painted on the same type of thin wood panels. It occurred to me that I'd seen exactly the same wood panels used as the bottoms of drawers in the seventeenth-century furniture I hunted to sell to dealers in the city.

When the opportunity arose, I procured three suitable panels scavenged from a third-rate piece of early European furniture. I went to the Met, studied the Flemish portraits for hours, and bought books containing reproductions of them. I noticed that many of the paintings shared similar characteristics: deceptively simple portraits of people with thin lips, long straight noses, medieval hairstyles, and ethereal expressions.

With the originals as models, I used a method I had once watched Tom employ. I got a sketch pad and, borrowing a little from each model, was able to complete several plausible portraits of imaginary sixteenth-century sitters. All I had to do next was to cut the panels to proper size, carefully burnish the edges, apply a thin coat of gesso, and finally transfer the sketches to the panels, again using a cut-out-and-trace method I had observed Tom use in his work.

Over the next two weeks, my mother couldn't get me out of the garage. I was either tuning up the Bentley or working on the portraits. At last, I produced three examples ready to be "baked" in the sun for the next couple of weeks.

After the paint was sufficiently hardened, the next challenge was the cracking. I noticed from my studies at the Met that not all paintings on wood panels display cracks, but when they do, they

show a unique crack pattern that resembles a macroscopic grid pattern that is referred to as "craquelure" by experts.

It was mentioned in Tom's book about van Meegeren that forgers sometimes used needles to engrave cracks into paintings. After raiding my father's tool chest for an engraver's needle, I began to engrave cracks fine as a human hair under a large mounted magnifying glass and lamp. It took several days to copy the "grid" pattern onto each panel.

The next step was to darken the cracks. Natural cracks in an antique picture appear black because of a deposit of microscopic debris and discolored varnish that has settled within them over the years. All it took was a wash of powdered pigment with some soap and water, wiped over the surface of each painting, to reveal the entire pattern right before my eyes.

I made an "antique" varnish by simply using a commercial brand of varnish and tinting it with a brown stain. After this was applied and the paintings allowed to dry in the sun for a few days, I rubbed dust thoroughly into the back, front, and edges of each painting.

I was very excited with the finished product. The portraits looked exactly like the real ones I'd seen in the Met, especially my third—and best—effort. It was a portrait of a man perhaps fifty years old. A black tunic covered his chest in pleats, and, in a corner at the bottom, a few fingers lay as if resting on a windowsill. His hair was clipped like that of a monk, and his face exhibited the serene expression of a saint.

With the Bentley on the fritz, there was no time to waste. I emptied a yellow manila envelope of some junk mail, slid the panel in, and left for the city.

As I was heading downtown on the Eighth Avenue A train, I was trying to decide which dealer I would approach. Then it came

to me. There was a miserly old curmudgeon called Ephron, whose posh gallery on East Fifty-Seventh Street near Lexington Avenue dealt in Renaissance art.

Ephron's window invariably displayed a rich array of early European furniture, tapestries, and paintings. Once, when I was trying to sell a couple of pieces of early furniture, I thought I'd give him a try and perhaps establish a new client. I entered, told him I was selling some period furniture, and showed him photos. He took them for a second, looked at them, and asked how much. When I told him the price, which was reasonable, he simply handed back the photos and showed me the door. So I figured, What the hell; I'm gonna try that prick again.

By the time I got out of the subway and started walking east along Fifty-Seventh Street, I began to lose my confidence. The reality hit me that I was going to show an experienced expert a painting I had created myself. As I approached the shop, I almost lost my nerve, but still I forced myself to open the door. The old man was there just like the last time. I slipped the painting out from the envelope and told him that I was selling it.

With a miserable scowl on his horribly ugly face, he paused, stared at the painting, and gave me the once-over; but this time, instead of showing me the door, to my surprise he offered me a seat at a seventeenth-century Bolognese table. He sat across from me and didn't utter a word; instead he held the painting, studying it closely. I sat there, nonchalantly gazing around the room. The walls were covered with Gobelin tapestries. Early Italian paintings in architectural frames were displayed on antique easels. Cabinets were filled with sixteenth-century lusterware, bronzes, and antiquities.

Still Ephron hadn't said a word. I noticed several marble busts of Roman emperors resting on pedestals. Their hollow eyes seemed

eerily fixed on me and my palms were beginning to sweat. Slowly Ephron started thawing and in a friendly manner began asking me all sorts of questions—who I was and how I'd come by the painting. I didn't even have a story planned, and the only thing I could think of was that I had "inherited a few paintings from my uncle." By now, I could see he was genuinely interested in the picture, and my confidence returned.

"And what are these other pictures like that you have?" he asked. I described a couple of imaginary Dutch landscapes to him and let the matter drop.

Ephron's gallery was a labyrinth of hallways and rooms going farther back behind us, and he suggested we go back into one of them. In a room we passed that looked like a repair or restoration studio, I noticed a woman in her seventies, wearing an artist's apron. When we reached the back rooms where he kept a horde of Renaissance treasures, he seated me in another antique chair in front of an Italian refectory table. This time he told me to wait and left with the picture, closing the door behind him.

I heard him through the door, talking with the woman in the apron. Obviously they were having a discussion about the picture. I became terrified when I heard the voices get lower and heard the sounds of bottles being jostled about. I suspected they might be performing some kind of tests on the painting. I did my best to suppress my fear. They must have kept me waiting twenty minutes. It seemed like eternity. In my naïveté, I thought perhaps they'd uncovered my scheme and were stalling until the cops came.

At last Ephron returned and sat down. "Well," he said, "it's a nice little picture, but nothing very important. I don't know if we'd be interested. How much were you thinking of getting?" In a flash, my fears disappeared.

"Twelve hundred dollars," I said confidently.

"Out of the question!" he protested.

I shrugged my shoulders and began to get up, suggesting that I was sick of waiting around and getting ready to leave. He made me wait and went out into the hall once again for further consultations. While he was gone, I noticed that on the wall were a couple of Flemish portraits similar to the one I was selling and of the same period. One was clearly a wreck, most of the paint was gone, and more wood panel showing than painting. However, it was in an antique Gothic frame. In spite of the stress I was under, I thought that if I could get that piece included in the deal, not only would I have the panel for my next painting, but an antique frame to boot!

Ephron returned and said, "Twelve hundred dollars is impossible. It's not worth more than five hundred." I knew he was playing games, so I proposed a compromise. "Look," I said, "give me that picture up there"—I pointed to the Flemish wreck—"and eight hundred bucks." He was puzzled that I wanted the picture on the wall, and for a second I thought I'd put my foot in my mouth and raised his suspicions. So I quickly said, "Just so I'd have something to put back on my wall." He took it down and considered it, shaking his head. I knew we were going to make a deal, and I adamantly stood my ground. Finally, doing his best to look as disgusted as he could, Ephron capitulated.

"Okay, okay. You want cash, right?" he asked. I nodded. "Well, you'll have to wait a few minutes," he said, and asked me to follow him back to the front room. He carried both paintings, placed them on the table, and asked me to have a seat. Again he disappeared with the old lady, who I glimpsed giving me suspicious looks. Again they kept me waiting, and again I heard more whispering. I was

cringing in my seat and becoming apprehensive. A couple of times, Ephron came out to assure me that the money was on the way.

Then, just when I expected a squad car to arrive, I looked on in wonder as a black Cadillac limo pulled up in front of the gallery. A chauffeur got out and opened the rear door. A voluptuous blonde dressed in black and wearing an expensive string of pearls alighted. She was just like the type I'd seen at Parke-Bernet. Ephron opened the gallery door and greeted her. She too gave me the once-over and asked, "Is this him?" Ephron nodded, whereupon she opened an exquisite little black bag. I watched with delight as her fine slender fingers extracted a wad of bills. Peeling off eight Ben Franklins, she handed them to me without a word, turned, gave Ephron a peck on the cheek, and returned to the waiting limo. I eventually learned that the blonde in black was the old man's mistress.

Our business concluded, Ephron got out a piece of paper, wrote down the phony name I had given him and a sentence or two, stating that I had received eight hundred dollars cash for a "portrait of a man." I signed it, and with a sweet smile he handed me the wreck.

Now that we were old friends, Ephron got back to the subject of the other pictures I'd mentioned that my "uncle" had left me. After making me promise I'd bring them by, he took a pair of plated gold cuff links off his shirt and, grabbing my hand, he said, "You're a handsome young man. I want you to have these . . . but don't forget those other pictures." I was thrilled with the gift he pressed into my palm and gave him every assurance in the world that I'd be back with more paintings. As I left the shop with the greatest feeling of relief, I flung the cuff links in the gutter and went straight to Bloomingdale's.

Just moments before, I had been flat broke, wondering how to finance a new voltage regulator for the Bentley, not to mention more hot dogs and French fries at Callahan's. Now, there were eight hundred dollars in crisp new bills in my pocket and a genuine antique painting and frame under my arm!

But my euphoria was short-lived. Just as I was entering Bloomingdale's, it hit me. I had left the manila envelope at Ephron's! It had my *real* name and address on it! Panic-stricken, I swung a U-turn in the store's revolving door and ran back to the gallery. I burst in, and there was Ephron. He looked at me, surprised. In a split second, I caught sight of the envelope lying under the table near the seat where I had waited.

"I forgot something," I explained, while scooping up the evidence and heading for the door.

"Don't forget the other—" were the last words I heard, as I closed the door and raced back to Bloomingdale's to buy a pair of leather boots on sale.

A few months later a suspicious noise in the engine warned me I was heading for trouble with the Bentley, so when a Brooklyn collector offered me four grand in cash for it, I grabbed the money and made the sign of the cross. With this windfall, I decided to take a trip to London and see Carnaby Street and Piccadilly Circus.

It was February 1970. After getting my passport, I packed my bags, tossed in the other two "Flemish" portraits, and booked a flight on Icelandic Airways. They offered a special "youth fare," aka "The Pothead Express," to Luxembourg aboard a ramshackle Lockheed Constellation. The earsplitting sound of the engines and the vibration of the propellers jarred my brains senseless. The food resembled K rations. Passengers in the know were pulling

piles of fruit and sandwiches from their knapsacks. A combat-booted girl in a granny dress with strands of beads and amulets dangling from her neck swept up and down the aisle dispensing marijuana brownies. After a stop in Iceland, our flying washing machine continued on to Luxembourg, air time fourteen hours. After we landed and I made it to a hotel, it was impossible to sleep. I couldn't get the sound of the plane's propellers out of my head.

The next day, I took a train to Amsterdam, hung around for a few days, and, after a dreadful channel crossing, found myself in a London B&B on Cromwell Road. The next day, I went out to explore London for the first time. I quickly learned to use the underground system and rode the double-decker buses around town. I was anxious to explore the art galleries and check out the fashions in Carnaby Street. When my interests became known to the proprietress of the hotel, she suggested that I visit the sales-rooms at Sotheby's. I had never heard of the place before, since Sotheby's had not yet taken over the Parke-Bernet Galleries in New York. I took a cab to Number 34-35 New Bond Street and looked up to see "Sotheby's Auction Rooms, Established 1744" in letters above the entrance of an impressive Gothic Revival building.

Inside, an exhibition of nineteenth-century European paint-ings was in progress. The walls of the stately rooms were literally crammed with canvases. Some were haphazardly propped against the wall. Dealers and collectors, some speaking Italian and French, pulled pictures from the walls like shoppers buying a bunch of bananas from a street stand. In the midst of all this, I noticed a woman, who looked to be in her eighties, wearing a magnificently ludicrous hat, swinging her cane in the direction of a painting

that had apparently offended her taste, and loudly declaring to the edification of the entire room, "Nothing could ever possess me to buy that painting. I simply couldn't live with it!"

As she ranted on, I joined the crowd and studied the paintings before me. Some appeared to be in perfect condition and were beautifully framed. Others, no less valuable, were in such disrepair, in such bad need of cleaning, that they were barely visible through layers of yellowed varnish. It was thrilling to think that all these pictures that had once graced the walls of mansions and town houses would soon meet their fate on the auction block and continue their journey through the ages.

London held one excitement after another for me. I discovered Christie's in St. James's and was once again astounded by the spectacle of so much art. From there I went to King's Road, where I came across a number of antique markets. Upon entering one, I found some dealers with whom I felt I could do some business. The next day, I returned with one of my paintings and met a dealer who was interested. He requested that I leave the piece with him for a day. When I returned the following afternoon, he made me an offer.

An hour later, and three hundred pounds richer, I was sitting in an expensive restaurant eating the first good meal I'd had in a week and thinking about my second sale. The speed and ease of the transaction gave me confidence. Now I knew that the Ephron sale wasn't just luck. The very next day, I went to Camden Passage with the other portrait. It was the first one I had painted, so I wanted to sell it fast for whatever I could get. Once again I found an interested dealer who showed it to several colleagues. Before I knew it, I had another two hundred pounds in my pocket and was in ecstasy.

Three months later, after I had searched out every art gallery, museum, and antique market in London, I was back in the States with fond memories of my stay in Britain. However, times were changing and having fun at the Castle was over. Tom was having more and more difficulty dealing with alcoholism. As he began to lose touch with reality, I spent more of my time at Tony and Barbara's apartment in the city.

Barbara was very interested in my artistic development, and for the next year I was completely under her spell. I was her slave. I hung on her every word, and she had a tremendous effect on my life. She was convinced that it was my destiny to become an artist. Although she was impressed, even amused by my surrealistic paintings, she spent a considerable amount of time and breath urging me to "progress," to find myself artistically and become part of the current "movement."

The more trouble I had in my struggle toward self-discovery, the more crises I encountered, the more attention Barbara paid me. The more I confided to her lovely ears, the more she listened. The more she soothed, encouraged, and flattered, the more I loved her. She was, in my mind, the height, the very pinnacle of sophisticated perfection. She was the epitome of all that was cool, intelligent, and knowing. But our days of hanging around the Village and sipping tea at the apartment came to an end when Tony got Barbara pregnant. They fled the environs of Fifteenth Street and headed for the serenity of the country, where they became parents of a beautiful baby girl.

One day, while looking through a newspaper, I noticed a Help Wanted ad asking for "young artists." In spite of my draft status, I called the number. It turned out to be an art restoration studio. The man who ran it, Erwin Braun, aka Sonny, was one of the best

conservators in the business, and all the major collectors and galleries used him.

He invited me to come down to his studio in a loft on Twenty-First Street off Fifth Avenue. After I arrived, Sonny took one look at a small copy of a Brueghel sporting an antique patina that I pulled from my shoulder bag and hired me on the spot.

Half artist and half philosopher, Sonny was possessed of a sarcastic and razor-sharp Jewish wit that he used unmercifully on his employees. When it came to restoration, though, Sonny could be described as near genius. As a matter of fact, the definition of what exactly constituted "genius" was a matter of constant and heated debate at Sonny's studio.

Sonny hired young artists to train as in-painters, i.e., artists whose job it was to touch up and make repairs on antique paintings during the restoration process. Although Sonny was an expert in-painter, he had to use his valuable time to clean the antique pictures, the most critical and potentially dangerous job. Nobody else even dared entertain the idea of cleaning a picture, for if the powerful solvents used to dissolve old discolored varnish weren't used correctly, they could destroy the painting.

Sonny had three boys seated at easels working on paintings, while he stood cleaning paintings at a table where he could keep an eye on us. This arrangement left us open to Sonny's wisecracks. His trenchant witticisms increased as the day wore on, due, no doubt, to the toxic effect of the chemicals used to clean the paintings.

Sonny was suspicious of everyone who came into his studio. Many pictures were parked there in rough, unrestored condition, waiting to be spiffed up and put on the auction block.

Should gossip or a derogatory rumor concerning the condition of an important painting leak out from a restorer's studio, it could

ruin the business. As a result, Sonny insisted that his employees just deal with the technical problems and never talk to art dealers about paintings in the studio, who owned them, or what went on there. It was like working at the CIA.

For the time being, I had a real job. I hated it but worked hard and learned fast. It seemed a rift was developing between Sonny and another boy who worked there—a fat, humorless, fart-blowing misanthrope who held the title "junior partner and assistant"—and Sonny began eyeing me as a possible replacement. He even took the unprecedented step of having me stand and watch him clean paintings. I looked on with fascination as Sonny performed the delicate procedure of removing old discolored varnish and previous retouching from the surface of antique paintings. I soaked up every facet of the work and learned how a picture, whether painted on canvas or panel, was systematically restored.

The fact that Sonny could be insufferable was of no conse-quence to me. Some guys took his crazy remarks to heart and quit. I threw everything right back in his face, and he liked me the more for it. Once one of us innocently remarked that an artist currently receiving publicity was a "genius." Throwing down his cotton swab, Sonny marched over from the cleaning table and confronted us.

"So you think that asshole is a genius?" he asked with contempt. We just shrugged our shoulders. Sonny then encapsulated for us his official definition of a genius. After establishing that a true genius is in possession of intellectual, artistic, or creative powers beyond the comprehension of others, which was fair enough, he curiously went on to include a number of personality traits as well.

"A genius doesn't care about money, fame, or any of that bullshit" (Sonny likewise had none). "It's work that's important to a genius,

nothing else." (Sonny was a pathological workaholic.) "Geniuses possess absolutely no sense of time or self-conscious awareness!" (Half the time, Sonny didn't know what day it was, let alone the time, and he dressed like a slob.) As Sonny's diatribe progressed, his audience was led inexorably toward the inevitable conclusion that the comparison between himself and a genius was incontestable!

After Sonny was finished, a profound silence descended, and sufficient time was allowed to elapse so that the striking resemblances could sink in. "Well," I asked bluntly, "if you're a genius, why ain't you a millionaire?" His wife, who sat at the reception desk nearby, chimed in with her nasal voice: "Yeah, Sonny. Why ain't you a millionaire?" That shut him up for the rest of the day.

To work for Sonny was important to me because I got to handle and examine many period pictures. I came to recognize every type of canvas and stretcher that was used by every major school of art. I saw every kind of wood panel and every kind of crack pattern in existence. I also saw every type of patch-up repair commonly used fifty or a hundred years ago.

From listening to Sonny, I picked up my first tips on what experts look for to establish the authenticity of a painting. I saw how he used an ultraviolet light that, when shined on the surface of an antique picture, could detect old repainting and touch-ups. Most importantly, it also detected whether the varnish applied to the antique painting was original to the painting. True antique varnish displays a characteristic green fluorescence when viewed under ultraviolet light. This fluorescence can't be simulated, so experts often look to this as a positive proof of age.

This was also the first time I was exposed to American paintings. I found them boring, but the market was experiencing a boom in nineteenth-century American paintings and prices were

going through the roof. The boom was drawing in a group of young, obnoxious, and greedy dealers who hunted around old historic towns in hopes of finding valuable paintings. I watched as they stood enraptured while Sonny did some quick cleaning and speculated what the painting might be worth.

Meanwhile, in a bizarre manifestation of his mounting paranoia, Sonny sought to compartmentalize everyone around him and was soon erecting partitions to block views of the studio from both his own employees and dealers coming in. He was convinced his employees were plotting against him to start their own studio. The whole place was eventually divided into little compartments with masking-tape markers on the floor designating where an employee might or might not go. Any violation of these directives would result, as Sonny put it, "in immediate dismissal." Finally, even his wife was stuck in a crazy-looking box he constructed of drywall, with a small square hole cut in it through which she spoke to customers. Indeed, Freud certainly would have had a field day with Sonny.

Around this time, I thought I should have my own apartment in the city. I found a studio in a grand-looking building designed by Stanford White at 43 Fifth Avenue, on the corner of Fifth Avenue and Eleventh Street. The rent was only a hundred and ten dollars a month, because the bath was in the hall. But this drawback was adequately made up for in charm. The studio had tall ceilings and French doors that stretched across an entire wall. They opened onto a small terrace enclosed by a low brick wall. Situated on the eleventh floor, the terrace offered a view of the surrounding area.

Back in Fort Lee, I'd found a real World War II Army Jeep with the original paint job, serial numbers, gas cans, and all. I

fell in love with it and reasoned that it would be the ideal thing to get around the city in. To live in Greenwich Village in my very own studio with a Jeep parked outside was a dream come true. I painted the walls, hung a few of my paintings, bought some old Oriental rugs, threw down a mattress—and I was in business. One of the first friends to visit and cruise around the Village with me was Michelle, a red-haired, blue-eyed model whom I met through Tom and whose brother Elliott, a rock-and-roll star, was playing at Max's.

We liked to visit the galleries in SoHo and have hamburgers at the Broome Street Bar. Other times, we'd go to the Met, look at the paintings, and take long walks on the Upper East Side where she lived with her mother. Once, while holding hands and strolling up Fifth Avenue at sunset, we started to walk past one of the big bookstores near Fifty-Seventh Street when something caught my eye. A few months earlier Tom had shown some of my surrealistic works to a few art directors, one of whom worked at Dell. He had liked what he'd seen and asked me to do a cover painting for a novel by Nat Hentoff entitled *In the Country of Ourselves*, a story about student revolutionaries. I did the job but had no idea when the book would be released. There in the window was the book. A hundred of them were stacked in a house-of-cards display. We stood there, staring in the window and laughing like schoolkids.

As time went on, though, I just couldn't stand having a job and being locked up in that loft all day long. The matter was finally settled by Sonny's junior partner and assistant. He resented me for the way I got along with Sonny. He, on the other hand, was forever catching hell for his endless blunders, and nobody liked him. He was in charge of opening the studio

every morning, since he got there before Sonny. One day, he informed me that I was to greet him with "Good morning" when I came in each day. I knew he was just trying to bust my balls, and I purposefully ignored him. The next day, I came in, sat down, and went to work without a word. He came right over and demanded, "Well, what are you supposed to say?" I looked up at the slob and said, "Go fuck yourself!" He threw a tantrum, fired me, and ordered me to leave at once. An hour later, Sonny came in and asked him where I was. When the assistant informed Sonny that he had fired me for not saying "Good morning," Sonny went out of his mind. He fired him on the spot and begged me to return. I was stubborn and refused. I had some savings and decided to say adieu.

I now had more time to attend the exhibitions of old master paintings at Parke-Bernet. This helped me to expand into Dutch painting. I was attracted by the river and harbor scenes of seventeenth-century Dutch painters such as Jan van Goyen and Salomon van Ruysdael. Their tranquil scenes, painted in cool blues, greens, and grays, portray people going about their work on the rivers. Not only was I convinced that I could paint them, but there was the added advantage that many of the originals didn't have cracks, thereby saving me the tedious job of engraving them into the panels. The wood panels they were painted on were, again, just like the ones commonly used as the bottoms of drawers from furniture of the period.

I had installed a small drafting table in my studio, and I completed four pieces, three of them river scenes with the initials and dates of van Goyen and other artists in his circle. The terrace was ideal for putting the pictures out in the sun to dry and harden. Then I applied a varnish, which I tinted with pigments simulating

an antique patina. As a finishing touch, I took something I'd seen Sonny fooling around with one day, a very fine powder he mysteriously referred to as "French earth." I finally discovered that the substance was *rotten stone*, a superfine powder made out of volcanic rock. It's commercially used as a polish when mixed with oil, but when applied as a dry powder it has an outstanding ability to create a hazy, dusty look in anything it's rubbed onto. So after I applied the final patina on each picture, I rubbed the "dust" on and blew it off. The result was amazing.

The fourth painting was a fine portrait of a Flemish gentleman, done on the Ephron panel I'd been saving. The sitter's face was delicately creased with the lines of age; a band of gray hair framed the sides of his balding head. Dressed in the usual pleated tunic buttoned up to the neck, he gazed stoically out at the viewer. After I gave it a "dusting" and placed the panel back in the antique frame, I was astonished by how much visual credibility the frame had added to the final effect.

When I'd worked at Sonny's, I had become acquainted with Walter P. Chrysler Jr., scion of the automobile family. As a hobby, he had a gallery on upper Madison Avenue, and he invited me to drop in sometime. Chrysler was forever dragging in paintings—which he imagined were lost masterpieces—for restoration. He was in the habit of deluding himself with ludicrously optimistic attributions—believing, for example, that the painting he'd just found was in reality an unsigned Rembrandt, Titian, or Vermeer. In short, he was the ideal candidate to buy one of my "Flemish" paintings. This time, I took a photo of the painting with me and dropped in at his gallery with a story that I was disposing of the piece for a party who wanted to remain unnamed. Chrysler took the bait and asked me to bring the painting in. The next day, I

returned with the painting and was soon collecting fifteen hundred bucks cash in the back room of his gallery.

—⁓—

From that point on, I understood that a fine frame is to a masterpiece what a Saint Laurent original is to a beautiful girl. Without delay, I put the three "Dutch" paintings into my shoulder bag and headed up to Sixty-Fourth Street and Lexington Avenue. Sometime back, I had noticed a dusty-looking second-floor shop that displayed a single antique picture frame in its window. The sign above the window read, in clear, elegant lettering, E. V. Jory, Picture Frames. When I entered, I might as well have been transported back in time to an eighteenth-century Parisian framemaker's shop. The walls, covered with the patina of age, were hung with arrangements of pricelessly beautiful antique frames nested within each other, according to their style, period, and size. An Empire table and a pair of armchairs in the center of the room for customers created an air of intimacy.

The proprietor, wearing an old suit and work apron, possessed perfectly erect posture despite his eighty-some years. He had striking blue eyes, silver hair, and a handsome mustache.

As I wandered around, I was enchanted by the reflection of the shop's warm light against the antique gilt and gesso on the ancient carved frames. When I produced my paintings and confided to him that they were my own work, he was greatly impressed. He asked me to leave them with him and he would see what he could do. A week later, I returned to find each painting fitted out in a beautiful period frame, complete with chips and missing pieces. When Mr. Jory offered to repair them because they were damaged and I told

ABOVE: *The Castle, Ft. Lee, NJ, 1967. Tom Daly on balcony.*
BELOW: *Lionel Goldbart in Tom Daly's studio at The Castle, 1967–68.*

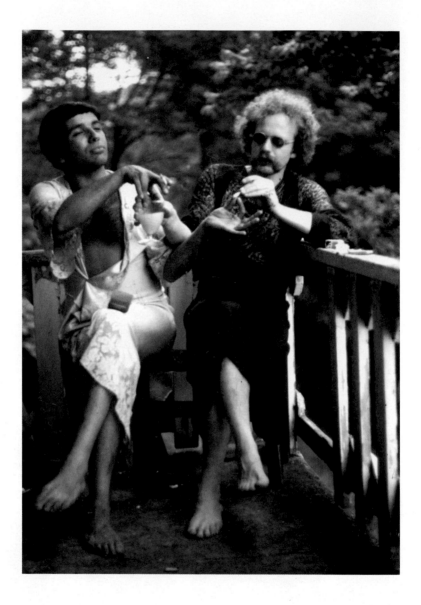

ABOVE: *Tony Masaccio and Tom Daly, 1967.* OPPOSITE ABOVE: *Poster for* Ciao! Manhattan, *1967.* OPPOSITE BELOW: *Andrea Feldman and Geraldine Smith.*

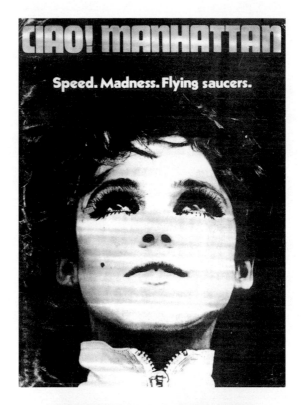

CIAO! MANHATTAN

Speed. Madness. Flying saucers.

OPPOSITE ABOVE: *Ken's Army jeep, May 1973*. OPPOSITE BELOW: *The Bentley.*
ABOVE: *Tony Masaccio, Frosty Myers and David Budd at Max's.* Photo
courtesy Anton Perich.

OZ 46 January/February 1973 25p

OZ magazine cover, February 1973.

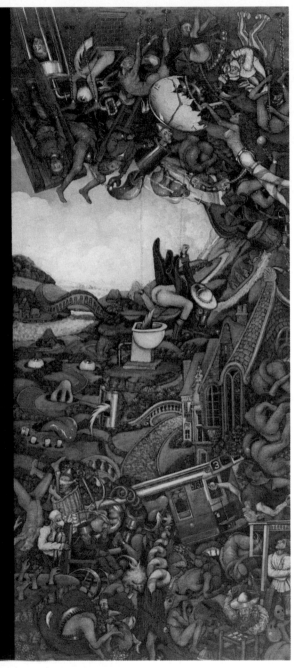

Welcome to OZ 46, a rich, juicy, bumper stew, which won't win friends or influence anyone, but tastes fingerlickin' fantastic. It spans 1930 to, well, eternity . .

You can singalong with Cole Porter while trudging through the long line of little red bookshops with John Hoyland. You can Squat in it Yourself, with our street talking guide, and increase your word power with our lexicon for screaming queens. What else ? There's the cut-out sensation to end them all (save it and make a fortune), a sad inside account from PROP, the prisoners' union, a true confessions putdown of prick piggery, a portrait of Paris for those who think the Commune will make a comeback, Richard Neville on his favourite subject, himself, a call for an amnesty for all dope offenders, and a full colour flashback to the Great Moments of Rock . . who says that Oz has lost its sting? And there's all the stuff we haven't even told you about. Now read on.

Cover painting by Ken Perenyi
Page opposite: Illustration by Roger Hughes
Photograph by Joseph Stevens

OZ is printed and published by OZ Publications Ink Ltd. 19 Great Newport Street, London WC2.
01-836 2857 (main lines)
01-836 3951 (mail order and subscriptions)

OZ magazine inside cover.

ABOVE: *Ken's window at the Ferguson Club.* BELOW: *The Ferguson Club, 35 East 68th Street, NYC.*

him I wouldn't think of it but would prefer the frames just the way they were, he gave me a knowing smile. It warmed his heart that I, like him, viewed such traces of time as part of their beauty.

From that point on, Mr. Jory was my exclusive source of antique European picture frames and a friend who could have come straight out of the eighteenth century. Born and raised in Paris, Mr. Jory came from a family that had been making picture frames since Louis XIV. The Jory family could visit the Louvre and point to frames carved by their ancestors.

Years ago, Mr. Jory had been able to count among his customers the Fricks, the Vanderbilts, and the Carnegies. For many of these clients, Mr. Jory carved the finest reproductions of French and Italian frames that could be found anywhere. When I eventually saw examples of his handiwork, I was left speechless. I knew at once that Mr. Jory could easily fulfill and exceed Sonny's Profile and Attributes of a Genius. Indeed, the magnificent Florentine frame on Titian's *Venus and the Lute Player* that hangs in the Met was entirely carved by Jory.

But all that had happened a long time ago. These days, Mr. Jory mostly sat in his old shop, alone with his memories and his frames. Whenever I had any extra cash, I made a beeline there. Soon I was incurably hooked on antique frames and either bought them for my own paintings or simply to nest them on the walls, just as Mr. Jory did.

Mr. Jory was the consummate artisan and loved discussing all the technical aspects of his trade. Not only did he know the precise procedures of fine frame making as it had been handed down to him, but he also possessed an intimate knowledge of artists and the way they'd done things in the old days. He critiqued my paintings and gave me many invaluable technical and stylistic tips.

Of particular concern to Mr. Jory was that I understood the precise way in which the old masters made real gesso. One day, he ushered me into the back workroom of his shop. The room was illuminated by a single soot-clouded skylight. Dust clung to every surface. The first thing that caught my eye was a fantastic assortment of antique tools. Sets of beautiful chisels, obviously handed down through generations of carvers, were hung on the wall above a long worktable. Huge unfinished frames awaiting gessoing and gilding hung like half-materialized ghosts from the shadows on the walls.

As I looked around in wonderment, Mr. Jory opened a cabinet and presented me with something he wanted me to have—two old glass jam jars, their faded caps proclaiming BAR-LE-DUC preserves. I was a little puzzled. I noted that one jar held a white powder and the other was filled with amber-colored crystals.

I followed Mr. Jory back into the front room. We sat down with the jars on the table before us, and he explained. One jar contained powdered gypsum from the white cliffs of Dover. The other held a substance known as *rabbit-skin glue*, which hails from France. Mr. Jory then proceeded to explain to me how real gesso was made by artists and gilders alike from time immemorial. The glue is prepared from the rabbit-skin crystals, which are soaked in water until they become soft. Then they are heated and dissolved in the water, making the glue. This glue is then mixed in specific proportions with the gypsum powder and water, making a thick white substance. Then, when spread like paint on canvas or panel, it would render, when dry, an ideal surface on which to apply oil paint or gilding.

I was very attentive, yet unsure whether I was going to undertake all that complicated bother just for the gesso. Although I

wanted to be authentic in every way, one really couldn't see the gesso, and besides, the commercial latex-based formula worked just fine. Nevertheless, I listened and retained all that Mr. Jory taught me. I left with the jars and extra gypsum powder that he insisted I take along.

The first time that I had a practical need for Mr. Jory's gesso occurred when I ran out of the sort I'd been using from the art-supply store and needed some in a hurry. Recalling Mr. Jory's instructions, I retrieved the jars, prepared the glue, mixed it with the powder and water to a workable consistency, and spread it like paint on some cardboard surfaces for practice. I then applied it to the panels and set them, along with the cardboard pieces, out on my terrace to dry in the sun.

When I got back to them, I noticed that Mr. Jory's gesso had dried to a much harder surface than the kind I had been using, and the pieces of cardboard I'd tested the gesso on seemed somehow different. I noticed that, as I handled the pieces of cardboard and bent them slightly, in the handling, cracks began to form in the gesso. I began to play with the pieces of cardboard, manipulating them to produce more cracks. When I repeated the same process with a piece that had been left inside to dry, I was unable to achieve the same effect. The cool pieces would not crack. However, when they were put in the sun, had absorbed its heat, and were gently bent, an area of fine and natural cracks appeared in the gesso.

When I spoke to Mr. Jory about this, I inadvertently gained some priceless information. He said that the effect was caused by the rabbit-skin glue. He went on to explain that the glue has a unique ability to become brittle or increase its *tensile* strength when exposed to heat, as opposed to most substances, which become softer. Even though he advised me that the cracks occurred

because I was using too much glue in my mixture, I chose to keep my formula the same.

From then on, Mr. Jory's gesso was the only kind I'd use, but I was still a long way from understanding its application and potential to produce genuinely convincing cracks in panels or canvas. As time passed and I used it on my wood panels for Dutch pictures that didn't require cracks, I used the leftover for experiments on different surfaces, understanding that if I could perfect an easy way of producing cracks, I could expand into other areas of painting. The more I experimented, the more I learned, but the basic facts remained: the gesso became brittle when heated, and it cracked when stressed or bent, as long as the surface remained hot.

I spent a great deal of time studying paintings in museums, staring at them for hours until they gave up their secrets, seeking to understand what made the paintings appear old. Was it wear, damage, style, dust, patina, cracks? Of course, I realized, it was a combination all of these elements. As I made new observations, it became a game for me to see how cleverly I could reproduce each one of these effects.

My parents retired to Florida, and I now realized that I was really on my own in the city. I was feeling a little lost when one sunny day I got some interesting news. Tony couldn't stand the quiet life in the country. He and Barbara weren't getting along, and word was that he was back in New York City, looking for a place of his own.

CHAPTER FOUR

Union Square

Tony found a loft at 864 Broadway, just off Union Square. It was half a block from Andy Warhol's building, two blocks away from Max's Kansas City, and a short walk from my place on Fifth Avenue.

The Psychedelic Sixties were over and the hippies were disappearing. There were no more be-ins, and Tompkins Square Park, the spiritual center of the counterculture, had become a haunt for drug addicts and bums. The building that had once housed the Electric Circus on St. Mark's Place was a drug rehab.

It was a sobering time. Edie Sedgwick had OD'd in California and was, indeed, "Eight Miles High." Poor Andrea Feldman went "flying" one last time, committing suicide by jumping out of an apartment window on Fifth Avenue. Tom was still living at the Castle as a recluse. The property had been sold and was now scheduled for demolition in order to build another high-rise. He was determined to stay until they drove up the road with the wrecking ball. And Don Rubow, the old beatnik who'd first invited me into the Castle and subsequently changed my life, was also dead. His sorry end was one of the last stories Tom told me before I moved to the city. As he explained it, "Don was running like a madman from job to job trying to keep food on the table for his wife and four kids in a loft on Canal Street, when his heart just exploded one day!"

When I'd first met Tom and Tony at seventeen, I hadn't cared about the future. To be part of their world was too exciting for me to pass up, even if I had burned my bridges behind me, but those few years changed everything. The Revolution was a bust, I was temperamentally unemployable, and by 1972 the future had arrived.

Reality for Tony and me wore a hard and brutal face. The economy was in a severe recession, and New York City was hit hard. Life was becoming a fight for survival in which we were willing to resort to more and more desperate measures. My plan was to struggle through this situation with the only means at my disposal, namely art. Tony simply refused to work in any way, shape, or form. Instead, he spent his time at Max's or hanging out in bars in Brooklyn with his hoodlum friends, figuring out their next score.

Nevertheless, I was glad Tony was back in New York and back to his old routine. As long as I'd known him, he'd sleep until two

in the afternoon, get up, pull himself together for the next couple of hours, and by four he'd be ready to go out to a café. Then he'd return at seven, lounge around for a while before hitting the bars at ten, stagger back home at three, and do the same thing all over again the next day.

Aside from a few extra pounds, Tony's looks and charm hadn't faded a bit. He moved in the highest circles of the contemporary art world and was invited to every party and gallery opening in SoHo. But ever since he'd cleaned out the museum in Lake George, his behavior had grown increasingly frightening.

Letting him into your home could be a disaster. He would be perfectly comfortable, sunk in a sofa, looking quite harmless. You could leave the room for moment and not give it a thought, return, and find him exactly as you'd left him, never realizing that the minute you were gone, he had rifled through every drawer and desktop and relieved them of any credit cards or checkbooks.

His victims were legion, and no one was immune: friends, family, or business acquaintances. He expected his victims not to take it personally. In fact, he often invited them for dinner or drinks, sometimes paying with his guest's own stolen credit cards. He seemed to possess—and I've heard others say this as well—almost a sixth sense telling him exactly where a checkbook or credit card might be.

Since I'd been living in the city, I'd continued my education at Parke-Bernet, and had also started visiting the galleries in SoHo. I was trying to follow the advice of Barbara (whose letters I waited for every week) to "find" myself artistically. I wanted very much to paint and succeed as an artist. I had come to the conclusion that I'd outgrown my surrealistic stage, and I certainly didn't view forgery

as a career. If there was to be a future for me in art, I would have to be part of the movement.

In the summer of '73, I was having dinner with Tony at Max's when I outlined for him a concept I'd formulated during the past year. I wanted to create a collection of art consisting of twenty-four pieces in three components: canvas, Plexiglas, and steel. The work on canvas would be composed of eight large abstract paintings measuring eight by ten feet each.

The second component would be made of eight rectangular Plexiglas boxes measuring four feet tall, three feet wide, and eight inches deep. Eight more paintings would be removed from their stretchers and then stuffed into the Plexiglas boxes, along with the empty tubes of paint, brushes, rags, and anything else used in their creation. Then each box would be sealed shut.

The third component of the collection was to be composed of eight boxes made of sheet metal four feet high, fourteen inches wide, and fourteen inches deep, with welded seams. These too would have crumpled-up paintings jammed into them along with brushes, tubes of paint, etc., before being welded shut on top. The idea was that one could only visualize—imagine—the paintings within. The gallery arrangement would consist of paintings on the walls, the Plexiglas boxes displayed on pedestals, and the steel containers placed on the floor.

Tony liked the idea, but two major impediments prevented me from getting started: lack of space and lack of funds. Without hesitation, Tony suggested I move in with him. He had little use for his loft space beyond the bedroom and, besides, he could use some help with the rent. He also suggested that if I could put this collection together, he'd be willing to use his connections in the art world to gain interest in it—for a piece of the action, of course.

That night, I thought about Tony's offer. I came to the con-
clusion that this was a golden opportunity. After all, Tony knew
everybody in the business, and the space in his loft would solve the
first problem. Now the only thing that remained was the money. I
needed at least a couple grand to buy the materials for the collec-
tion. The only possibility I had of raising that kind of money fast
was to sell the few "Dutch" paintings I had, including the three
Mr. Jory had framed for me months ago. If I can go out and sell
them, I thought, then I'm gonna move in with Tony.

Although I was dying to let him in on my little secret and tell
him of my plan to raise the cash, my instincts told me not to. Aware
that he was still wanted for questioning by the FBI, and certain that
he'd insist on selling some of my paintings, I knew that if anything
went wrong and he got in trouble, the cops would surely tag him
to the museum robbery, and instead of moving into the loft with
Tony, my next home might be the bottom of the East River.

A few days later, I was ready for action, and I didn't have to go
far. The streets just east of University Place were crammed with
antique shops, many handling paintings, and most with signs in
their windows stating "We Buy Antiques." A week later, I had
raised over twenty-five hundred dollars. Convinced that I was
being guided by the hand of providence, I loaded up the Jeep and
moved to Union Square.

The loft was on the second floor of a run-down building above
a Jewish dairy restaurant. It was practically empty, not much more
than a dingy storage room illuminated by two windows at the front
that looked down upon the street. The furnishings consisted of
a table and two old chairs, a stepladder for guests to sit on, and
a neurotic refrigerator that never stopped rattling and shaking.
Tony was basically living in the bedroom, the only room with

heat. The door to it had always been conspicuously closed on my previous visits.

When I got the chance to peek in, I nearly gagged. A bed was inexplicably mounted on a crazy-looking platform that Tony had built himself. It was about five feet above the floor. On it was a pile of clothes, pillows, and blankets that swept up into a corner reaching halfway to the ceiling. Tony's old poster of Mussolini that went everywhere with him hung crookedly on the grimy wall above the bed like a picture of a saint. A wretched three-legged table supported a lamp with a broken shade. The rest of his wardrobe was stuffed in a heap beneath the bed. A path through piles of bottles, books, and boxes containing God-knows-what led to the bed, where Tony had to leap up and burrow in to sleep.

I threw the mattress I'd brought from my studio against a wall in the main room of my new home, but I experienced a sinking feeling when I was faced with the prospect of spending my first night in Tony's dungeon. During the time I had planned this move, Tony mentioned in passing that there might be another lodger, who I assumed would be a girl, staying with us, but the excitement of embarking on my first serious artistic effort caused me to forget this detail.

I was sitting at the table having a glass of wine with Tony, who was doing his best to cheer me up. I looked at him in surprise when I heard the door lock being turned. Tony was smiling, and I wondered who this could be. I was speechless when a gorgeous African-American girl with the most beautiful smile poked her head around the door. She flung a modeling portfolio onto a chair and lighted on my lap!

"You must be Ken," she said, laughing. I was smitten on the spot and instinctively wrapped my arms around her tiny waist. When

Andrea Sutton introduced herself, I was staring at a hundred blindingly white teeth framed in the biggest lips I'd ever seen.

With the formalities out of the way, Andrea told us about her day spent auditioning for a part in a movie, all the while getting more comfortable in my lap. For the first time all day, I was smiling, and Tony was delighted.

Andrea was a model and actress who Tony had found at Max's. In need of a place to stay, she'd been keeping irregular hours at the loft for the past month. She had an exuberant personality, a devastating smile, and a body so slinky it looked like she'd been squeezed out of a tube. Tony was preparing to leave for his afternoon routine of a sauna and rubdown at the Russian Baths on East Seventh Street, before reading the paper at his favorite espresso bar.

I got up and poured a glass of wine for Andrea while she turned on some music. As we sat at the table sipping our wine, we began staring into each other's eyes and smiling. The door hardly closed behind Tony before we:

A) raided Tony's stash of joints,

B) undressed each other,

C) went straight to bed.

Andrea definitely helped buffer the shock of moving into that place. One day she came home with a beautiful Irish setter that had been abandoned by a recently evicted friend. We walked the dog around the Village, enjoying beautiful carefree days together while I gathered materials and arranged to have my steel and Plexiglas containers made at a fabricator in TriBeCa.

Unfortunately, Andrea finally had to split. She landed a part in a movie and flew out to L.A. I immersed myself in my work, and it wasn't long before I was in a routine of eating, sleeping, and

painting. The exciting prospect of creating my first collection of art put all thoughts of forgery out of my mind. In fact, I was convinced that my days of faking paintings were in the past.

Tony and I couldn't have been in a better position. The location of the loft was perfect, and Tony had all the contacts. In fact, I had already been brought to the attention of Robert Hughes, the author and art critic. Tony was friends with Robert and had met Richard Neville, the publisher of *Oz* magazine, at Robert's loft in SoHo when Richard was visiting from London in late '72.

Oz was the leading British counterculture magazine started by Richard in the 1960s. Grossly obscene, drug oriented, and politically radical, *Oz* enraged the British public. It exemplified the philosophy of the counterculture and promoted every type of deviant sexual activity. It featured columns such as "Letter from an Ever-Open Pussy" and articles like "The Queen's Vernacular," a satirical compendium of gay slang.

The magazine finally provoked the wrath of the British government with its hilarious sexual satires, often aimed at political and royal figures. After numerous warnings went unheeded, the government took action and charged Richard and his editors with criminal obscenity. As the trial date approached, protests in support of *Oz* broke out around London. Some were violent and attracted celebrities like John Lennon and Yoko Ono. Meantime, Richard was having engraved invitations mailed out to subscribers, inviting them to attend "Obscene Courtroom Dramas" at the Marylebone Magistrates' Court.

On the day of the trial, Richard argued the case himself, defending the magazine's right to free speech and expression. He and his cohorts lost and were slammed with fifteen years

in prison. There were riots in the street. Then, in a stunning reversal, the case was reviewed and thrown out. The magazine continued to be published and was never shut down by the government. The case inspired a play titled *Oz* that opened briefly in the East Village.

While Richard, Robert, and Tony were having drinks at Max's, Richard mentioned that he was on the lookout for something "far-out" for the cover of his magazine. It occurred to Tony that the surrealistic masterpiece I had done years before—my impression of the Castle, which was decorating the wall of my studio on Fifth Avenue—might be just the thing for him. Richard was interested and asked Tony to bring the painting to Robert's loft. When Richard saw it, he was impressed and wanted to meet me.

The next day, I went to Robert's loft in SoHo and met both Robert Hughes and Richard Neville. It was agreed that the painting would be sent to London and used on the cover of his magazine.

When *Oz* came out some months later, the cover was attacked as "disgusting" by the public, and I was immediately contacted by the Portal Gallery, located just off New Bond Street. They were interested in giving me a show, but I was in no position to take advantage of the opportunity. Besides, I was through with surrealistic paintings and wanted to get on with more serious art. The upshot was that I had made an impression on Robert Hughes, and he was interested in what I'd be doing in the future.

On Union Square, I sometimes saw Andy Warhol out on the street on his way to his building. He began giving me very hard stares, and if by chance I passed him and looked back, he'd be standing there waiting. I realized that he wanted to meet me,

but I foolishly put it off, reasoning that I'd have plenty of time to meet him and invite him to the loft as soon as my collection was finished.

In the meantime, a steady stream of friends was dropping in. Frosty Myers, the sculptor, was a constant visitor. His most famous piece was a long, wavy tube painted red that was suspended above the bar at Max's. Julian Schnabel was another who would stop by. Sometimes we'd all get in the Jeep and cruise around the Village trying to pick up girls.

And of course there was Michelle, my beautiful uptown model who'd stop by between fashion shoots to encourage me. It was bad enough that she incited a terrific envy in Tony toward me, but when he came home one afternoon and discovered her favorite pendant in his bed, he went through the roof, throwing it at me and threatening to hang me by my balls—as he so elegantly put it—if I ever crawled into his bed again.

—⁓—

As work on my collection progressed (and most of my money was used up), the loft began to look like a real artist's studio. Huge paintings were propped against makeshift easels. The steel and Plexiglas boxes were awaiting paintings to be jammed into them. I was very excited, working on pure adrenaline. I had perfect faith, absolute conviction in my envisioned collection. No matter how bad it was living at the loft, no matter how broke I was, I was prepared to survive on a diet of sawdust to make the collection a reality; but the worst privation of all was that there was no way to take a bath. The bathroom outside in the hall had only a sink and toilet. While Tony promised to rectify this situation soon

and install a tub in the loft, I was forced to visit friends across town in order to take an occasional shower.

Added to the misery, I hated Union Square. Whenever I sat at the window and looked out, I was sickened by the dreary commercial scene below. In spite of my high hopes, I wondered what would happen if my planned collection didn't succeed. The city was full of would-be artists who ended up as clerks in art-supply stores or waiters in SoHo restaurants, fates too awful to contemplate.

Sometimes I'd go for breakfast to the restaurant down below our loft. It was an old-fashioned Jewish dairy restaurant, where no meat was served. I sat there and gazed through the steamed-up windows at all the people rushing to work in the morning. All dressed in suits and fancy hairdos, they reminded me of goldfish streaming by in a bowl. But they went to school, they had jobs, they had done the "right thing." It was frightening to consider having to do that every day, but just as frightening to know I couldn't even if I'd wanted to.

By the time winter came, life there was even more depressing. The loft was freezing and we were broke as usual. If Tony did manage to lay his hands on any money, he instantly transformed into a tyrant, barking orders and expecting everyone to kiss his ass. Every night he'd go out and blow a couple hundred bucks in bars and classy restaurants. He loved to yell at the waiters and make a scene. I finally realized why he always had that old poster of Mussolini around. That's who he wanted to be—fuckin' Mussolini!

Then one day Tony came in bubbling over with excitement. A drinking pal had met Paloma Picasso at Max's and had arranged for Tony to meet her one day for lunch. Tony put on the charm, and

she was smitten. Phone numbers were exchanged. Dates, dinners, and romantic interludes followed.

It was all very glamorous: there were stories of a huge fortune, an apartment filled with her father's paintings, trips to Paris, and romance. Tony was ecstatic. Visions of a life in the international jet set danced in his head. Winters at Saint Moritz and summers on the French Riviera!

I was trying to figure out how I would pay for the loft myself, when the situation came to a climax. Paloma had to leave for Paris, and Tony was getting his passport. She would call in a week and have a ticket waiting for him at the airline counter. Tony was beside himself with anticipation. All he would have to do was pack a bag and fly off to a new life in high society.

Tony recounted this while treating me to a steak dinner! When it came time to pay the bill, I almost choked when he pulled out a wad of French francs together with some American money.

"Where did you get that?!" I gasped. Tony just laughed and shimmered like a bowl of Jell-O as he peeled off a C-note without a care in the world. When I dragged the story out of him, I learned that Tony had spent the night with Paloma before she left for Paris, and finding himself alone in the bedroom for a while, he noticed her handbag lying conveniently on the floor next to the bed. Instinctively he'd reached down and pulled out her bankroll. He'd been exchanging it for American money and spending it all day long. It was a pity, because there never was a call or a ticket to Paris waiting for him. He never heard from Paloma again, and his calls and messages went unanswered.

The money quickly ran out. Tony managed to pay one month's rent of two hundred and forty dollars out of the three grand he'd lifted from her. As dreams of Gstaad and Saint Tropez faded, it

was time once again to deal with more down-to-earth matters. The refrigerator had a nervous breakdown, the windows leaked so badly that the wind howled through the loft, and of course I still faced the ongoing problem of running out in the now-freezing weather to take a bath at someone else's place.

Tony would go out and steal a car as casually as normal people would go out and rent one. He would scan parked cars until his sixth sense guided him to exactly what he was looking for. Usually that was an unlocked station wagon. The rationale behind his choice was that it would serve a dual purpose, that of transportation and the perpetuation of his nefarious schemes. So one day, out of the blue, Tony announced that he had a new set of wheels and that we were going out for a ride. After dropping in on Julian Schnabel at his studio in Little Italy, we were leaving the building when Tony noticed a pile of custom-made artist's stretchers in the lobby waiting to be carried up to Julian's loft. In a flash Tony scooped them up and threw them on the top of the wagon, and we sped away.

Living with Tony began to distort my view of reality until it all began to seem normal, as though everybody lived this way. And when necessity demanded that we address the bath problem, it was solved in a perfectly logical way. We were sitting at the table having coffee when Tony mentioned he'd found an old bathtub in the back of a deserted fortune-teller's shop on the Bowery. He proposed that we boost it with the hot station wagon that very night.

I was depressed, run-down, underweight, and dirty, so there was simply no proposition at all, no matter how ridiculous or bizarre, that I was unwilling to accept. After all, what could be more logical than stealing a bathtub in order to take a bath?

"Great, let's go," I automatically replied. It was one in the morning when we pulled up to the remains of what had once been

a fortune-teller's parlor on a street that is known around the world as the home of every bum and failure. I couldn't help but see the irony of the situation. There, painted on the window of the shop, was a gigantic hand, and on the palm were all the lines and their meanings. I questioned what my life had become and what the future held.

Tony carried the tools, while I had the flashlight. The door of the shop was already kicked open. We passed through a couple of stinking rooms. Mattresses, bottles, and debris littered the floor. Then Tony pointed to the bathroom. We had to pry open a half-closed door blocked with a pile of water-soaked newspapers and were flattened by the horrific stench that poured out. The beam of the flashlight revealed a filthy old cast-iron bathtub on one side of the room.

We went to work with the wrenches and crowbars. Tony unhooked the plumbing while I held the flashlight. We pulled and tugged and rocked the four-legged monstrosity until it finally broke free. As Tony cursed and yelled, we dragged it along, through the rooms and out onto the street. In one superhuman effort we heaved it into the back of the station wagon, jumped in, and burned rubber halfway down the street.

The next day, Tony got the two cooks from the restaurant to help him get the tub up the steps to the loft. Tony would let it be known, when it suited him, that he was a construction worker by trade. In fact, he had worked on the Brooklyn Expressway when he was a teen and even set up his buddy "Sammy the Bull" Gravano with a job. At any rate, he did have a collection of tools, and he let the cooks know he was going to install the tub himself. He went out and got some lumber and pipes he needed for the project.

Tony explained that the tub needed to be elevated to tie into a drainage pipe. But I wasn't so sure. He had conceived the same type of thing with his bed, claiming that he liked to sleep high up. But I saw all this as just another manifestation of his Mussolini complex.

The bathtub was finally installed and mounted on top of a rectangular wooden box about four feet high, adjoining the wall. When you sat in the tub, you felt as if you were in some kind of tower looking down. After bringing in lines for the water, Tony ran a drainpipe from the bottom of the tub down into the box and through the wall before finally connecting it to the drainpipe in the bathroom in the hall. The whole thing looked like something an escapee from a lunatic asylum would dream up.

One cold, gray afternoon I was on my way back to the loft from a particularly depressing walk around the neighborhood. I had had my food ration for the day, a lousy hamburger and greasy French fries in a joint on Eighth Street. On my way back home I was contemplating the new splendor of taking a bath in my own place. It had been in use now for only a week and already Tony had nearly killed himself climbing out of the tub while drunk.

When I came through Union Square and around the corner onto Broadway, it was getting dark. As I began to go in the street door, I noticed that the restaurant was closed and dark inside, which was unusual—especially at dinnertime. When I went up the steps and opened the door to the loft, I was confronted with a strange sight.

There was Tony, sitting on a stool in the middle of the dark room. He seemed to be laughing and crying at the same time, holding out his hands and pleading with someone who wasn't there. I slowly approached him. He stank of alcohol, and I could

see he was in pain. "What's goin' on?" I asked, and he showed me his arms, covered with red welts and bruises. Then he pulled up his shirt to show me more all over his body. I was horrified. "What the hell happened?" I asked. Finally, pulling himself together, he told me the story.

"I just got up and took a bath! I didn't do anything!" he said. "Then I was just sitting at the table having coffee while the tub was draining, and I heard these big bangs down below. I could feel it right through the floor! And there's all this yelling and screaming. I'm wonderin' what da fuck's goin' on! I thought a stove blew up or somethin'. I looked out the window, and all these people are rushing out into the street. The next thing I know, I hear people charging up the steps and pounding on the door! I thought the place was on fire! When I open the door, those two fuckin' cooks with their yarmulkes come bursting in and start hittin' me with these big ladles! I'm yelling, 'What the fuck are you doin'?' but they just kept screaming Yiddish curses and hittin' me. Look what they did to me!" and he showed me more welts on his body.

I closed my eyes and asked, "What happened?" At this point, unable to continue, Tony pointed to the tub and broke down in drunken laughter. He couldn't bring himself to say the words, and only made a twisting motion with his hands, like he was tightening a jar, and then threw his hands up in the air as though it all came apart.

Now I understood. Apparently Tony had done a half-assed job of connecting the drainpipe that ran under the wooden box the tub was mounted on. Every time we drained the tub, water leaked out and soaked into the floor beneath. In between the floors was a bed of ash, used in the old days as insulation. Probably the ash,

getting heavier by the day as it soaked up the leaking water, became too much for the ceiling to bear. When Tony pulled the plug that afternoon and the tub drained, it must have hit the breaking point. The ceiling caved in, showering the customers with a deluge of water, plaster, and ash, and just at dinnertime when the place was packed. It was a wonder the whole damn tub with Tony in it hadn't gone right through the floor.

I began getting a numb, sick feeling. The restaurant was our landlord. I left Tony in his delirium. I went down the steps and out onto the sidewalk and looked in the window of the dark restaurant. The ceiling had that old-fashioned pressed-tin decoration. It hung down in sheets from the epicenter of the damage. Beneath it on the floor was a pile of plaster and debris. The customers, no doubt fearing that the building was about to collapse, had panicked, trying to get out through the narrow door. The whole place was a shambles, and I was in a state of shock. I knew this meant eviction.

I had to get away, and I started walking. I crossed Union Square and saw Andy Warhol getting into a big black limo with some friends. Again he stopped and gave me a deliberate stare, but I just passed quickly by. I felt his eyes follow me, and the sensation had an unreal, nightmarish quality. I lacked the nerve to go up to him and tell him what had happened.

The following day, the landlord ordered us to be out in a week. Where was I going to go? What was I to do with all my artwork? I saw my dreams of becoming a successful artist going, literally speaking, down the drain.

A few days later, the restaurant was fixed up and back in business. Tony walked in one day to talk to the cook and see if he could smooth things over. When he entered the kitchen, the cook was

dicing carrots with a large cleaver. The guy was in such a state of sustained rage and became so incensed at the sight of Tony that he lost control and chopped off the tip of his finger along with the carrots. Tony fled as blood was squirting all over the place and the cook's agonized screams rent the air. The cook was rushed to the hospital, where they sewed the tip back on.

I couldn't stand living with Tony anymore. I was low on money, and I was suffering from psychological torture. Tony was barricaded in his room. He'd been drunk for days and was waiting for them to physically throw him out. I spent the next few days aimlessly wandering around the city, freezing in telephone booths, dialing numbers and getting nowhere. Everybody I knew was either living with someone or already sharing an apartment. The snow, the cold streets, and the fruitless phone calls put me in a state of desperation.

Then one day, as I sat in a luncheonette having a cup of coffee, convinced that it was the end of the world, I was about to pay my bill when I noticed a small piece of newspaper tucked in the corner of my wallet. Something urged me to take it out. As I unfolded it, I saw it was an advertisement I'd saved from when I was looking for a studio and landed the place on Fifth. It read: "Live in an exclusive East Side town house, $40 per week, 35 East Sixty-Eighth St." and listed a phone number. The ad was so old, it seemed pointless to try, but having wandered all the way up to the East Side, I decided to trudge over and have a look.

I went up Madison Avenue to Sixty-Eighth Street. Number 35 was a magnificent Beaux Arts–style town house just east of Madison Avenue and one house down from Halston's showroom boutique. I stood in the freezing cold, looking up at the house, not knowing what to do. I felt foolish inquiring about an ad that

was so old. A massive glass-and-iron grill door opened and a few young people who looked like students came out excitedly talking and laughing as they passed me and went down the street.

The gnawing dread of returning to the loft for another sleepless night gave me the courage to ascend the granite steps and press a big brass doorbell button. I was buzzed in. I entered a beautiful marble vestibule with tall ceilings, a chandelier, and a large marble fireplace.

Seated behind a fine Charles II desk was an elderly lady in a dark-blue dress, the very embodiment of propriety. Directly across from her by the fireplace sat a handsome young man in a comfortable wing chair. I was still not sure exactly what this place was. I approached the desk and politely inquired if there were any vacancies.

"No, not at the moment," the woman replied as the two carefully looked me over. But instead of letting me walk away, she asked me what sort of accommodation I sought and what I did for a living. The pair exchanged a glance when I mentioned I was an artist. I explained, carefully avoiding details, that, due to circumstances beyond my control, I had to vacate my current lodgings and needed something without delay. Though she flatly reiterated that there were no vacancies, her lengthy explanation of the rental terms and living situation at the residence heartened me.

The town house, the lady explained, was a "residential club" and in original condition, just as it had been built at the turn of the century. Rooms were let, but few had their own baths or kitchens. There was an original basement kitchen for common use. Rooms on the upper floors shared bathrooms in the hallways, and rooms on the lower floors had their own. Different rooms had different prices. Some, like the drawing room and study, were quite grand.

They had parquet floors, marble fireplaces, and Louis XV paneling. Other rooms, not as ornate, were formerly family bedrooms. The servants' quarters on the uppermost floor were small and devoid of decoration. An old-fashioned elevator had been installed decades ago and was the only "modern" convenience in sight.

As she was explaining all this to me, I noticed that fine period furniture was arranged around the lobby. Tenants' mail was laid out on a beautiful seventeenth-century Italian refectory table. A pair of Louis XV shield-back armchairs flanked a gilded Louis XIV console that supported a cheap lamp. She finished by quoting me the prices of the various rooms. The small rooms on the uppermost floor went for forty dollars a week, and the large rooms on the lower floors went for double that rate.

The woman who explained all this to me was Mrs. Parker. She was in charge of the house. The young man, Jim, was the super. The house was called the Ferguson Club. As there was nothing available now, my heart sank, but Mrs. Parker suggested I try their *other* club, the Warren Club, down the street on Sixty-Eighth off Fifth Avenue. She thought they might have something, but added that, if not, I should return.

I crossed Madison Avenue and walked over to Fifth. It was bitter cold and the wind was blowing hard. When I reached the address of the Warren Club, I found that it was a large town house with a more austere façade than that of the Ferguson. Despite its exclusive location, the impression I got upon entering the lobby was of a cheap hotel.

In contrast to the Ferguson's stately atmosphere and fine period décor, here was a Coke machine, an old black-and-white TV, and a few boys lounging on broken-down sofas. All eyes were on me as I surveyed the scene. I sensed that I'd intruded upon their private

domain. Amid the trashy ambience, I was surprised again to spot a few pieces of fine antique Italian and French furniture.

A sandy-haired boy in a bathrobe and slippers, who appeared as though he was still trying to wake up although it was late afternoon, called someone in charge. Soon a tall, thin boy with short hair and an earring came to greet me. "Mrs. Parker from the Ferguson Club sent me over. I'm looking for a room," I announced, and the two of them accompanied me to an elevator so small that I could feel their breath on my neck. We got out on the third floor and I marched with the pair to a door near the end of the hall. The boy with the earring made a grand display of producing a jangle of keys from the end of a long chain attached to his skintight jeans.

When he opened the door, I was confronted with a tiny, windowless room that resembled a prison cell. Dumbfounded, I wondered if this wasn't a joke they were having on me. Smiling, they demanded fifty bucks a week. I thanked them and said, "I'll have to think about it." Back in the lobby I noticed a guy in a biker jacket and a shaved head staring at me on the way out. I returned to the Ferguson Club and told Mrs. Parker that all they had was a small room and I doubted I wanted it. Jim tried to keep a straight face as Mrs. Parker politely said she understood perfectly. She took my name and phone number and said she'd see what she could do.

Several days later, as I sat biting my fingernails in the loft, the phone rang. Mrs. Parker informed me that she had a room on the top floor, plus storage space in the basement if I could commit to stay for any length of time. Without hesitation, I told Mrs. Parker I'd take the room. I loaded up a rented truck with my artwork, told Tony to go fuck himself, and split.

CHAPTER FIVE

The Ferguson Club

My artwork went into the town house basement, and I stored my Jeep in a garage on West Fifty-Seventh Street. I was pale, run-down, and depressed. I holed up in my small room on the fourth floor. The weather outside was horrific. Sleet storms raged day and night. I ran to Third Avenue for groceries and returned to my room. It had been a long time since I could take a bath, eat in peace, and sleep in a warm bed. I bought a copy of Dickens's *Hard Times* and read it over the next week in bed. I knew that once I felt better and could think straight again, I'd have to plan where to go from here.

After I convalesced and began to explore my new surroundings, I discovered that every evening, a group of residents gathered in the basement kitchen to prepare dinner for themselves. Like everything else, the kitchen was original to the house and, with the exception of two refrigerators, it retained all of its antique charm.

I began to frequent the kitchen with the others, but, still in shock over the downtown debacle, I skulked around like a zombie and kept to myself. The first person to approach me was Ann. A tall, well-preserved, gregarious woman of forty, she wore her blonde hair in a ponytail and sported horn-rimmed glasses. Articulate and highly intelligent, Ann had an authoritarian air about her. I felt like I was in the presence of one of my grammar-school teachers again. It was Ann's allotted duty to make preliminary overtures to any new and potentially interesting member.

We quickly became friends, and I discovered that Ann was the intellectual and social backbone of the club. She could be found almost any night in one or another tenant's room holding stimulating conversations on most any subject. I learned from Ann that the Ferguson was home to an interesting and somewhat eccentric assortment of people. Many of the long-term tenants liked to swap stories about how they'd found their way to the club, the way religious people like to recount how they've been led to Christ.

Ann herself had once led an exciting life in society when she was married to a young composer. It all came to a sudden end when he died of a heart attack, leaving her almost destitute. Ann's problems might have been solved had she somehow been able to obtain what she claimed was a fortune in royalties due her. She believed that her husband's works were in the possession of scheming lawyers

who were in cahoots with everyone from the Bilderberg Group to the Trilateral Commission. She claimed that they had conspired to keep her from collecting as much as a penny in royalties. Furthermore, she was certain that she was being watched at all times by elements of what she referred to as "the overworld" and that monies earned from the royalties were being funneled to right-wing hit squads in South America.

I had viewed the Ferguson Club as a temporary refuge, but after meeting Ann I began to feel at home, part of the family, and I wasn't so anxious to leave. I learned from Ann that the house was owned by Phoebe Warren Andrews, a rich, elderly recluse who lived in two adjoining brownstones on East Sixty-Second Street between Park and Lexington Avenues. She nurtured a lifelong penchant for handsome young men, was a friend of Doris Duke's, and shared many of Doris's peculiarities.

As a young girl, Phoebe had been employed as a maid at the house. The property was owned then by a rich elderly financier who owned several residences. Rumor had it that Phoebe became his mistress. Whatever the circumstances, he died and left her the property. Phoebe displayed remarkable business acumen. She borrowed against the property, purchased other town houses, rented them out, and eventually parlayed her property on Sixty-Eighth Street into a small real estate empire.

Phoebe bought estates in Oyster Bay, Long Island, and Newport, Rhode Island. In Newport, Phoebe became president of the Arts Council and took up with Igor Reed, a handsome school-teacher. Together they joined the two brownstones that Phoebe owned on East Sixty-Second Street and spared no expense on rich, opulent decorations. Phoebe insisted her help be young, male, and handsome. That was Igor's department. In fact, his tastes were

the same as hers, so he had no problem staffing their houses with friends and friends of friends.

Phoebe held a sentimental attachment to the Sixty-Eighth Street town house and, although she used it commercially, she kept it as original and unaltered as possible. During the sixties, the house was opened as an exclusive finishing school for girls. Its clientele came from among America's best families. It was so successful that she acquired the town house up the street, off Fifth, and established one for boys, calling it the Warren Club after a late husband.

As Phoebe aged and became less involved with managing her properties, standards dropped. The buildings went from exclusive boarding schools to coed residential clubs. The Ferguson, however, enforced a restriction imposed by Phoebe as "reserved for young people in the arts," and Mrs. Parker tried to maintain that policy.

Already a recluse for some years, Phoebe was ill and housebound and rarely left her bedroom. Igor was around fifty or so and reputedly in charge. One could clearly discern the remnants of his former good looks, but years of overindulgence had taken their toll and he was now running to fat. He spent his afternoons walking a pair of shih tzus and sitting at the Carlton Bar on Madison Avenue, sipping martinis. It was common knowledge that when the old lady died, Igor would get the lot, and her demise was expected momentarily.

The first thing that struck me as I settled into the house was the frequent appearance of two sinister-looking guys who projected distinctly unpleasant vibrations. They collected rent receipts from Mrs. Parker. Like twins, they both had shaved heads and wore black-leather biker jackets, motorcycle boots, and tight jeans.

Silence would descend on the lobby whenever they entered. They would demand the cash box from Mrs. Parker and shamelessly rifle its contents in front of everyone. A quick check of the receipt book, and they'd leave without a word. When I ran into them, they'd stare holes through me.

Ann explained that their names were Kevin and Allen. They were Igor's lieutenants. In addition to collecting rent, they acted as roving supers for the many properties. They called their company Marshall Management. The clubs offered not only hard and immediate cash, but also new recruits they might consider for positions at either Sixty-Second Street or in the clubs.

Of the two clubs, the Ferguson had a more genteel reputation, in great part due to the presence of Mrs. Parker, who would have made a perfect English public-school headmistress. Not only did she live in the house, she maintained high standards, even forbidding the installation of a Coke machine. In contrast, the Warren Club's reputation was besmirched, and it was whispered that Igor was known to occasionally spend a night or two there.

As a matter of practicality, I realized that I'd be at the Ferguson for the rest of the winter. Ann introduced me to all the tenants, including Raun, a beautiful former model who worked as a secretary and took acting classes.

Al occupied a beautiful drawing room situated in the front of the building. The entrance was to the side of the main lobby where Mrs. Parker had her desk. The interior of the drawing room was designed like an opulent Louis XV salon. It featured carved paneled walls, murals, a marble fireplace, and a single large window overlooking the street. With its own bath and galley kitchen, it was the finest accommodation in the house.

Al was anxious for me to meet his friends and fellow workers from Bloomingdale's who came over to hang out almost every night. Like me, they were struggling to survive by whatever means they could, while nurturing dreams of success as actors, fashion designers, or models.

One day Al announced that he was leaving New York City and moving to LA to take another job in the fashion industry. It was proposed that I take over the drawing room once he vacated. Until this time, I hadn't taken staying at the Ferguson seriously. There wasn't much I could do in my small room on the fourth floor that I shared with a young man who worked at Tiffany's and a half-crazed writer who talked to himself and never ceased banging on an old typewriter.

Although Al's apartment would cost nearly twice what I was paying for my garret, it was an offer I couldn't refuse. Not only was the apartment magnificent—it also came with its own bathtub—but more importantly, I'd be able to *work* in it as well.

My fellow tenants were delighted that I was staying and had agreed to take the drawing room. Mrs. Parker was particularly pleased. Often I would sit and listen to her stories about her friendship with Phoebe years ago, about how they had met socially and gone shopping together along Madison Avenue. She described how Phoebe had entertained at the house and enjoyed getting drunk with her friend the actress Hermione Gingold in the very room that was to become my home. She mentioned that it had also once been the home of Shirley MacLaine. Mrs. Parker went on to explain that, sometime after she lost her husband, Phoebe offered her the position of housemother after it was decided that the house was to open as a finishing school for girls.

When the subject of Igor, Allen, and Kevin cropped up, there was a change in her demeanor. She confided to me that since they had taken charge, Phoebe had become a virtual prisoner to them over the years and now harbored a secret fear that they might try to sell off the properties one day.

My resources were getting dangerously low, and my move into the new apartment made it even more urgent that I start making some money fast. Now, with my plans to create a serious body of work in shambles, I didn't have to think twice about what had to be done. I had hardly finished hanging my clothes in the closet of my new apartment before I ran over to several antique warehouses in Yorkville.

One establishment offered four floors crammed with furniture and architectural fragments. I dove into a pile of broken furniture used for repairs and hit pay dirt. I discovered a collection of Gothic linen-fold panels, ten in all, tied in a bundle. They were thin wood panels, exactly the type on which artists painted in the seventeenth century, except that they bore a carved decoration on one side that resembled a small sheet of cloth folded in pleats. These panels were commonly used in the sixteenth and seventeenth centuries as decorations on the fronts of cabinets and chests. A hundred bucks took the lot, and I was back in the forgery business.

After a stop at the hardware store, where I purchased a plane, a chisel, and some sandpaper, I returned home and went to work. Before the night was over, the linen-fold decoration had been removed from half the panels. After they were prepared with gesso and left to dry, I spent the next few days settling in. I painted the Louis XV wall panels white, hung a couple of my contemporary paintings, and Mrs. Parker let me drag in a few

pieces of antique English furniture that weren't being used in the house.

Two "van Goyens" and a "van Ruysdael" were finished and drying under heat lamps before I'd spent my first week in the apartment. Once they were aged and varnished, I took them directly to Mr. Jory to be fitted up in frames.

Desperate and down to my last hundred bucks, I shoved a "van Goyen" into a Bonwit Teller shopping bag someone had left in the lobby of the club and headed up Madison Avenue. Not far away at Seventy-First Street was a dealer in early *objets d'art* by the name of Gluckselig.

His small shop, crammed with paintings, icons, and antiquities, resembled the kind one would expect to find in the backstreets of an old European city. Dressed in a worn, faded suit, the old dealer was dusting and polishing things when I walked in. He instantly fixed his eyes on the edge of the antique frame protruding from the shopping bag. Before I could even finish asking him if he bought antique paintings, he was reaching for the painting in the bag. He produced a large magnifying glass from a drawer and examined the painting closely. It was a beautiful picture of a cottage set in a barren, windswept landscape bathed in a warm golden light. A traveler with a cart being pulled by a jackass could be seen in the distance approaching the cottage.

Gluckselig turned the picture around to examine the back and then the front again. I followed his eyes and knew exactly when he spotted the initials V.G. running along the rail on the fence near the cottage.

"How much?" he asked quietly, never raising his head.

"Fifteen hundred," I whispered.

"I'll give you eight hundred cash," he said.

"Nine hundred and you can have it," I said with a feeling of relief.

"Wait here," he said and went into a back room.

On an early Italian table he counted out nine one-hundred-dollar bills. He took the painting and handed me the cash and the empty shopping bag.

On my way back down Madison Avenue, I was about to toss the bag into a nearby bin when I thought, Maybe it's a "good-luck" bag. I'll keep it for the next painting.

Never was I more thankful for my talent than when I returned home, paid my rent up in advance, and opened a savings account for the rest. I was still a long way from regarding forgery as a career; at this point I viewed it as something to temporarily keep me going. For now it was the only thing that stood between me and starvation, and I determined never to be without fakes again. From that point on, I always kept a few "Dutch" paintings framed and ready for a sale.

I developed a dual-track work routine. With hope that I could still save my planned artistic career, I painted "Dutch" in the mornings and worked on my contemporary art in the afternoons. With money in the bank and the pressure alleviated, I planned sales trips at my leisure, sometimes traveling with a painting in my Bonwit shopping bag to dealers in Englewood or Brooklyn Heights who had ads in the yellow pages stating that they purchased paintings for cash.

Along with my new apartment came a new ready-made assortment of friends I met through Al, who dropped by in the afternoons and evenings. Terry, Phoebe's nurse, worked the night shift and would visit me in the afternoons. He'd been employed by Igor for over a year, first at the Warren Club, where he lived

(and where I'd first met him wearing a bathrobe and slippers), and now at Sixty-Second Street. Terry had drifted to New York City years earlier, and contacts in the gay community led him to Kevin and Allen. Where Igor had picked them up, Terry couldn't say, but they'd been with him for years and he'd grown utterly dependent on their managerial skills.

There was a fourth person in this arrangement who Terry described as a "slimeball", a lawyer known only as Rubel. Rubel was one of Igor's buddies, and his sole practice was handling Phoebe's legal affairs. Allen and Kevin's duties, however, extended beyond management to that of procuring for their hopelessly timid boss Igor. Terry described Allen as a particularly nasty piece of work. He would find handsome young men for Igor. They would enter the luxury and comfort of the town house—at least for a time—or be housed at the Warren.

Some, like Terry, would eventually be given a position. But not before they dealt first with Allen, who enjoyed subjugating the employees to vicious rounds of sadomasochistic sex. Terry also divulged another bit of intelligence that I found most interesting. Speaking of Igor's revolving door for young houseguests, Terry explained in hushed tones that "things are constantly disappearing."

"What kind of things?" I asked.

"Jewelry, money, silverware, and antiques," he divulged. "Even a genuine Corot that Phoebe paid over twenty thousand dollars for walked right out of the house one night!"

"Well, doesn't Igor call the cops?" I asked in bewilderment.

"Not a chance," Terry laughed. "He's afraid of the questions they'd ask."

To my surprise, there was an inhabitant directly below me whom I had yet to meet. No one had ever mentioned him. Gino

Comminchio occupied a basement apartment with its own entrance down a staircase below my window. He was the dark secret of the house. All I could get out of Ann and Raun was that he was a gangster rumored to be a Mafia enforcer and usually late with the rent, but no one disturbed him about it, not even Kevin and Allen, leather jackets and all.

The most anyone knew of Gino was that he was never without a high-society girlfriend, that he hung out every evening at a restaurant in the East Fifties, that he wore fifteen-hundred-dollar suits, and that he collected a paycheck for it. I finally met him one afternoon when he made a rare appearance in the lobby. I had just returned from having lunch with Michelle, and he was in conversation with Mrs. Parker just outside my apartment door.

Mrs. Parker introduced me to Gino as "the young artist who moved into the drawing room." Gino stuck out a huge hand. We shook. He said that he'd like to see my work, and I invited him in. Gino was an enormous hulk of a man. He stood six feet, four inches tall and was around fifty years old. He wore an expensive Burberry trench coat draped over a gray sharkskin suit. He had a built-in suntan, and deep furrows lined his broad face. His hair was graying at the temples, and he was everything you'd expect a godfather to be. It was a wonder that he never went to Hollywood to play the part.

Gino entered my room, we chatted, and I showed him the various components of my collection. He nodded in approval and then asked, point-blank, "Wadda ya do for money?"

"I move antiques whenever I can lay my hands on them," I replied. Gino gave me a wink and said, "I'll let you know when somethin' comes my way." He slapped me on the back and was on his way out when he paused and looked at the pair of "Dutch" paintings hanging on the wall.

"Like these?" he asked.

"Exactly," I answered, and he left.

With each passing day, I felt more at home at the Ferguson Club. Even Kevin and Allen acted friendly when they saw me. One day I was surprised when, answering a knock at my door, I found them standing in the lobby holding a supposed Canaletto. The painting had been stored in the attic of the club. They asked my opinion of the picture and if I would carry it to the Sixty-Second Street residence and hang it for Igor. The request struck me as suspicious, but I agreed. At least it would provide the opportunity to see the inside of Phoebe's much-touted town house.

The maid admitted me to the Sixty-Second Street residence and asked me to wait in the drawing room. The opulence of the décor left me speechless. Walls covered with the finest Venetian green silk damask set off exquisite paintings hung in gold-leaf frames. To my surprise, there were numerous examples of fine seventeenth-century European furniture. This explained the overflow of period pieces at the clubs.

A pompous middle-aged man wearing a dark suit and tie appeared. I assumed this was Igor, and he coldly asked me to follow him to another room. Once there, he directed me to hang the picture from a wall fixture. After I was done, he thanked me, and I left.

Not long after this, Mrs. Parker informed me that Jim, the super at the club, was leaving, and the management wondered if I'd be interested in the position. They offered me my room, plus a salary of seventy-five dollars a week. All that was required was a few daily chores such as filling the boiler each day with water, mopping the marble floor in the lobby, and generally keeping an

eye on things. I would be on duty five days a week, and I could paint in my apartment during the day if I was free.

No words could adequately describe the feeling of elation I felt at that moment. To live in my magnificent room, to paint all I wanted, and to be paid for it as well! It was a dream come true. Now the debacle on Union Square seemed like an act of divine intervention. It was Terry who had taken the liberty of suggesting to Allen that they offer me the position. The charade of having me deliver a painting to the Sixty-Second Street town house was a ruse in order for Igor to check me out. When I saw Terry, he made it a point to let me know there were "no strings attached," but he added, "Igor wants to know if you'd paint some murals on the walls of the place in Oyster Bay."

As things stood, Jim would leave in a month and then I would assume the position of super. In the meantime, Jim showed me my duties in the house and the operation of the ancient boiler in the subbasement. Indeed, I felt like the luckiest person on earth.

And right on cue, Tony, affecting one of his remarkable turn-arounds, once again showed up looking like a movie star. He had found lodgings with an old girlfriend on Ninety-Fifth Street. He was absolutely floored when he saw my new royal digs.

"How the fuck are you paying for all this?" he demanded to know. Unable to contain myself any longer, and no longer under his control, I just pointed to the pair of "Dutch" paintings hanging on the wall. "You paint them?" he asked.

"Right," I said.

"And where do you sell 'em?" he asked.

"Around the neighborhood," I answered, with the air of a person who hasn't a care in the world. As Tony took one of the paintings

down and studied it closely, a sly smile, one I'd seen many times before, began to spread across his face.

"So, when are we going into business?" he wanted to know.

"I'll let you know," I answered sarcastically as I pulled the painting from his sticky hands and replaced it on the wall.

The fact was I had no intention of doing anything with Tony. I was still steamed over the disaster downtown and wanted only to torture him. Besides, since I'd been offered the position at the club, I had stopped selling any more fakes. Nevertheless Tony was back and now, courting me like a virgin, he was taking me around to the best gallery openings and parties in town.

I should have known it was all too good to be true. I came home late one afternoon feeling on top of the world and just days away from taking over as super to find once again that the roof had caved in on me—figuratively this time. Upon entering the lobby, I was confronted by Ann, sobbing into a handkerchief and consoling Mrs. Parker. My first thought was that Phoebe had died. When I asked what had happened, Mrs. Parker replied, " The ax finally fell!"

Ann, waving a piece of paper, said "These were posted on everybody's door," and, sure enough, there was one on mine too. Dumbfounded, I looked at it and read the words "Notice of Eviction" printed across the top in bold letters. After a bunch of legal mumbo-jumbo, it gave us two weeks to vacate the apartments. It was signed at the bottom by a lawyer, slimeball Rubel. In shocked disbelief I went into my room to be alone.

This can't be happening, I thought. They promised me a job! It didn't make any sense. I felt sick and forgot about making dinner.

The eviction notice offered no explanations, alluding only to tenants without leases, therefore etc., etc. All we could elicit from

Mrs. Parker was that "they leased the building and they won't talk to *anybody*." For me it was Union Square all over again.

Kevin and Allen never showed their faces at the house again. No one, not even Terry, had had any forewarning of the management's plans to vacate the house. When I saw Terry, he told me he was just as stunned as I was and said he'd try to find out what was going on.

The next few days were a nightmare. Like other tenants, I ran around the neighborhood in a futile search of a vacancy. Suddenly, the neighborhood that I'd become enamored of, with its elegant façades, didn't look as good, as fine, and as friendly as it had before.

We were down to a week before the deadline to vacate. Ann, Raun, Gino, myself, and a few other tenants, including Mrs. Parker, still remained. It was depressing. The house that Mrs. Parker worked so hard to maintain had become a pilferer's paradise. Pots, pans, lamps, and even chairs and beds disappeared with fleeing tenants. I didn't know what to do. Where could I go with all my artwork? It was February, when apartments were scarce, and those that were available were way beyond my means. Between deposits, key money, and rent, even my fakes couldn't save me now.

I hated Igor, Allen, and Kevin. Throwing us out on the street in the middle of winter didn't mean a thing to them. I was lying awake nights trying to come up with a plan to get even somehow. But *they* had all the money; *they* had all the power. Every night, Terry told me, the three of them were served gourmet dinners prepared by their cook and served by the houseboy in the cozy candle-lit dining room surrounded by beautiful paintings and antique furniture, far removed from the petty problems of their tenants. Even Mrs. Parker was being turned out, without any help or an offer

of another position. To add to our troubles, the management, not satisfied with the speed with which the house was being vacated, sent a message to Mrs. Parker threatening that *force* would be used if the house was not empty by the deadline—including cessation of all utilities.

No sooner did Mrs. Parker show me the message than Terry dropped in. "You're never gonna believe why they're emptying the house—they just leased it to a drug rehabilitation clinic!" he declared. Mrs. Parker looked straight up at the ceiling and almost fainted. We had to hold her up and guide her to my sofa.

The idea of putting a drug rehabilitation clinic on East Sixty-Eighth Street, one of the most fashionable residential areas of New York, was like sticking a methadone clinic in Rockefeller Center. Terry speculated that the deal had probably been dreamed up by Igor's lawyer, Rubel.

No longer beholden to the management for employment, and furious about our treatment, Mrs. Parker came into my room for a private chat. "Kenny, you have to do something. There's no telling what they might do next week when they close the house." Then she handed me a piece of paper with a name and telephone number on it. "You call this man and tell him what's going on. He's a big lawyer who lives on the block. He might help."

When I looked at the piece of paper, the name Roy Cohn didn't mean a thing to me. I appreciated Mrs. Parker's concern, but I dismissed the idea as too little, too late. Three quarters of the tenants were gone, we had no leases, and the clinic was scheduled to move in. There didn't seem to be any hope, but little did I realize that the revenge I so desperately wanted had just been handed to me in spades.

The following day, Friday, I ran into Mrs. Parker in the lobby.

"Did you call him?" she asked.

"No," I had to confess. "I didn't get around to it yet." She insisted I sit down at her desk and make the call at once. I dialed the number. A secretary answered and told me, "Mr. Cohn is not in at the moment and is not expected back until Monday." She asked if I'd like to leave a message.

"Well, my name is Ken Perenyi," I said. "I live next door at number 35. I don't know if Mr. Cohn would be interested, but all of the tenants here are being evicted because a drug rehabilitation clinic is moving in next week, and we wanted to know if there is any way we can fight this."

The secretary asked for my number and promised to give the message to Mr. Cohn. I hung up and turned to Mrs. Parker, who stood with her arms folded and an expression of satisfaction on her face. Ann and Raun were just returning from work and joined us. We were sitting around the lobby ruminating when the phone rang. It was the secretary. She said that Mr. Cohn would like to see me Monday morning at nine and told me to bring any documents I had with me.

I hadn't seen Gino in a while, and when I ran into him the next day in the lobby he wasn't concerned at all and had no intention of moving out. "Those fuckin' faggots come around here, I'll send them home in shopping bags," he said.

"But what about the eviction notice?"

"That's no legal document!" he said with contempt. Then I told him I had an appointment to see Roy Cohn.

"Good, tell him that Gino from P. J. Clarke's lives here too. No way he's gonna let a bunch of fuckin' junkies live next

door to him." With that, he slapped me on the back and left laughing.

Monday morning, I got dressed, had a cup of coffee, and left for my appointment. Out in the lobby, Raun and Ann gave me their work numbers to call in case of news.

Roy's town house and law offices, number 39, were just one door down from the Ferguson Club. The entrance of the building's fortress-like façade offered nothing more than two small windows fitted with heavy, ornate bronze bars that flanked a pair of massive oak doors. Two fearsome lion's-head knockers greeted the visitor. I pulled open one of the doors and entered the street-level room that served as reception. It was an ill-lit area with a sofa and a few chairs. To one side, a girl was seated behind a desk. Toward the back I noticed an open door, beyond which was a communications room.

I approached the desk and announced, "I'm Ken Perenyi, the neighbor next door. I have an appointment to see Mr. Cohn." She raised an eyebrow and said, "Yes. Just go up the steps. Mr. Cohn is upstairs and will see you."

I headed for a wide, curving staircase covered by thick red carpeting, followed it up to the second floor, and found myself in a bright, lavishly furnished living room. It was a beehive of activity. Several lawyers milled about, talking and studying documents. At the far end of the room I saw a man seated in a wing chair. He was radiant in a gray suit and a deep suntan. He was giving instructions to a secretary, and from across the room I caught the brilliant turquoise of his eyes. Suddenly I felt self-conscious in my old army coat and jeans, but no one even gave me a glance as I walked toward him.

"Hi. I'm Roy Cohn," he said, looking up from the chair. "What's up?" As the other attorneys looked on, I introduced myself

and explained the situation. The room quieted down. Everyone was looking at us. Roy stared at me. "Are you putting me on?" he asked after I'd concluded.

"No!" I assured him. "We got an eviction notice, and the name of the clinic moving in is Encounter. I got it straight from someone who works for our landlord. The lease has already been signed and most of the tenants are already gone."

Rolling his eyes, Roy stuck out his hand for the eviction notice I'd brought. Like Gino, he took one look at the paper and declared: "This isn't an eviction notice. It's nothing!" I shrugged my shoulders and felt like a fool. He asked if I knew who ran the clinic, but before I could answer, he called across the room to Tom Bolan, his law partner, "Hey, Tom, wait until you hear this one. They're moving a drug rehab in next door!"

Roy rose and said, "Follow me." We took the elevator up to his office. In the elevator, Roy looked me up and down, asked how long I had lived at the town house, where I came from, what I did for a living, and what I paid for rent. By the time we were two flights up, he knew my life history. The next minute, I was sitting in Roy's office and he was asking questions and writing down names. "So how many tenants are still there?" he asked.

"About ten, but the numbers are dropping each day. By the way, Gino from P. J. Clarke's lives below me and says hello."

Roy, raising his eyebrows in surprise, said, "Okay." After some more questions, he told me to go back home and said that he'd call later.

I returned to the house, sat in the lobby with Mrs. Parker, and at noon Roy's secretary called to say, "Mr. Cohn would like to see you in his office." I knew this was the moment of truth. I took a deep breath, Mrs. Parker patted me on the back, and I was off.

As I approached Roy's office, I noticed that the door was open and there was a cutout of Mickey Mouse on it. Roy waved me in, and I took a seat.

"Ken," he began, "I checked it all out. They're planning to move in next week." My heart sank. "But," he said, "we're gonna stop them." I almost jumped for joy. Then he asked me if there were tenants willing to stay and fight. I assured him that at least some of us were, and Roy said, "Okay, then I want you to give me a list of names of those willing to stay in their apartments and be part of a lawsuit. The eviction is illegal. The management has no right to lease the property with tenants in place and I'm sure we can win this thing." He added that his services would be pro bono. We shook hands. But before we parted, Roy told me to be at his place the following morning at eight for breakfast.

By the time I got out on the freezing street, I was so excited I didn't know what to do first—call Ann and Raun, or just go and eat. I was suddenly famished. I hadn't felt hungry in a week. I went to a Greek luncheonette on Third Avenue and ordered bacon, eggs, toast, and coffee. Saved from disaster, I felt like a new person and sat there for an hour letting the events of the day sink in.

"Oh, shit!" I thought. "Wait till Igor and the other two find out what's going on!" I paid my bill and left.

That night, as several of us gathered in Ann's room, the mood was jubilant. Roy Cohn was the main and only topic of conversation. Ann—whose paranoia and need to keep tabs on the "overworld" required her to read three newspapers a day, all the weekly newsmagazines plus several tabloids—was the house oracle, brain trust, and historian.

For the first time I learned about Roy Cohn's role in Senator Joe McCarthy's hunt for Communist spies in the 1950s and that he was the most feared, notorious, and highly paid lawyer in the country, if not in history. He was courted by politicians, mobsters, and tycoons. He lived a jet-set lifestyle, hobnobbed with the rich and famous, and had his own table at '21'. Roy was big enough to take on anybody or anything. Indeed, as Ann explained it, he'd been indicted three times by the federal government for such crimes as fraud, conspiracy, blackmail, and extortion and had defended himself each time and won.

CHAPTER SIX

Number 39

The next morning, I went to Roy's and found him in the dining room, decked out in a silk Hermès dressing gown, sitting at the head of the table breakfasting with two impressive-looking men. He invited me to sit down and order from his Spanish cook. Then he introduced me to Mike Rosen, the firm's top litigator, and Paul Dano, his business partner.

Roy came straight to the point and explained that he was bringing lawsuits against Igor, Phoebe, the clinic, and anybody else he could go after. Then, in a moment of melodrama, with all

eyes fixed on mine, Roy said: "You're gonna be our main witness. You just have to be in court when we need you." And, he added, "Don't worry: we'll tell you what to say."

"Sure!" I replied enthusiastically, gaining nods of approval from everyone. After I finished breakfast, Roy shook my hand, called me "partner," and everyone was all smiles. Before I left, and with my absolute loyalty established, Roy told me to come back and check with him at eight that evening. I spent the day strolling around the neighborhood, greatly relieved and delighted by the course of events.

At eight, I rang Roy's bell. Roy answered, and I followed him upstairs to the living room. There, seated in the wing chair, was an exceptionally handsome and well-built guy who Roy introduced as Dave Tacket and who I came to understand was Roy's "friend." Dave fixed me a drink as Roy filled him in on the situation next door. I noticed a change in Roy's personality compared with our previous meetings. He was very charming, wanted to be addressed as "Roy," and spoke to me in familiar terms as one does to a friend.

Up until this point, Roy was only aware of the basic facts about the Ferguson Club, Igor, and Rubel. Now Roy wanted to know all I could tell him about the club and its operation. When I told him about Igor's situation, his dependence on Allen and Kevin, and my friendship with Terry, Roy was intrigued. He found it particularly interesting that a large portion of the rents was paid in cash and anxiously collected by Allen and Kevin. When I mentioned that Terry suspected that a lot of this cash went unreported, Roy asked me to write an estimate of the rent the house took in per week and drop it off at his office. When he asked me about my artwork and I explained that I was currently working on my first collection, Roy

said that they would come over and take a look, and he suggested that he might be able to help me as well.

Before I left, Roy gave me a copy of a letter he had sent to Igor, Rubel, and the clinic. It was a chilling statement that spelled out in no uncertain terms that their actions were illegal. It informed them that the tenants were now represented by Saxe, Bacon, and Bolan (Roy's firm), that the tenants would remain in residence, and that the case was being handled personally by Roy M. Cohn, Esq. It was signed by him.

Several days later, I dined with Terry. He said that Roy's letter had hit Igor like a bombshell and sent him into a panic, yelling and screaming at his idiot lawyer, Rubel. Terry said that on that evening, Igor, Allen, and Kevin were at the table, where for so many nights before they had dined in comfort. On this night, the dinner was left untouched. "It all had to be thrown out because they were too upset to eat." Terry continued, "And they discovered that it was *you* who went to Cohn." That was music to my ears.

Roy lost no time in organizing the neighborhood, the inhabitants of which read like *Forbes*'s list of America's wealthiest people. He had pamphlets distributed describing "lines of methadone patients" on Sixty-Eighth Street if action wasn't taken. The following evening, Roy held a neighborhood meeting at his town house. Everyone showed up, from wealthy antique dealers parading around in mink coats to stockbrokers and investment bankers in hand-tailored suits. Rich decorators came with their poodles, and society women lamented that "the neighborhood was going to the dogs." A row of neighborhood dowagers, dripping with diamonds, were planted on a sofa.

Roy appeared and announced to the crowd his intention to petition the court to issue an order restraining the clinic from moving

into the town house. The evening turned into a society cocktail party. Neighbors vented their anger and swore the clinic would have to move in "over our dead bodies," but they offered nothing else beyond signing a petition and shaking Roy's hand.

The clinic, which was called Encounter Inc., was a rehabilitation program for troubled teens involved with drugs. It was designed to treat twenty patients at a time, who would reside there. The program had originally begun down on Spring Street, and it was state funded, but it had also attracted donations from wealthy supporters. Mr. Levi, the managing director, had staffed the clinic with several psychologists and counselors.

Roy's investigators discovered that a friendship had long existed between Mr. Levi and Rubel, Igor's lawyer. Together they had devised a cushy arrangement whereby the clinic would renovate the house and pay Igor a hefty yearly rent, using taxpayers' money provided by the state. And the director, Levi, was planning to have an apartment for himself in the town house, to boot.

The eviction deadline came and went without any show of Igor's enforcers. Mrs. Parker bid us a sad farewell and wished us luck. In her distress, she left her set of master keys on the desk—which quickly found their way into my pocket. I was elected super, being the only person who both owned a toolbox and knew the secret formula for filling the ancient boiler with water each day.

Roy got his restraining order, but it didn't do much good. Right on schedule, Encounter's counselors and patients moved in and occupied every vacant room in the house. A hearing was called in the New York State Supreme Court, and it didn't go our way. With the press and a number of powerful politicians taking Encounter's side, the judge wasn't about to enforce the court order. Instead he

modified it, allowing the program to coexist with the remaining tenants until the issue of who had the legal right of occupancy was decided.

The judge was also about to grant the clinic's request that the plaintiffs post a ten-thousand-dollar bond to cover damages in the event the plaintiffs lost, but in lieu of a cash bond, Roy persuaded the judge to accept a notarized guarantee signed by a "responsible individual" to cover up to ten thousand dollars in court-awarded damages. Of all the millionaires in the neighborhood who vowed their support, Roy couldn't find a single one who would sign it. In the end, *I* wound up signing the document. I don't know how Roy got the judge to accept it, but he did.

It was obvious that there wasn't going to be any quick fix to the problem. Each side was intent on evicting the other. For Roy, the stakes were high. All the newspapers were following the story, and his reputation was on the line. He called me over almost every evening around seven for a daily briefing on what had gone on at the house.

I'd have to hunt around to find him. Sometimes he'd be in the penthouse, the kitchen, his bedroom, or even in the bathtub while we had our talks. I noticed a Brice Marden hanging on the wall of his bedroom and recognized the painting. Tony and I had dropped in on Brice when he was working on that series. When I mentioned it to Roy, he offered to have the dealer who sold it to him come over and see my work. Indeed, Roy started to send all kinds of people over to my place to look at my paintings, even a couple of guys from the Gambino family who were waiting for the old man, Carlo, to finish up his business with Roy.

One evening, Roy explained that we could be tied up in court for at least a year. His plan was to "quiet things down" and "get

it out of the press" so that he could "take care of it behind the scenes."

For me, this news was a godsend. After having the rug pulled out from under me twice in the past year, I only wanted some time and breathing space to make enough money so that, no matter what happened next, I'd be able to handle it. The good news was that since the lawsuits had begun, we hadn't paid another cent in rent. The bad news was that, without my promised job, I was under pressure to make money again.

Gino's favorite pastime, or rather his second occupation, was circulating in café society and certain Upper East Side bars frequented by rich single women. Gino suggested that I put on my suit and join him on his forays. His main hangouts were the bars in the high-end hotels like the Sherry-Netherland. He was quite the Romeo and had a number of middle-aged lady friends with Park Avenue addresses. Although we didn't have much luck hustling "high-class broads," it gave us the opportunity to discuss business and hatch Plan B.

Gino was not ignorant on the subject of art and antiques. In fact, he confided to me over drinks at Elaine's that he sometimes fenced stolen *objets d'art* to crooked dealers in the city. When he mentioned that even some of his rich friends had bought hot items from him, I decided to confide to Gino the truth about the "Dutch" paintings in my room and the way I made money.

Gino began to get the word out among his millionaire friends that he was helping the Mob move some artworks stolen from museums and galleries in Europe. As predicted, they took the bait and wanted in on the action. Cloaked in secrecy—like under the Brooklyn Bridge at two in the morning—Gino would produce a "van Goyen," but the customer had to be ready, usually with a

couple thousand bucks in cash. Soon Gino was making sales to "rich broads" on Fifth Avenue and Garment District businessmen, with the proviso "You gotta bury the piece for twenty years."

"But Gino," I remarked after he'd made a few sales, "what if they find out it's a scam?"

"No problem," he assured me. "I'll just break their heads."

Gino was particularly agitated after the judge modified the court order. With his patience wearing thin, he was ready to take matters into his own hands.

"Kenny, let me tell ya somethin'," Gino said as he hunched over me in a confidential chat in a bar. "I'm gettin' sick of all this bullshit, ya understand?" I promised him that I did, as I glimpsed the strap of his shoulder holster beneath his jacket.

"So, what can we do about it?" I asked him.

Gino got down close to my ear. "Look, we put two gallons of rubber cement in that fuckin' furnace that heats the boiler downstairs, set the timer, and take a walk. When we come back, the place is a parking lot!"

"I don't know, Gino. Look, I just want to make money out of this whole thing somehow."

"Okay, so listen to this," he said. "I saw 'em filling up a storage room in the basement across from my room, with all kindsa stuff that businesses donate to 'em. They put a padlock on the door. We can bust in there tonight and see what they got."

Equipped with flashlights and tools, Gino and I broke the lock and entered the storage room at two in the morning. At first it looked like a bust. There was nothing but cases of canned food and bags of rice. Gino started ripping open boxes, and he hit pay dirt. "Olive oil! There's a ton of olive oil here! I can move this shit!" he said. Gino had discovered box after box, each containing six gallons

of imported olive oil. Before the night was over, we had boxes of olive oil stacked to the ceilings in the closets of our rooms.

A ferocious hatred grew between me and Mr. Levi, the director of the clinic. Levi was a creepy-looking guy who was in the habit of striking intimidating poses in the lobby just outside my door. He dressed in outdated mod clothing. His favorite ensemble consisted of a ghastly double-breasted suede overcoat that reached his ankles, leather boots, and a hat that resembled the kind worn by the Three Musketeers. His attire, I believe, fulfilled a romantic fantasy in which he cast himself as a courageous cavalier on a noble quest to defend his clinic and vanquish all his enemies.

Levi vowed to make my apartment his abode. I, in turn, told him to "fuck off" on every occasion. He saw me as the embodiment of all his troubles and was convinced that, if he could only get me out of the house, he would be on the road to victory. But this enmity hardly approached the contempt Roy had for Rubel, architect of the whole ridiculous scheme. An incompetent, middle-aged oaf, Rubel had a long nose that hung down in the middle of his fat, florid face in a way that made it look like the rear end of a baboon. He showed up in court wearing a cheap, ill-fitting overcoat and a dopey Russian hat of fake chinchilla that he twisted onto his head. As an added refinement, he carried a plastic attaché case that refused to stay closed.

Rubel was hopeless in the courtroom. Since he'd gotten Igor into this mess, he had no choice but to play it out to the end. He went on the offensive and brought a pathetic lawsuit against me, designed in his fertile imagination to get me evicted. After reviewing the papers, Roy was so appalled at the man's stupidity that he briefed me on a few simple points of law so that I could show up in court and get the case thrown out myself.

It just so happened that the day before I was scheduled to appear in court, Tony showed up, broke as usual. He was desperate to go to Boston with friends from SoHo for an important sculpture show that weekend. Again the subject of his selling a "Dutch" painting came up, but then I had another idea.

Having just sold a painting myself, I was flush, and sitting in the lobby of the Warren Club was an exceptionally fine seventeenth-century Italian credenza. Things had been known to disappear there, and under the present circumstances anything could happen.

Tony was taking a bath in my tub when I put it to him. "You want four hundred bucks?" His eyes grew big. "I'll tell you what. You know the club they have down the street, the Warren Club? Well, there's a small cabinet next to the Coke machine in the lobby that I want. You grab it, and I'll pay four hundred for it."

The next day I went to the court on lower Broadway. It turned out that Rubel hadn't even brought his case against me in the right kind of court! Instead of landlord-tenant court, he'd brought the suit in small claims court. It was a rinky-dink affair where they handled dog bites and broken windows. The judge, who had long since gone crazy there, resembled a mad scientist, with a mess of gray hair and disheveled robes.

Rubel began by accusing me of all sorts of crimes, from destroying property to refusing to pay rent. With each charge Rubel made, the judge snapped his head toward me and glared through his Coke-bottle glasses. For a minute I began to get worried, but when the judge realized that Rubel was asking for an eviction, he blew his top.

"Mr. Rubel, you're in the wrong pew!" he yelled. "Why don't you go back to law school?" and he promptly threw out the case.

Rubel turned purple with rage, slammed down a stack of papers, and began to yell at the judge. The judge threatened to have him arrested if he didn't shut up. As I left the courtroom, I looked back and saw the judge lean over the bench and scream at Rubel, "Now get outta here!"

As soon as I returned to the house, I was confronted by Ann and Raun, who were engaged in serious conversation outside my door.

"Did you hear what happened last night?" Ann excitedly asked as I approached. "Somebody went into the Warren Club and took a valuable piece of furniture. The police were over there and came here too!"

"Well, who took it?" I asked, turning pale.

"Oh, they don't know," she said, "but some guy was seen running out of the lobby and diving into a Checker cab with it. The police asked a lot of questions and filled out a form." Blood returned to my face, and I regained strength.

"Well, I hope they catch 'em," I replied with outrage.

Then they wanted to know what had happened in court. As I opened the door to my rooms so we could talk in private, I looked down, picked up a folded note on the floor of the foyer, and slipped it into my pocket. I pretended to have to use the bathroom and pulled out the note. It read: "Got the piece at my place. Call me later. A."

CHAPTER SEVEN

Urban Survival

B y the time spring came, things had quieted down. I loved
the Upper East Side and Sixty-Eighth Street. I made many
new friends, and the neighborhood held a lot of promise
for me. I even saw Halston walking his dog most every day, and
we began saying hello as we passed. Just knowing Roy was a huge
asset. Despite his high-flying lifestyle, I was struck by how down-
to-earth he was.

Roy invited me to hang out at his town house any time I liked,
giving me carte blanche with the telephones, sundeck, showers, and

even the occasional use of his limo and comedian chauffeur, who could pass for a rabbi, for errands around town. The atmosphere there was exciting, even addictive. Roy was addictive. I never knew who I might meet there or who Roy might introduce me to. And he wasn't shy about putting me to work. He always needed something delivered, something picked up, or something done at the house. Once he had me stationed at his place all weekend just to hand an envelope to a couple of scary-looking guys who showed up in a flashy car. Sometimes he'd stop by with a friend or two to look at my paintings. He'd get my attention by standing out on the sidewalk and throwing quarters at my window. I'd look out, and Roy would be standing there with a large scotch in his hand.

Roy was diabolical, but very funny, and never lost an opportunity, no matter what the circumstances, to use his dry New York humor to crack me up. Once I got a postcard from him when he was in Europe. It pictured a fabulous palace, something like Versailles. On the back, Roy had scribbled, "I found this place over here. Do you think we could interest Encounter in it?" One evening I went to a gallery reception with him and Dave on Fifty-Seventh Street. I found myself with a group of people in evening dress gathered around a painting. Basically it looked like some slime smeared around a canvas, but everyone was trying to look thoughtful and take it seriously. Roy sidled up next to me and whispered in my ear, "What kind of bullshit is this?"

Roy's power was astonishing. On one occasion I found out what just a letter from him could do. When I had moved into the Ferguson Club, I placed my beloved Army Jeep in dead storage in a garage at the west end of Fifty-Seventh Street. Months passed, and when our situation stabilized and things quieted down, I

decided to get it out of storage and park it locally so I could drive it around again. I went over to the garage, entered a dirty little office, and presented my receipt for the car to a tough-looking manager seated behind a desk.

He took a long time looking at the wrinkled-up piece of paper. He shook his head and informed me he couldn't release the car with this. He wanted to see a title (which was at my parents' house in Florida), he wanted a registration, he wanted my driver's license, and on and on. But no matter what I came back with, it still was no good. Finally I got angry and started yelling, but it seemed that's just what he wanted. He ran up to me and yelled in my face, "Now, listen, if you know what's good for you, you'll get the fuck outta here! And I don't want to see you here again!" He shoved me right out to the street.

Walking back home and thinking about the situation, it occurred to me that every time I went back to the garage, I noticed a young punk who looked like the manager's son hovering in the background and taking everything in. I began to suspect that the kid wanted the Jeep and the old man was going to see if he could get rid of me. I had once heard that many of the city's garages are Mafia operations, and they have no trouble getting new papers for a vehicle. The old man sure looked like a wise guy to me.

I thought I would call Gino, but the next day I was at Roy's and mentioned the situation to him. "Go see Scott," Roy said casually. "Bring your receipt along, and tell Scott to make up a letter, and I'll sign it." Scott, a partner in the firm, composed a letter that politely requested the Jeep be released to me, their client, at once. It was signed "Roy Cohn." A few days later, I got a call from Scott. "Ken, you can go and pick up your Jeep anytime."

There was never a dull moment, and there were always people dropping in. Some of my new friends were people I met at Roy's. Others I met in the neighborhood. And sometimes via circumstances that only happen in movies.

Around the Upper East Side, it's not unusual to see cover-girl models on the street, but every so often you see one so stunning that you feel like passing out as she walks by. Just such a girl lived in my immediate neighborhood, and occasionally I'd pass her on Madison Avenue. She had sandy blonde hair with hazel eyes and was of course pencil thin. Every head turned when she passed by.

One afternoon, I was painting in my room with the music playing when I heard a knock at the door. I went over and swung the door open, expecting to see one of my friends. Instead, there in front of me stood *that* girl. Not only was I not dreaming but, even better yet, she was a damsel in distress! She introduced herself as Alexandra King and explained that she and two other girls (all models) shared an apartment just around the corner on Madison Avenue. She had heard of me in connection with the legal case we were embroiled in and wanted my opinion on a document that she had just found posted on her apartment door. Of course I invited her in, and, being an expert on the subject, took a look at the document. Unfortunately, I had to inform her that, *unlike* the eviction notice that was attached to *my* door, this was the real thing, a genuine court order signed at the bottom by a judge.

"What this means," I informed her, "is that your landlord can enter the premises at any time, remove your possessions, and lock you out!"

"You mean we could be thrown out at any time?" she exclaimed in alarm. I told her it was so and offered my help without reservation. She thanked me profusely and fled.

Two hours later, there was another knock at the door. Alexandra was back, this time with one of her roommates. Sure enough, they were being evicted. We ran around the corner to Madison Avenue, where a big truck was double-parked in front of their apartment house. The moving men were already loading furniture into the truck.

"Oh, my God!" Alexandra shrieked. "They're gonna take our clothes!" We all ran into the apartment. The girls frantically grabbed suitcases from a closet and began stuffing them with clothes. "They're taking the bureau!" someone screamed as two men made for the door with a chest of drawers. The girls lunged for the chest and pulled the drawers open even as the goons were carrying it through the hall. What seemed like hundreds of bras, panties, and nightgowns were being thrown toward me as I followed with a laundry basket to catch them. For the next hour, to the astonishment of mink-coated, poodle-walking passersby, we ran down Madison Avenue to my place with lamps, chairs, boxes, and anything else we could grab before it went into the truck.

Exhausted, we sprawled around my apartment and tried to figure out what had happened. The girls had fallen victim to an old New York scam. They had subleased the apartment from someone else. The original tenant to whom they were paying rent had no intention of returning to the apartment, so he simply pocketed the rent instead of paying the landlord. Hence the eviction.

A week later, I helped them move into a new apartment just around the corner on East Sixty-Seventh Street. They were still traumatized by the eviction, and we sat around eating hamburgers, discussing how miserable our lives were, and thinking up novel ways to commit suicide. The upshot was that not only did I now

have Alexandra as a friend, but she brought her model friends over to my place to hang out as well.

One evening, Roy asked me if there was any way I could obtain information on the clinic's funding—in particular, their private sources. I told him I'd see what I could do. The following Saturday night, I returned to the house at around 3:00 a.m. after a night out with Tony. The clinic's offices were on my floor, to the rear. Armed with a flashlight and a pair of gloves, I crept through the dark lobby all the way back to their offices and pulled out my set of master keys.

I opened the door and went straight for the file cabinets. They weren't even locked, and, sure enough, there was a file titled "Donors." It was at least an inch thick. I took the whole thing and replaced the missing documents with papers I pulled from other files. Next, I found some files relating to the clinic's sources of funding. I left with a three-inch stack of papers.

The package was passed on to Roy. This was the sort of thing that excited him, and I got a message back that he was "very pleased," but I never mentioned the subject again, and neither did Roy.

Shortly after that, I asked Roy to autograph a book I'd bought about the Army-McCarthy hearings. This famous case centered around Senator Joe McCarthy and his aide Roy Cohn in the 1950s. They were investigating the infiltration of Communist spies into the army after World War II. Their efforts revealed that a Communist, an army dentist by the name of Irving Peress, kept getting rapid and unjustified promotions until he was positioned in an area where he was able to gather valuable intelligence. Despite their efforts, they never found out who had promoted Peress. It remained the unsolved mystery of the book.

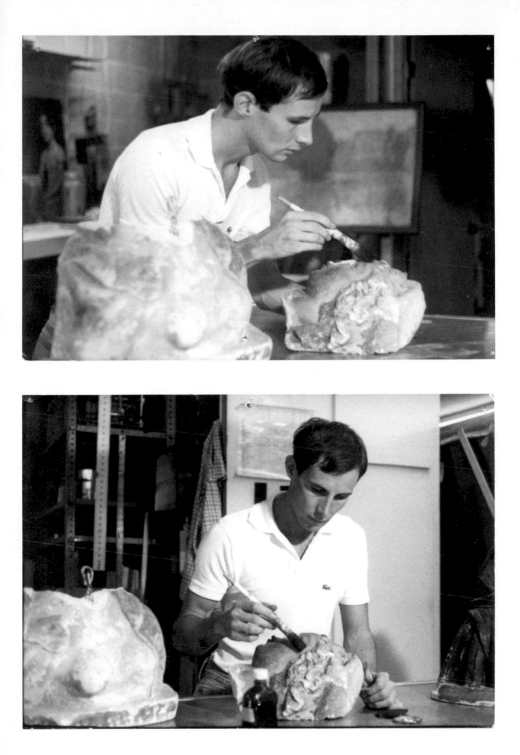

ABOVE and BELOW: *Ken working on sculpture restoration in the Florida studio, 1978.*

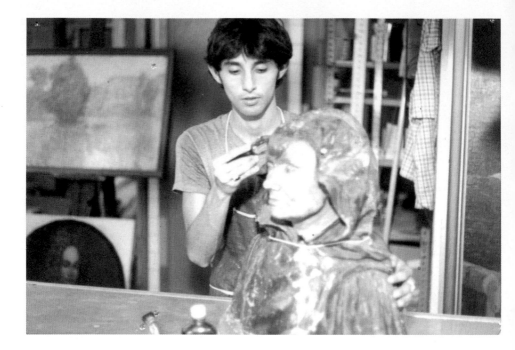

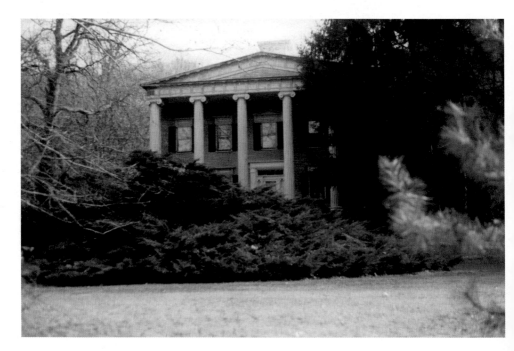

ABOVE: *José at work in the Florida studio, 1978.* BELOW: *James H. Ricau estate, Piermont, NY, 1979.*

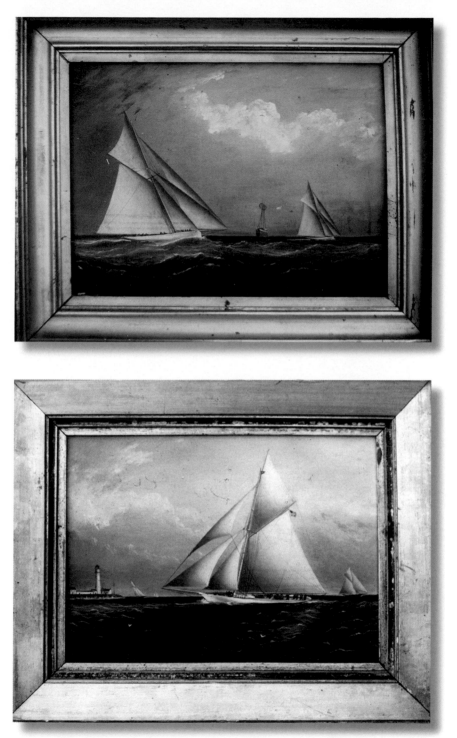

ABOVE: *After James E. Buttersworth, c. 1979.* BELOW: *After James E. Buttersworth, c. 1990.*

ABOVE: *After Martin Johnson Heade, "Gems of Brazil," c. 1980.* BELOW: *"Martin Johnson Heade, "Gems of Brazil," c. 1980.*

ABOVE and BELOW: *After Charles Bird King, c. 1979.*

OPPOSITE ABOVE: *After Martin Johnson Heade, "Gems of Brazil," c. 1990.* OPPOSITE BELOW: *After Martin Johnson Heade, c. 1990.* ABOVE: *After Antonio Jacobson, c. 1980.*

ABOVE: *After Antonio Jacobson, c. 1990.* BELOW: *After Gilbert Stuart, c. 1997.*

Roy inscribed it "To Ken, who I'm sure would have found out who promoted Peress. Best wishes always, Roy."

One night, Gino called me from the restaurant on Fifty-First Street where he "worked," a restaurant that now had a twenty-year supply of olive oil. "Hey, Kenny, c'mon down here. I gotta deal for you." Over drinks, at a corner table in the back, Gino explained that he and his uncle who owned the restaurant had met a businessman who wanted to start an auction house.

"Yeah, we already rented him a building my brother owns across the street," Gino explained, "and this guy is looking for somebody who knows antiques and can help him get the thing off the ground. So I told him I got a cousin who's just the right guy and knows all about antiques. So whaddaya think?"

"Well, yeah, Gino, but do you really think it's gonna work?" I asked.

"Absolutely not. The guy's an idiot. He don't know what the fuck he's doin', but he's got a lotta money and we're helping him out, ya understand?"

"Oh, yeah, well, okay, who is this guy?" I asked.

"His name is Rodger. He'll be here tonight," Gino said. "I'll tell him you're his man." Later that evening, Gino introduced me to Rodger, who arrived in a three-piece suit, spoke with a phony British accent, and had pretensions of coming from an "old" family.

Rodger was under the delusion that he was going to start an auction house that would rival Parke-Bernet, with a warehouse full of antiques consigned from dealers. Ninety percent of it was stuff they couldn't sell. Rodger explained, with his aristocratic airs, that he needed someone to "oversee and direct" the workmen decorating the building, but help organize and catalog antiques as well. Not only did he offer me the position, which paid two

hundred bucks a week in cash, but he asked me if I could find an assistant who would be on the payroll too.

Maurice, another regular who hung out at my place, was a handsome Latino in his twenties. He wore his hair in a ponytail, dressed in black, and loved Elsa Peretti jewelry. He worked part-time for Sabu, an exclusive hairdresser on Sixty-Eighth Street next to Halston. The small salon attracted such VIPs as Jackie Onassis and Liza Minnelli. Maurice knew everyone who worked in the local boutiques and had a clandestine trade in hot pieces of Gucci, Saint Laurent, and Chanel. He lived out of a Louis Vuitton duffel bag wherever he could crash, and was eyeing my place for some temporary shelter.

Even though I was aware that Maurice was a compulsive thief, drug addict, sexual degenerate, and pathological liar, I had to come up with someone fast for Rodger. Despite his shortcomings, Maurice had a few redeeming qualities. He cultivated a chic, sophisticated appearance, spoke with a European accent, and often showed up with Dominique, a beautiful and deceptively innocent-looking Puerto Rican girl of nineteen. She worked in a local boutique, did some modeling, was completely uninhibited, and had eyes that could have been painted by Goya.

"Yes, I have someone who can be my assistant," I informed Rodger the following day. "He's very good and works with me on artistic projects. I know a young lady as well, if you need a receptionist." Delighted, Rodger shook my hand and told me to come by the gallery with my colleagues on Monday.

Meanwhile, over the weekend, Maurice arrived with his Louis Vuitton bag and Dominique in tow. We passed the time and had a few bottles of wine, staging fashion shows with all the latest merchandise Maurice was fencing for his friends.

Monday morning, Maurice and I presented ourselves, appropriately dressed, at the raw space that was to become a premier auction house. It was agreed that Maurice and I would begin at once and that Dominique would start at the opening.

For the next three weeks, we worked ourselves ragged hauling antiques around, organizing a catalog, and helping the workmen get the place in shape. After I became acquainted with the inventory and saw the impossibly high reserves that Rodger allowed dealers to place on the items, it became obvious to me that he didn't know what he was doing and that this whole thing was doomed to failure.

As we approached the opening, work became frantic. Rodger promised us a bonus if we got everything ready on time. By opening night, not only had we not seen our bonuses, but we were still owed pay from the previous week. Nevertheless, Maurice, Dominique, and I were heartened to see the place fill up to overflowing. Unfortunately, Rodger decided that he *himself* was going to be the auctioneer.

The sale began, but lot after lot had to be passed. An hour had gone by, and not more than half a dozen pieces had met their reserves. The crowd was getting restless. Finally, a feisty little woman grabbed a Chinese lamp she'd been waiting for and approached the podium.

"Hey, mista, I can't wait any more. Could you put this up next?" Rodger's downfall came when he accommodated the woman. Soon another person followed her example and tried to have a piece of sculpture sold next. With that, a virtual stampede of people lunged for whatever they wanted. Fights broke out, people were yelling at each other, and soon we had a riot on our hands. Rodger, on the verge of a heart attack, was running

KEN PERENYI

around hysterically, grabbing items out of people's hands and yelling his head off. A mob of people, many of them consignors, had seized their goods and were trying to get out the door for fear that things would get stolen.

"Holy shit!" I said to Dominique and Maurice. "Let's get outta here before we get killed." The last thing we saw as we ran out the door was Rodger being shoved back and forth by a bunch of Armenian dealers fighting over a pile of rugs.

Back at my apartment, we opened a bottle of wine, and I got an idea. "Why don't we go out to a bar, and we can pass the gallery and see if Rodger is still alive."

It was ten o'clock, and we decided to march down Third Avenue to Fifty-First Street. The gallery was dark and locked up. We peered through the window. It looked like a bomb had hit the place. As we pondered the mess, an idea came to us all simultaneously.

"Did you bring the keys?" Maurice asked.

"No, I left them at home." In a minute, we were in a cab racing back to Sixty-Eighth Street. Flinging open the closet, the three of us were dumping out clothes from every bag I had. A minute later, we—and the empty bags—were in the cab, heading back to Fifty-First Street.

"Oh, this is beautiful!" Maurice said.

"Yeah, Rodger is history. We're never gonna see a bonus," I said. Dominique just sat there with a Madonna-like smile. Within five minutes, we were in the gallery grabbing every valuable item we could stuff in our bags. An hour later, we were back in my room dividing everything up on my Chinese carpet. We had a small fortune in bronzes, silver, Tiffany glass, Battersea boxes, ivory carvings, and much more. It was perfect.

Nobody had a clue how much stuff had gone out the door that night.

Two days later, after I had the loot stashed at Alexandra's apartment, I was ordered to the local precinct for questioning by detectives. Tens of thousands of dollars in antiques were missing and Rodger was officially "out of business." Following Tony's example, I assured the cops that I had no idea what had happened to the missing antiques, and the case was closed.

—⚌—

I can only speculate whether that file of private donors was of any use to Roy. However, some time after he received it, he asked me if I'd noticed any change in the running of the clinic. I told Roy that there had been a marked curtailment of their activities and several counselors had been let go. Roy nodded in satisfaction. "They're dying a slow death," he said.

Levi was cracking up from all the pressure. He hated my guts and they tried for a second time to evict me. I heard a rumor that this time, Levi had hired a specialist in evictions to handle the case. Furthermore, Levi himself was going to show up in court as a witness against me, and Rubel was going to be there too.

When I told Roy what was up, he said, "Don't sweat it. Bring me the papers, and I'll handle it myself." I was a little skeptical. Lawyers like Roy wouldn't be caught dead in Landlord and Tenant Court. Nonetheless, on the appointed day we jumped into his limo and headed down the FDR.

When we arrived at the courthouse, we were met by Mike Rosen and Roy's law clerk. They were scheduled for a conference in a judge's chambers, and there was no telling how long it would

go on. "Okay," Roy said, "go and wait in the courtroom. If you get called up, tell the judge that your attorney is presently in room 205 on another case and will be in directly." And off they went.

When I entered the courtroom, a hearing was in progress. I took a seat and looked around. Suddenly, my gaze was met by the cold stares of Levi, Rubel, and a nasty-looking lawyer who, I could tell, meant business. They were sitting together on a bench against a wall not more than twenty feet from me. They whispered something among themselves and then looked at me with smiles.

I was certain that they thought I had come by myself, as I had the first time they'd tried to evict me. I deliberately swallowed hard and looked worried. Levi seemed to be savoring every moment. This went on for nearly an hour, and they were convinced I was alone. As our docket number approached, I began to get nervous, and Levi was beside himself with glee. Then I spotted Mike Rosen looking through the small window in the courtroom door. A few seconds later, it opened, and Roy marched in with his million-dollar suntan and Dunhill suit. Right behind him followed Mike and the law clerk, carrying briefcases. As if that weren't enough, Ann, Raun, and Gino all showed up too.

A buzz went through the courtroom as people whispered, "That's Roy Cohn." The judge called for order but was clearly thrilled that such a celebrity was present in her courtroom. I looked over at my adversaries, this time with a big smile, as Roy sat down on one side of me and Mike on the other. Levi looked as though he was about to throw up, Rubel resembled a corpse, and the eviction specialist looked like he was thinking about packing up and leaving.

Roy got right down to business. The clerk opened a briefcase and took out a stack of papers. I was very impressed. But after Roy

made a big show of handing some of the papers around to me and Mike and I looked at them, I realized they had absolutely nothing to do with my case. It was all a bluff.

Then Roy whispered in my ear: "What should I tell the judge if they bring up the fact that you haven't paid rent in over a year?" I had to think for a moment on that one. Then it hit me.

"Tell her about that phony bond I signed!" This time *I* cracked Roy up.

Our case was called, and the judge was gushing as Roy approached the bench. Levi's Big Gun swaggered up next to Roy, but he never had a chance. Roy just took over the proceedings. He asked the judge for a five-minute delay to talk to the plaintiff's attorney. It was granted, and Roy led the lawyer and Levi out into the hall. A couple of minutes later, the door opened again and Roy led the lawyer, meek as a lamb, back in before the judge. Levi remained out in the hall, and Rubel fled.

"Your Honor," Roy began, "I'd like to read into the record that the plaintiff has agreed to withdraw this case against my client, Mr. Perenyi, and to suspend all other actions designed to evict him, until the matter of who is entitled to occupy the building at 35 East Sixty-Eighth Street is resolved in New York Supreme Court."

When we got out into the hallway, Ann, Raun, and Gino were celebrating with me while a mob surrounded Roy. Some were courtroom buffs, others were attorneys trying to say hello and shake his hand, and some just wanted his autograph. You would think we had just won the biggest case in the world.

Some time after that, I received an urgent call from Roy's secretary. I was wanted in Roy's office immediately. When I arrived, my heart sank. Roy was seated behind his desk. One of his lawyers

who had worked on the Encounter case was standing at his side. They were staring down at the floor. I knew this was trouble.

"Read this," Roy said, tossing a letter across his desk. The blood left my face. I was certain the courts had ruled against us.

It was an impressive-looking document with the New York State seal embossed at the top, but it was a letter issued to the clinic from the commissioner of the Addiction Services Agency, the clinic's source of state funding. In the bluntest terms, it informed them that, due to cutbacks and a lack of efficiency in their program, Encounter Inc. was having its funds terminated. When I looked up, they were laughing.

It was only a matter of time before the clinic would have to pack up and leave. Levi had a complete breakdown and had to be hospitalized. Phoebe died, and, thanks to Roy Cohn, her empire, hopelessly tangled up with lawsuits, the IRS, and state authorities, began to crumble. On top of that, everything was in hock. Igor was flat broke and had to move into a small Yorkville apartment with all the antiques he could grab. Kevin and Allen were last sighted tearing out of New York City on motorcycles, headin south, and Rubel was arrested for "running a male brothel."

Marshall Management no longer existed. The estate's assets were being sold to settle claims, and the clinic finally left, leaving all their records and office equipment behind. State auditors swooped in, took an inventory, and sealed everything up in a room in the back. From then on, we had to run the house ourselves.

I painted pictures as though my life depended upon it. It was still the only thing that put immediate cash in my pocket. I expanded my circle of Dutch painters to include artists such as Adriaen Brouwer and continued to make trips around the city

with my Bonwit shopping bag, but I knew I couldn't go on doing this forever.

As I spent more time at number 39 and got to know Roy better, it became apparent, as Ann had explained, that Roy was a lot more than just another big-shot attorney. The town house was a theater of intrigue, and Roy directed everything. All kinds of people—celebrities, politicians, priests, mobsters, rabbis, and tycoons—were coming and going throughout the day and night.

People came to Roy with all kinds of problems. He was the ultimate power broker, and he knew no bounds, legal or otherwise. He could make happen what no lawyer—no matter how high powered—could make happen. Let's say you were a public figure caught in a compromising situation. Maybe you were a judge, a movie star, or even a cardinal. You didn't need a lawyer. You needed Roy Cohn!

Right from the start, one of Roy's friends gave me some friendly advice: "Around here, don't ask questions, and don't gossip. If anything gets back to Roy, you're finished." Yet the whole place was a hotbed of gossip. In fact, it was one of Roy's favorite pastimes. As the picture was being filled in, I came to see that Roy had an organization. His network included ex-FBI agents capable of accessing information beyond the reach of even the best private eyes, locksmiths ready to perform jobs "no questions asked," cops ready at his service, and several shadowy, well-dressed young men who came and went on a regular basis.

"Roy has judges all the way up to the Supreme Court in his pocket," I was told. How? "He gets them appointed!" And politicians? "They're the easiest. All he has to do is make a phone call." And the Mob? Well, he definitely had a special relationship with them. He was counsel to the Gambinos. "There's simply nothing

Roy couldn't fix or take care of," I was told by a loose-tongued friend of Roy's over drinks one night at Chez Madison.

"Really," I responded, eager to hear more.

"Damn right," he went on to impress. "How about things vanishing?" he continued.

"Like what?" I asked, my ears the size of pizza pies.

"Like criminal charges. Like stories about to appear in the news. Like items straight out of the evidence rooms. Like witnesses' memories, and sometimes even the witness himself. If the situation was big enough, Roy could arrange anything—get the picture?"

Indeed I did, and I wanted to be part of it. "What about those smart-looking young guys always showing up with their attaché cases? I know they're not lawyers."

"Oh, they run businesses for Roy. They're making the weekly delivery." These weren't just *any* businesses, but cash-and-carry gold mines like porno theaters in Jersey and hot dog concessions in Grand Central Station. Businesses otherwise controlled by the Mob but "sanctioned" to Roy.

One evening, Roy called me to come over to his place. In the living room, Roy introduced me to Martin Shambra. He was in his late twenties and owned Marti's, one of the most successful restaurants in New Orleans. Then Roy told me what they had in mind.

"We're thinking about buying the town house and turning it into an exclusive members-only club, and you're gonna be the manager.

"But," he continued, "you're gonna have to give up your room. We'll renovate the top floor for you, and Gino can stay where he is and be in charge of security."

Needless to say, I would have done anything to stay at the town house and was thrilled at the news.

"You can even hang your paintings and we'll sell 'em," Roy suggested. I was positively overwhelmed. This was undoubtedly the most exciting position he'd ever offered to any of his young friends, and I was flattered. A couple of hours later, after we had discussed the details, including that the property would be titled in my name, I left the town house walking on a cloud.

Roy now stopped in frequently. He wanted to know how I was getting along, specifically how I was making money. I showed him my "Dutch" paintings and, without going into detail, I confided, "I sell them on the side."

"I'll tell Marty about these," Roy said, looking over a "van Goyen" hanging on the wall. "He collects art and antiques; I think he might go for this. Just level with him. He's cool." I still had a small surrealistic painting lying around from my Castle days. It caught Roy's eye, and I insisted he take it as a gift. Al, his chauffeur, later told me Roy spent three hundred bucks to have it framed.

I didn't have to wait long before Marty showed up at my place. As a friend of Roy's and the future manager of their planned club, Marty was anxious to ingratiate himself with me. I showed him my "Dutch" paintings and explained to him what I did. He was very impressed and bought two of them for sixteen hundred bucks on the spot. More importantly, he was intrigued with my contemporary collection in progress. He was an artist himself and was preparing to have a show of his work at Emmerich Gallery. Not only did Marty offer to introduce me to an antique dealer who could be interested in my "Dutch" paintings, but he suggested that he might help me with my contemporary work as well.

The following evening, Marty invited me to join him for dinner at the Sign of the Dove on Third Avenue. The purpose of the

dinner was for me to meet Paul Gabel, an antique dealer who had a big operation just north of New York City in Nyack. Paul did a lot of business with city dealers and had a special connection with New Orleans.

Paul arrived at the restaurant, was escorted to our table by the maître d', and introductions were made. Paul was a good-natured man in his forties. He'd been in the business all his life, had extensive connections in the trade, and a particular interest in period paintings. As Marty had predicted, he was anxious to see what I did.

A couple of days later, Paul came by for a visit. He was agog when he saw my room and equally impressed when I showed him a pair of my "Dutch" paintings hanging on the wall.

"If you can keep making paintings like that," Paul said over lunch at a nearby café, "I know where I can place them." I wasn't exactly sure what he went by "place them," but I wasn't asking any questions. I gave him a painting, and a week later he was back with cash. I gave him another, and it looked like I had steady money coming in.

Once again, it was blue skies ahead on the Upper East Side, the neighborhood where I felt I belonged. Even Andy Warhol had a house nearby. We'd pass each other on the street as we had downtown, but now at least we said "Hi" to each other, as I did with Halston. I planned, as I had downtown, to introduce myself and invite him to my studio as soon as my collection was ready. But, for the time being, my attention was on the purchase of the house and Roy's plans.

The asking price for the house was a hundred and twenty thousand dollars. Roy offered eighty-five thousand, and neither side was budging. I started to get an uneasy feeling when the deal

began to drag on far too long. It was the summer of '75, and I got tipped off that a storm was brewing at number 39.

Since the plan to buy the town house had come up, a lot of new faces started showing up at Roy's house. Many were friends of Marty's, and Dave Tacket didn't like it one bit. He was on a campaign to kill the whole deal. By now, I was getting used to being disappointed, but at least this time I was forewarned. So as not to get caught on the short end again, I started making arrangements in case I found myself on the street.

I hadn't seen my parents since they'd retired to Florida, and I thought that not only would it be nice to see how they were doing, but it might be a good idea to set up a fallback plan in case things didn't work out on Sixty-Eighth Street. I had a collection of valuables scattered around the city. This included the credenza that Tony had grabbed from the Warren Club and a duffel bag full of items taken "in payment" from Rodger's defunct auction house. These were residing at Alexandra's apartment. One morning, I gathered them up into the open back of the Jeep, prayed for good weather, and drove from morning to night for three days straight until I landed on the white-sand beaches of Florida.

I had no intention, especially after being victimized by Igor, of leaving Sixty-Eighth Street without the seventeenth-century refectory table in the lobby. So, before leaving Florida, I found a cheap storage unit that not only accommodated the Jeep and the antiques I had carried down, but also had plenty of room to spare in case I found a way to ship the table down too. This way, I reasoned, I'd have something waiting for me if I wound up in Florida myself.

Suntanned, and reenergized from pots of lasagna and veal parmigiana my mother fed me morning, noon, and night, I hopped

on a plane and flew back to the Big Apple. It was August when I returned, and the city was dead. Roy was out of town, and the deal wasn't going anywhere. I knew for sure that this situation of living in the town house couldn't go on forever, and at this point I didn't know what I should do. Then began a series of events that made up my mind for me.

José was another of the new friends I had made on the Upper East Side. He was a few years younger than me and shared an apartment with a hairdresser around the corner on Madison Avenue. José had an endearing nature, and everyone liked him. He worked with a veterinarian and cared for animals. His parents were Costa Rican and lived in Miami.

It turned out that he and his roommate had lost their lease, and he needed a place to go immediately. I knew that José loved art and paintings. In fact, he once brought over a picture he had painted to show me. So I told him that, despite my own tenuous situation, he was welcome to move in with me. Things were so quiet at the town house that no one even noticed he had moved in, and it gave me an idea.

This might be the perfect time—and maybe the last opportunity —to grab the refectory table. In fact, this might be the time to grab everything!

Kay L., a wealthy socialite whom I'd met through Roy, had once told me an amusing story. After hearing her neighbor's screams one afternoon, she'd run down to the woman's floor to find her hysterical in a completely denuded ten-room Fifth Avenue co-op.

Apparently, Roy had secured a judgment in favor of his client, the woman's former husband, against her. In the space of three hours, while the lady was out shopping, Roy had arrived with a

sheriff, three moving vans, and a locksmith—and totally cleaned the place out!

Why not apply a similar strategy? I reasoned. Igor and Rubel were gone. The whole estate was in disarray, and nobody had ever come around to inventory anything. With the help of José, I could move all the antique furniture in the house into my room and call a moving company to come and take it away, instead of boosting everything in the middle of the night like some kind of thief.

Traffic was blocked for twenty minutes as José and I helped the men carry a dozen pieces of antique furniture into the North American Van Lines truck. From there, it went straight to Florida and into storage.

The next order of business was the clinic's assets, which state auditors had locked in a room at the rear where they had posted a notice, bearing the official seal of New York State, that the contents of the room were state property. One blow from a sledgehammer smashed the lock right out of the door. Everything from adding machines to typewriters was thrown into the back of a rented truck one night and sold for fifteen hundred bucks to a dealer of used office equipment on Fourteenth Street.

CHAPTER EIGHT

The American School

At the end of August, Roy was still away on vacation and there was still no decision on the purchase of the town house. With the extra money we'd raised from the sale of Encounter's assets and plenty of time on our hands, I thought it wise to get away from Sixty-Eighth Street for a while and let things work themselves out.

With that, José and I packed our bags and booked a flight to Tampa. We rented a second-floor apartment in an old cottage on Madeira Beach, not far from my parents' house. We went

swimming in the Gulf, caught fish, and cooked it ourselves. I even brought along a few panels, in case I felt like painting.

Then one night, after coming back from a movie, I bounded up the staircase on the side of the house. Near the top, I slipped and came tumbling back down the flight of steps. When I regained my senses, I realized that my leg was badly broken.

The next day, when I woke up in the hospital, it was bad enough when the doctor told me that my leg was broken in three places and the bones would have to be screwed back together, but then I almost had a heart attack when he informed me that I'd be in a plaster cast up to my thigh for the next five months and that it would be a year before I could walk without crutches. For the next week I lay in the hospital bed, worried about how I would survive this. I told José that he could go back to New York if he wanted. Instead, he refused to leave me laid up in the hospital and went out and got a job as a gardener. Soon I was back in the cottage, propped up in bed, and trying to get used to the idea of a long, slow recovery. Months passed; my mother brought over home cooking, and José went to work every day to pay the bills.

Eventually, the Ferguson Club was sold. A developer bought it for a hundred and ten thousand dollars and planned to divide it into co-op apartments. It was some time later that I got in touch with Maurice, who was back at work at Sabu. According to him, one by one, everybody finally left the house, as it became unmanageable. Then one day, from the salon, he saw a truck pull up. "Several well-dressed people went into the house," he said, "and removed all your artworks, loaded them into the truck, and left." Everything left behind at Sixty-Eighth Street was lost. All that counted now was to survive the months ahead.

The Jeep was a lifesaver. We got it out of storage and had transportation. When I felt well enough, José drove me to an art-supply store so I could buy some paint and brushes. Fortunately, I had brought four period panels with me from New York. José helped me set up a table and a chair from which I could paint.

After I had completed my new "collection," I thought it was time to get in touch with Paul Gabel. I told him what had happened and that I was stranded in Florida. It turned out that Paul was preparing to load up a truck with antiques and do the winter Miami Beach Antiques Show. He suggested that he could stop by on his way down and see how I was doing.

A couple of weeks later, Paul showed up at the cottage. He volunteered to take some of the antiques I had in storage and a pair of the "Dutch" paintings I had finished to the show and raise some badly needed cash for me. I didn't have to wait long before Paul called with good news. The show had been a success. He had sold the antiques and the paintings as well.

Finally the cast was removed, but it would take the next year to get my muscles built up again and to be able to walk normally. During that time, José continued to work and I stayed home painting pictures. Local antique shops supplied the necessary furniture that I could break down for panels. I sent completed works in the styles of van Goyen, van Ruysdael, and others directly to Paul in Nyack. He in turn sent money as soon as a picture sold. Eventually, José and I moved into a larger house that we rented on the beach.

Paul insisted that as soon as I was able to walk again, I must come up to Nyack and meet some of his friends. Nyack is a charming old town overlooking the Hudson River, just a half-hour drive north from the George Washington Bridge. It's one of a number of towns

along the Hudson that date back to the Revolutionary War. I was already familiar with it from my days at the Castle, when several of us used to drive up there to explore the old town.

In the summer of 1977, I packed a bag and got a night flight to New York, and Paul met me at LaGuardia.

The next day, I woke up in Paul's luxury high-rise apartment on the Hudson River. I went out on the terrace and took in the panoramic views and the fresh air. After breakfast, Paul wanted to show me around Nyack. We visited a number of antique shops whose dealers rented space in properties Paul owned. Paul was aware of my experience working for Sonny and suggested that if I opened an art-restoration studio in Florida, he could ship work down and keep me busy with jobs from his tenants alone. Then we headed to Paul's shop, where he wanted me to meet his partner, Sandy, who had seen my work and was in on the secret.

Paul had bought a nineteenth-century Masonic temple that he converted into the biggest antique shop in town. He kept it loaded to the rafters with furniture, paintings, china, architectural fragments, and bric-a-brac—some junk and some valuable. Every weekend, his shop was crowded with well-heeled day-trippers from the city.

When Paul introduced me to Sandy, I was not impressed. At thirty-two, he stood five feet, five inches tall and weighed around a hundred and eighty pounds. He wore cowboy boots and blue jeans that prominently displayed a huge silver buckle on a belt that stretched across his belly. His big head of bushy hair and oversized mustache gave him all the charm of a cartoon cowboy.

Sandy was a local Nyack boy. His father, a prominent accountant, had raised Sandy with a silver spoon in his mouth. Problem

was, he was never encouraged to make anything of himself, and his parents had recently passed away. Sandy's inheritance was about a hundred and fifty thousand dollars and part ownership in a swank Rockland County country club.

When Sandy got his hands on the money, he bought a Winnebago, managed to acquire a girlfriend, and spent a few months touring the Northwest. When he finally returned to Nyack, the girl fled and Sandy decided he would become an antiques dealer.

He lived with two humongous sheepdogs named Kook-a-poo and Pook-a-noia. They inhabited a big old Victorian house that he rented in town. He was obsessed with treating his dogs as though they were human: gourmet meals from local restaurants, weekly visits to the groomers, hundred-dollar pedicures, a professional trainer, and even a psychoanalyst. It was to no avail. They shit and pissed all over the house and ripped every piece of furniture to shreds the second he left them alone.

Paul agreed to take him in and teach him the business—but Sandy's idea of being an antiques dealer, according to Paul, was "going to Paris on buying trips, checking into the George V hotel, knocking back bottles of Château Lafite, and coming home with an asparagus dish!" After two years of "this bullshit," as Paul described it, and innumerable trips to the local bank that allowed him to borrow against his share of the country-club property, all Sandy had to show from his inheritance were a few antiques scattered around Paul's shop, his shiny cowboy belt buckle, and a secondhand BMW that broke down on a weekly basis.

When I met Sandy, he looked like a person on the verge of a breakdown. The last of his money was rapidly disappearing in T-bone steaks for his dogs, repairs on the BMW, and (like his dogs)

weekly visits to an analyst. In fact, some weeks he went twice, so great were the issues he was grappling with.

For some time now, Paul had urged me to expand my horizons and begin to study American paintings. "If you could start painting me some portraits of American Indians," Paul said, "we could sell them like crazy. Besides, you can't go on just painting the same stuff. You've got to diversify, and American paintings are red-hot."

"Oh, that American stuff," I said. "It's so boring. I used to see it all the time down at Sonny's, and it didn't interest me."

"Well, we're going to see my friend Jimmy tomorrow, and you'll see how boring it is," Paul said.

"So who is this guy?" I asked.

"He's a collector of American paintings and sculpture, one of the biggest. I showed him some of your work, and he was very impressed. He uses Sonny, and he thinks he remembers you working there."

The following afternoon, we drove down to the picturesque village of Piermont. Nestled in a hollow along the banks of a creek that empties into the Hudson was a collection of beautiful eighteenth- and nineteenth-century homes. Perched on a knoll overlooking the creek stood a neoclassical mansion that resembled the Parthenon. This was Jimmy's "house."

We parked in back of the mansion, walked around to the front, and knocked on the big antique door. After some moments, we heard the sound of bolts being thrown open. We were greeted by a tall, aristocratic-looking man dressed in a dark suit and tie. His bald head and prominent nose reminded me of Charles de Gaulle's. He looked straight at me with piercing hazel eyes and welcomed us in.

I was speechless the moment I stepped into the entrance hall, where magnificent paintings in antique gold frames contrasted beautifully with the lavender walls. Impressive pieces of antique sculpture stood next to the entrances of the various rooms.

With a wave of his hand, Jimmy graciously led us through to a drawing room containing more beautiful paintings. All the furniture was Empire, Jimmy's favorite, circa 1820, the approximate time the house had been built. Jimmy motioned us toward an Empire sofa as he settled into an armchair. I knew at once that I was in the presence of an extremely intelligent, unique individual who could be very eloquent one moment and then gruff, even arrogant, the next.

"I remember seeing you down at Sonny's," he said. "He had one of my Benjamin Wests at the time." I couldn't recall seeing him and so quickly turned the subject to the history of the house and his amazing collection of paintings.

As Jimmy rambled on and I glanced around, I realized that there wasn't a single thing in sight, not even a lamp, that reminded me that we were in the twentieth century. Like Mr. Jory's shop, the atmosphere in Jimmy's home was enchanting. The house was enveloped in a wonderful silence, broken only by the occasional call of the crows outside. A woody scent common to ancient buildings permeated the air.

Everything was a little faded, a little dusty, and, like Jimmy himself, a bit frayed at the edges. From the paths worn along the old pine floors to the splits in the silk upholstery, everything convinced me that nothing here was contrived. Even Jimmy was like a ghost from another century. Or perhaps, I mused, maybe I'm wrong, maybe this is all staged, an act put

on for my benefit? Whatever the case, I had never come across anything quite like this before, and I fell utterly and completely under Jimmy Ricau's spell.

Our visit came to an end as the sun began to set and the soft light in the drawing room grew dim. Casually, before Paul and I got up to leave, Jimmy mentioned that he'd seen a few of my paintings and thought they were very well done. As he walked us to the door, he suggested that I come back the next day, preferably in the morning, and we could spend the day "looking at pictures."

That evening, Paul invited a few friends over for a dinner party, and Jimmy Ricau was the main topic of conversation. James Henri Ricau had been born in 1916 to an old New Orleans family. He had been sent to the best schools, received a classical education, and eventually entered the U.S. Naval Academy in Annapolis.

Jimmy cultivated an enduring love of Greek sculpture, neo-classical painting, and literature. In World War II, he served as a navy bomber pilot and narrowly escaped from a burning plane just seconds before it exploded during a crash landing. After the war, he came to New York City, where he settled into an apartment on East Eighty-Sixth Street. At one point, he worked on a tugboat by day and then got dressed to hobnob with high society at night, even palling around with the Guggenheim sisters. His society connections eventually led him to *Life* magazine and a career as a film editor.

Jimmy was regarded as a pioneer in the collecting of American art, an interest he had developed as a young man growing up in New Orleans. He collected paintings by artists no one had ever heard of and works by sculptors that were literally being thrown out in the garbage.

In the 1950s, when people wanted boomerang tables and swag lamps, Jimmy didn't have to look much farther than local junk shops around New York City to find some of his best pieces. When he had time off from work, he'd travel down to cities like Savannah and his hometown of New Orleans in search of treasures.

Jimmy also enjoyed a reputation as a certified eccentric, and many stories of his mysterious life were part of local lore. Even the purchase of his house in 1958 had a dark and sinister tale behind it. As the story goes, while hunting for paintings in the old towns north of the city one weekend, he discovered his lifelong obsession, one of the finest neoclassical mansions in the Hudson Valley. It could be his, in all its original unrestored glory, for a mere twenty-five thousand dollars.

After the purchase, Jimmy had a housewarming of sorts, so the story went, and invited the owners of a famous gallery, a gay couple who ran their prestigious establishment from a landmark neoclassical town house on upper Madison Avenue. They arrived for an overnight dinner party with a Russian teenager they had been keeping as a houseboy, who was, according to Jimmy, "the most remarkably beautiful boy you could imagine—and he didn't speak a word of English."

At some point during the course of the evening, the company noticed that the boy hadn't been seen for quite some time. Alarmed, Jimmy went about the house looking for him. To his everlasting horror, he found him—dead, slumped over a toilet seat. On the floor were a syringe and the paraphernalia to cook heroin. Jimmy was hysterical, and there was nothing for his guests to do but spirit the body away, presumably to be deposited in some back alley of the Lower East Side.

Whether or not this incident had anything to do with it, one thing was for sure: as the years passed, Jimmy invited people out to his house less and less, as he became stranger and stranger. These days, Jimmy rarely went out to hunt through antique shops. Nevertheless, he still maintained contacts in New Orleans with dealers he'd known for decades who still found items that held special interest to him. Paul acted as Jimmy's representative and often went there on business for him. Through those contacts, Paul had met Marty.

The morning after I met Jimmy, I awoke to a beautiful day and decided to walk the roughly three miles from Nyack to Piermont. A sidewalk made of worn slabs of slate and lined with oak trees led right along the Hudson River, through the town of Grand View, and then into Piermont. Jimmy welcomed me at the door, wearing one of his old suits and a tie that he wore every day, whether he was shoveling snow or planting petunias. He invited me once again to sit in the drawing room and offered me an armchair as he flopped down onto the antique sofa.

I discovered Jimmy to be a master at the art of conversation. He could draw on his extensive knowledge of history. He could easily quote Plato and Socrates as well as Benjamin Franklin and Samuel Adams. He could entertain guests for hours with stories of how he'd made some of his greatest finds as a collector.

But Jimmy preferred to keep the focus away from himself. He was a sly old man, and he slouched down in the sofa with his fingertips pressed together as he drew me out in a discussion about art. Evidently, he had been briefed by Paul and wanted to know the details of my life as an artist in New York City. He was particularly interested in why I painted only "Dutch" pictures and what I planned to do in the future.

I satisfied his curiosity with a brief history of my unfortunate experience at Union Square and told him how the "Dutch" paintings had kept me alive at the Ferguson Club, and how my future there had ended in disappointment. I explained to him that this series of misfortunes had derailed my plans to become an artist, and at this point I didn't seem to have much choice but to continue painting fakes. Often, during the course of my sad narrative, Jimmy would close his eyes as a thin smile would appear across his lips, and he'd slowly nod his head in understanding. After he was convinced that he'd extracted every secret, every scheme, every devious plan and ulterior motive of my young life, he slowly began to reveal the reason he had invited me there.

One might assume that Jimmy, a respected collector of American paintings, would naturally be offended by anyone counterfeiting them, but, to my surprise, this wasn't the case at all. On the contrary, his purpose in having me there was to encourage me in precisely that direction. Not only was I surprised to discover the proverbial streak of larceny in the old man, but I was amazed that he delighted in hearing stories of art dealers getting screwed.

"Well, why the hell don't you start painting American pictures, if you really want to make some money?" he asked.

"Yeah, Paul wants me to paint him some Indians" was all I could say, somewhat taken aback.

"What the hell does that mean?" was his reply. "Haven't you ever heard of Catlin, Charles Bird King, or Inman?" I had to confess my ignorance and admit that I knew practically nothing about American painting except for a few names I had picked up at Sonny's.

My introduction to the history of nineteenth-century American painting began that very day. I knew that Jimmy liked me right away, and I was flattered by his interest in my paintings. Now it seemed that the old recluse had someone who could genuinely appreciate and use—in the most practical way—knowledge that he had accumulated over a lifetime and was willing to share.

Without further delay, Jimmy led the way up a flight of stairs to the second floor, where he used the old bedrooms to store piles of paintings and a collection of Empire furniture. Desks, tables, consoles, sleigh beds, and bureaus were crammed into the rooms. We spent the rest of the morning squeezing around and climbing over furniture to get to stacks of paintings leaning against walls. Jimmy pulled out every picture he thought I needed to see and handed them over to me, and I put them out in the hallway.

We lugged the paintings down to the drawing room, and the rest of the day Jimmy lectured for me on the various schools of American painting. We covered still-life painting, one of his favorite categories, and then moved on to marine painting, portraiture, and historical painting.

Before the day was over, I was familiar with such names as John F. Peto, Raphaelle Peale, John F. Francis, and Levi Wells Prentice in the still-life school; James E. Buttersworth, Antonio Jacobsen, and James Bard of the marine genre; and Charles Bird King, George Catlin, and Henry Inman, all of whom specialized in American Indian portraiture.

After familiarizing me with these artists, Jimmy lectured on the history of painting in nineteenth-century America. He explained that most of these artists had had their studios in the Northeast: Boston, New York, Philadelphia, and Washington. Some, like George Catlin, traveled west to paint the Indians

from life in their natural surroundings, while others, like Charles Bird King, resided in Washington, DC, and preferred to paint Indian representatives when they came to the capital to receive peace medals or sign treaties. Another interesting painter of the nineteenth century who Jimmy made a point of bringing to my attention was Martin Johnson Heade. Heade specialized in painting haystacks in the New Jersey meadows. Eventually he traveled all the way to Brazil, where he painted orchids and hummingbirds.

Next we dealt with the technical aspects. We turned the pictures around and carefully examined the weave of the canvas and the types of stretchers used, some still bearing the labels of their nineteenth-century manufacturers.

Then Jimmy pointed out something that I found exceptionally interesting. One of the still-life paintings we were studying was painted on a curious piece of cardboard. Jimmy explained that many nineteenth-century paintings were executed on a patented cardboard panel known as *academy board*. He said it was a product of the Industrial Revolution and had become an economic replacement for the wood panel.

"Do you have any more pictures on these boards?" I asked.

"Yeah, up in the attic. Let's go," he said, and I followed Jimmy out of the drawing room through a hall and into the kitchen. Disguised in a panel of wainscoting was a small door that Jimmy swung open, revealing a steep wooden staircase that led up to the attic. The attic, I discovered, was Jim's secret place—a place, I later heard, to which no one had ever been invited. Jimmy pulled a string connected to a single lightbulb. Through the dim light I noticed piles of books surrounding an old desk where Jimmy did his research.

"Here," Jimmy pointed. "Come over here." I followed him to some old file cabinets. They were filled with small beautiful paintings. He pulled out a few pictures on academy board. One was the finest little picture of a sailing yacht I'd ever seen. The ripples on the water looked so real and fluid, the sails of the yacht so light and translucent as they caught the wind, that I expected to see the boat sail right off the thin board it was painted on.

"That's James E. Buttersworth," Jimmy said. "He's a guy you should be able to do." I agreed. The other pictures were still lifes, one by John F. Peto and another by John F. Francis. When I turned them around and studied the backs, I realized that I had indeed seen panels like these before, at Sonny's and lying around antique shops. The back of the panel was coated with a dark gray paint called "slate paint" because, not surprisingly, when it dries it resembles slate. Each panel displayed an old manufacturer's label. The Buttersworth had a Winsor & Newton label on it, the Peto had one by Devoe, and yet another had one by Weber.

"You can find them all over the place," Jimmy said. "All the artists used them in the nineteenth century."

The next day, I was back at Jimmy's again with a notebook and Paul's 35-millimeter camera, fitted with a close-up lens. I took a number of paintings outside on the columned porch. I photographed the front, the back, close-ups of signatures, and other details of each painting done on academy board. I recorded the measurements and made notes on brushstroking, thickness of impasto, patina, and something I found most interesting: long (and straight) cracks peculiar to the academy board. These cracks were slightly elevated and often ran diagonally across the board. As soon as I saw these cracks, I remembered the cracks I had inadvertently

produced on cardboard when I was first experimenting with old man Jory's formula for gesso.

Jimmy lost no time in putting me to work around the house. There was always another painting to hang or a piece of sculpture to move. Although he owned many beautiful paintings, Jimmy's real pride and joy was his collection of nineteenth-century American sculpture, a collection accumulated over forty years and regarded as the single most important one in the country.

Jimmy had me follow him down to the basement of the house. "I want you to help me get a marble up from downstairs and put it on a pedestal in the hall," he said. Jimmy went down first and pulled at a string, illuminating the second lightbulb I'd seen in the house. Through the yellowish glow of its twenty-five watts, I was astonished to see row after row of priceless marble busts resting like tombstones on the dirt floor.

The last topic we dealt with during my indoctrination period was the aesthetics of framing American pictures. Jimmy was delighted with my love of period frames, and he was impressed with my stories of Mr. Jory (who had since passed away) and all I had learned from him. However, instead of the ornately carved European frames that Jory specialized in, I now had to develop an appreciation for the simple cove or wedge frames that had been favored in early America. Back up in the attic, Jimmy pulled out frame after frame that he placed around paintings he'd spread out along the floor, demonstrating to me the type of frames required for still lifes, marines, and portraits.

For me, meeting Jimmy was an epiphany. Jimmy had made a school of art that I'd once thought boring fascinating, even exciting. Now I had an appreciation of its beauty and importance.

After a week of studying pictures, listening to Jim's lectures, moving marble busts around, and hanging paintings, I was anxious to return to Florida and get back to work.

Before I left, Jimmy loaded me down with books on Buttersworth, Charles Bird King, Martin Johnson Heade, and William Aiken Walker, plus a book on American still-life paintings authored by William Gerdts, an old friend of Jimmy's and the country's leading expert on the subject.

Paul was delighted by the way things had gone between Jimmy and me. When I told him that I needed to find some old academy boards with worthless paintings on them, he went around town and scavenged some up from his tenants. That left only one last errand to run before heading home: I went downtown to David Davis art supply and picked up some rabbit-skin glue and a few pounds of gilders' whiting.

"Please, bring me back some Indians," Paul pleaded as he dropped me off at the airport.

When I got back home, I excitedly told José all about my visit with Paul, the introduction to Jimmy Ricau, and my plans to expand into the American school of painting.

By the next day, I was sanding off the original paintings from the academy boards. I cut the boards down to the size James E. Buttersworth commonly used: approximately eight by twelve inches. Then I mixed up the E. V. Jory recipe for gesso. After tinting it with some raw sienna watercolor, I took a wide, flat, brush and painted the creamy substance onto each board.

After it had thoroughly dried, I noticed that the gesso was hard, like the surface of an eggshell. In the nineteenth century, when these panels were originally manufactured, the gesso was applied by a patented method that produced a surface as smooth

as glass. This meant that when the preparation of the boards was complete, the surface had to be perfectly smooth. Any surface irregularity could arouse suspicion to the trained eye, indicating the existence of another painting underneath or a reworked panel. So I laid each board down on a table as I carefully sanded out the brushstrokes left by the application of the gesso. After holding each panel at an angle to my eye to satisfy myself that they were perfectly smooth, I sealed each panel with a coating of shellac.

James E. Buttersworth, the first American artist I wanted to imitate, was born in England. He, like his father Thomas, was an accomplished marine artist. Their work is noted for the exceptionally fine detail displayed in the ships they painted and the coastal scenery in the background. James immigrated to America around 1847 and settled in West Hoboken, New Jersey, near where I was born. There he specialized in painting the ships and yachts that plied the Hudson River. Ultimately, he became the official painter of the New York Yacht Club and was commissioned to paint the yachts competing in the America's Cup races.

As I studied the work of Buttersworth, a very clear pattern emerged. When Buttersworth was painting for the New York Yacht Club, he executed individual images of famous racing yachts and scenes from Cup races featuring two or more yachts in competition. The pictures of Buttersworth's paintings in the book Jimmy had given me quickly made it obvious that Buttersworth had used several well-known settings over and over again. These included the East River at the Brooklyn Navy Yard; Sandy Hook, New Jersey; Boston Harbor, Massachusetts; and his favorite of all—the area of the Hudson River off Lower Manhattan. This venue showed Castle Gardens, an ornate Victorian pavilion in

Battery Park, to the left, and Governors Island to the right, where a fort dating back to the Revolutionary War remains today.

Further study revealed that many of the yachts depicted were Cup winners and appeared repeatedly in these various settings. In other words, Buttersworth was constantly making new paintings by juggling around a collection of standard boats and settings. Finally, I noted that he made numerous copies of these compositions, no doubt to satisfy the demands of yacht-club members. It occurred to me that if I could begin to think like Buttersworth, then I would have enough yachts and backgrounds to invent new compositions ad infinitum.

I began by cutting out and arranging in a group every Buttersworth print with the same background, regardless of the yacht portrayed. Then I did the same with a particular yacht, regardless of the background. Drawing on the book Jimmy had given me and a couple of other books I had found on my own, I soon had several groups of yachts and backgrounds to study for common denominators. For example, I saw at once that virtually any yacht that Buttersworth painted in the America's Cup races could be placed in the Castle Gardens setting and be perfectly correct. Thus, superimposing a yacht from one painting onto the background of another painting, just as Buttersworth did himself, proved to be a simple way to create new and historically correct "Buttersworths."

I was amazed to find similar compositional characteristics in the other artists Jimmy recommended to me. John F. Peto, a Philadelphia artist of the late nineteenth century, specialized in quiet still lifes. His favorite props—a pipe, an inkwell, tobacco tins, and books—were arranged and rearranged in endless "new" compositions. It would be child's play to isolate

these props, juggle them around, and create a new "Peto" over and over again.

William Aiken Walker was an itinerant artist who traveled around the South in the nineteenth century producing countless paintings of former slaves going about their business in the fields and the shacks they lived in. These small pictures, painted on academy boards measuring six by twelve inches, arc highly prized by collectors, and, as Jimmy explained, "You never know where another one could turn up, and many of them still have the original price of two dollars written on the back in pencil by Walker himself." I made a quick study of these pictures, and once again it became obvious that figures, shacks, and even animals were repeated in painting after painting.

Martin Johnson Heade, the American artist who specialized in delightful pictures of hummingbirds and orchids, exhibited the most obvious pattern of all. He copied the same birds and the same orchids over and over again in varying compositions.

Another important American artist who Jimmy gave me a book on was Charles Bird King. He specialized in portraits of American Indians proudly wearing their silver peace medals. The medals had been presented to them in Washington, DC, by the US government in the 1830s to commemorate the signing of a peace treaty before double-crossing them.

King's clientele was fascinated by Indians. To meet his growing demand, if he couldn't find a live one, he'd simply copy one of his portraits that had been published in the McKinney and Hall book of engravings. There's no record of how many replicas King made.

I could easily scc the similarities in technique between the work of these American artists and the seventeenth-century Dutch

paintings that I had mastered so well, and it didn't take long to realize that identifying patterns in the work of these artists would be the key to making convincing fakes.

At last I had six small academy-board panels ready. I planned to paint three Buttersworths and three Petos. For Charles Bird King, who favored wood panels measuring approximately eleven by fourteen inches, I relied on the system I had used for the "Dutch" paintings and used the bottoms of drawers removed from pieces of antique furniture.

Next, it was time to organize my research material and design some new Buttersworths and Petos. In the case of Buttersworth, I superimposed an America's Cup yacht from a race scene off Sandy Hook onto the Castle Gardens setting. Other yachts were borrowed from Boston Harbor and placed off Sandy Hook. The same method was applied to J. F. Peto: a book that appeared in one painting was placed next to a pipe and inkwell from another. And as for Charles Bird King, there wasn't much more to do than paint a variation of Ma-Ka-Tai-Me-She-Kiah's portrait and add the twenty-sixth to the twenty-five known portraits of Petalesharo.

A month later, I had completed the first prototypes of American pictures. After a thorough drying in the Florida sun, they were ready for the next step: the cracking.

Now the time had finally arrived when the experiments I'd performed with Jory's gesso on cardboard would be put to the test.

After I placed the "Buttersworths" in the hot sun for a few minutes, I could feel the academy boards stiffen, as the rabbit-skin glue's tensile strength increased. I picked up a board, held it at each end, and gently stressed it by pulling the ends down

and forcing the center up. As I did so, I heard a fine crackling sound and could feel it through my fingers. The gesso was cracking, but the cracks were so fine that they were impossible to see. Only after a wash of black watercolor and soap was wiped across the surface of the painting did they become visible. And, to my amazement, they came out as long, straight cracks running diagonally across the board—just as they had on the originals.

Then, as an added bonus, as I examined each panel and held it at an angle to my eye, I was delighted to find that the crack lines actually "stood up." This was caused by the gesso swelling from the absorption of the watercolor. The result was perfect.

In the case of the Charles Bird Kings, however, many of the originals, like the Dutch paintings on wood panels, did not have cracks. All that remained to be done was the application of a patina that I made by tinting some varnish with a yellowish dye. A final dusting with rotten stone, and the job was done.

A week later, and after each painting had been fitted up in an antique American frame, I was on a flight to New York with my precious cargo. Paul met me at LaGuardia, and on the way up to Nyack he asked me what I'd brought along.

"I've got eight pieces—three Buttersworths, three Petos, and two Charles Bird Kings."

We went straight to Jimmy's, and once again the three of us were sitting together in the drawing room.

"Well, let's see what you've brought up for old Ricau!" Jimmy said from his easy chair. With that, I opened my suitcase and began laying paintings out. "Wait, hold on," Jimmy said as he dragged his chair toward a wall. "Line them up against the wall here so I can study them."

As I leaned the collection of paintings against the baseboard, Jimmy lounged back in his chair and gazed up at the ceiling until I was done. Then he looked down and passed judgment.

"I'll be damned," he muttered. "They look good." He leaned forward, picked up each picture to study it closely, and chuckled to himself.

"Look carefully at the cracks," I said as I handed him a "Buttersworth" and a magnifying glass.

When Jimmy was through, he turned to me, lifted one eyebrow, and asked: "Mr. Buttersworth, I presume?"

That night, over dinner at Paul's, I made plans for what I had really come to New York for: money.

"Leave the Kings with me tomorrow," Paul said as he poured the wine.

"Sure," I replied. "I'm gonna take a Buttersworth to a gallery in my old neighborhood where Jimmy said they would 'appreciate' it."

Soon we were joined by Sandy, who just that afternoon had had a heavy session with his analyst: and at last there was some good news. Sandy, according to the shrink, was in reality "a beautiful person only temporarily trapped in an ugly body." Reinforced with the self-confidence that this latest diagnosis gave him and desperate to get in on the action, he lunged for the "Buttersworth" and "Peto" propped up on the sofa. He begged me to let him sell them in Boston. Even though I had misgivings about him, I didn't want to be responsible for deflating his ego at this critical stage of his therapy, so I reluctantly agreed.

The next morning, the "Buttersworth" and I took the bus into the city. An hour later, I was standing before the impressive façade of Hirschl & Adler Galleries on East Seventieth Street. I

took a deep breath and walked in. I explained to the receptionist on the ground floor that I had a painting by James Buttersworth that I wanted to sell. She escorted me to an office on an upper floor and offered me a seat in a small reception room.

"I'll inform the director that you have a painting you want to sell," she said, tactfully ignoring a man's voice yelling furiously at someone behind the door in the office. From the sentence or two I heard, the man's displeasure had something to do with an associate who had failed to close on a deal. The diatribe ended the instant the receptionist knocked on the door, opened it a crack, and slipped in. After a few seconds, the door swung open, and for a split second I glimpsed a woman, completely broken down in tears, seated in a chair. A nattily dressed little man strode out with a big smile and shook my hand.

"How do you do," he said. "I'm Stuart Feld. I understand you have a painting?"

I slipped the painting out of a shopping bag (Bergdorf's) that I'd gotten from Paul.

"A fine little Buttersworth," he said, grabbing the painting. "How much do you want?"

"Well, I was thinking about two thousand dollars."

"How about twenty-five hundred?" Obviously he was thrilled with the painting, and I was equally thrilled with his generosity.

"Sure," I said. With that, he shook my hand and instructed a secretary to "write out a check to this gentleman" before disappearing behind the office door with the painting and resuming his harangue at the hapless woman.

Five minutes later, I was back out on Madison Avenue with a check for twenty-five hundred bucks and a receipt that I signed

using my old address of 35 East Sixty-Eighth Street. Planning for a sale, I had brought along several savings-account passbooks that I used when I lived in the city. In fact, I had one for just about every major bank in Manhattan, always opening a new account when I moved to a new neighborhood. Fortunately, not knowing when or if I might need one again, I never closed them out, but left them open with small balances. As an added benefit, they had all been opened while I was living at addresses long since vacated, so flipping through the collection and turning out the one for Manufacturers Hanover Trust, I only had to walk two blocks to the branch at Seventy-Second and Madison, where I presented the passbook and deposited the check, with nothing more than a signature on the back. Before the day was over, I returned and withdrew most of it in cash.

"That," I told Jimmy when I got back to Piermont that afternoon, "was the fastest twenty-five hundred bucks I ever made." When I told Jimmy who the director was, he howled with laughter. Jimmy had a particular distaste for Stuart Feld, who he described as an "obnoxious, conniving little creep." Jimmy said, "Of course he threw you the extra five hundred. He would have gladly paid five *grand* for a picture like that!"

No sooner had Sandy heard the story that night at Paul's than he was packing his bags for an early-morning flight to Boston. Sandy suffered from an acute fear of flying, but so desperate was his need for money that he was ready to do anything. It took half a quart of vodka and grapefruit juice to give him the courage to go to the airport and get on the plane.

Then four days went by, and we hadn't heard a word from him.

"Well, what the fuck could have happened to him?" I asked Paul while sitting in his shop.

"I have no idea," Paul said. "I wouldn't be surprised if he wound up in a nuthouse."

But it wasn't so: later that day, Sandy burst into the shop with a grin on his face.

"Here, this is for you!" he said, tossing me a wad of C-notes with a rubber band around them. It turned out that Sandy had sold both a "Buttersworth" and a "Peto" the first morning he got there, and then had gone on a side trip to visit friends and smoke pot for a few days.

"I sold the Buttersworth to Vose," Sandy bragged. "They're the experts! Old man Vose told me they'd been selling Buttersworths since the artist was alive." Sandy had scored over five grand for both pictures, and it transformed his personality. For the first time in his life, he had succeeded at something. He was in a state of euphoria, and visions of a new BMW, a girlfriend, and filet mignon for his dogs every night were dancing in his head.

"Man, if I'd had those two paintings of the Indians, I could have sold them in five minutes to a dealer up there," he lamented. But that would have to wait for another time. Paul already had them out and was expecting a call. In the meantime, Sandy ran another "Peto" over to a wealthy collector, the owner of a sausage factory in Tarrytown, and made another three grand. The next day, a runner who worked with Paul showed up at the shop with an envelope. Inside was seven grand in cash, the proceeds from the Indians.

By the time I left Nyack, six paintings had been sold, and I had ten grand cash in my pocket, more money than I had ever had at one time in my life. Once again, as far as I was concerned, faking paintings saved my life. Now I was a believer, and I knew what Paul meant when he said that American paintings were "red-hot."

From now on, forgery wouldn't be just something to fall back on when times got tough, but rather a full-time career.

Finally, José and I were in a position to return to New York City, and we would have, had not a particularly charming house in Florida come on the market. The house, situated on the Intracoastal Waterway in Madeira Beach and just two blocks from the Gulf, had been built in 1924 by a New Englander who'd copied the design of a whaler's cottage from his native Nantucket. It was a two-story waterfront saltbox with a center chimney and early-American paneled rooms. The money I had went for a down payment, and Madeira Beach became our home.

With a new home came new responsibility. Soon I was shuttling from Florida to New York with a suitcase full of pictures every other month. No one had ever faked American paintings in this manner. So when Paul "placed" paintings with other dealers, and Sandy went running around the countryside selling them, nobody suspected a thing. Jimmy was thrilled with my progress and insisted that I stay at his house when I came to town. He assigned me a beautiful bedroom decorated with Empire furniture and a Napoleonic sleigh bed. Another room was set aside as a studio where I could paint under his direction.

Staying with Jimmy took a little getting used to. He had no television and only a small radio, which he kept carefully locked up in a cupboard. The sole forms of entertainment were reading books, looking at paintings, having conversations in the drawing room, and the occasional appearance of a black one-eyed cat that obeyed Jim's every command.

As our friendship grew, I was still puzzled about *why* Jimmy was so intent on my developing as intense a love and appreciation of American painting as his, but most baffling of all was why he

would have me fake, and thereby possibly undermine the value of, American paintings. During our long evening talks, which were one of his keenest pleasures, I queried him on that subject. He answered philosophically.

Jimmy harbored a deep contempt for art dealers. "They're a bunch of prostitutes," he said. "And their primary appreciation of a picture is its price tag." Unlike the dealers he so despised, Jimmy was a true lover of paintings, which he valued strictly on their merits as works of art, not on the signatures they bore or their auction records.

Jimmy had no argument with my work at all. In fact, he viewed me as the natural continuum of what he called "the triumph of American painting," which, according to Jim, "refines and elevates a society." Jimmy wanted to leave a legacy to the art world. He greatly esteemed my ability as a painter and wanted me to carry on where his beloved artists had left off.

Jimmy had a devilish sense of humor and enjoyed tormenting art dealers. Once he took one of my "Martin Johnson Heades" that I had stored upstairs, a painting any collector would have given his right arm for, and left it propped casually in the drawing room when a couple of dealers and a museum curator came for a visit. According to Jimmy, "They pounced on it the second they walked in."

"Where did you get that?" one of them asked, after catching his breath.

"Oh, that," Jimmy nonchalantly remarked. "I just found it the other day in a junk shop for five bucks."

A casual walk around the house would only deepen the mystery of Jimmy Ricau. Time and again, I discovered unfinished games of solitaire laid out in nineteenth-century playing cards on Empire tables. Then he had spoons—antique silver

spoons—arranged according to their size, in graduated rows, and they moved, appearing on a breakfront one day and then on a side table the next. Lord only knows what these things meant to Jimmy.

Occasionally, when we'd go hunting through local antique shops in search of old picture frames, he'd insist on putting on disguises for fear he'd be recognized. These consisted of old hats, dark sunglasses, and coat collars pulled up high.

Only once did I see a visitor at the house. I was introduced to a strange-looking man in a long black overcoat who glowered at me without ever saying a word. He made my skin crawl, and I quickly found an excuse to leave the room. Later I learned that this was Professor William Gerdts, America's foremost expert on nineteenth-century American still-life paintings, an old friend of Jim's and a man said to be weirder than weird.

With our newfound wealth, José and I frequently flew to New York. Now instead of just looking into the windows of the expensive shops along Madison Avenue, we were able to buy whatever we wanted. The Alray Hotel at Sixty-Fourth Street just off Madison served as our home away from home in the city. We passed our time shopping at Brooks Brothers, Bergdorf, and Bloomingdale's. We found many of our old friends from the Ferguson Club and took everyone out to dinner at some of the best restaurants on the Upper East Side.

One day, walking along Madison Avenue, I ran into Alexandra King. She was as beautiful as ever. With our acquaintance renewed and my fortunes dramatically improved, I began spending nights out on the town with her and friends at Studio 54 and all the best restaurants.

As it turned out, her father, Bayard King, a retired diplomat, lived in Boca Grande, an exclusive enclave on the Gulf of Mexico about an hour's drive from my Florida home. Once during this period, while visiting her dad, Alex invited me down to his home to meet him and have dinner. Bayard King was a tall and distinguished-looking man who dabbled in art and antiques. We really hit it off, especially since I complimented him on the beautiful seventeenth-century vargueño (an early Spanish cabinet) in his living room.

"You're the only person who has ever known what that is!" he declared with delight.

"And from Seville, I see."

"However can you tell?" he asked in astonishment. When I pointed out the little cast-iron seashells used as drawer pulls, the same shells used as the identifying symbol on the coat of arms of the city of Seville, he was floored. Hooking his arm around mine, he proceeded to escort me around the house to critique his other treasures. After that visit, we regularly met for lunch in Florida and New York.

My favorite spot in the city was Gino's, on Lexington Avenue near Sixty-Fourth Street. When I strolled in one day for lunch, a huge figure lunged from the bar and swallowed me up in a bear hug. It was Gino! We had drinks and laughed about the old days at the Ferguson Club.

"So where are you living now?" I asked.

"I'm livin' in the Dakota," he bragged, "with a broad who's givin' me ten grand a week just to screw her!"

Another day at Gino's, I was shown a table by Mario, the maître d', and who was sitting at the next table, slurping down a bowl of pastafiole but Tony. We both nearly dropped dead.

"Where the fuck you been?" he asked, and ordered another bowl for me.

Tony was now living in a charming apartment in a nineteenth-century brownstone on Eleventh Street in the West Village. He'd been getting along by his usual means of mooching off women, bouncing bad checks, stealing credit cards, burglarizing antique shops, fencing stolen jewelry, stealing high-class cars, hijacking trucks, and shaking down restaurateurs.

Incredibly, he had even robbed a bank by pulling up to it in a taxicab and having the driver wait while he went in and stuck a toy gun in a teller's face. Tony walked out with ten grand in cash. True to form, he had come all prepared, suitcase and all, for a vacation. He had the driver take him directly to JFK, where he caught a flight to Paris and lived with "a bunch of whores for six months."

After filling him in on what had happened to me, my new life in Florida, and my new career, I was back out on the streets with him as if we hadn't been apart for a day. Our meeting was fortuitous, because Tony now fancied himself a "private art dealer," which I took to mean a "stolen art dealer."

Tony wanted to see examples of my work at once. When we got to my room at the Alray, I opened a suitcase and spread out a collection of paintings I was planning to take up to Nyack. Tony's eyes almost bugged out of his head, and his nostrils flared open.

"And nobody questions 'em?" he asked.

"No way," I assured him. "It's like shooting fish in a barrel."

That was enough for Tony. Despite my protests, he grabbed an empty shopping bag (Saks) and shoved in a "Peto," a "Butters-worth," and a "Walker."

"Give me a few days with these," he said and was gone.

Tony's lifeblood was a little black book in which, over the last two decades, he had collected the numbers of artists, photographers, fashion models, lawyers, stockbrokers, call girls, drug dealers, priests, gamblers, restaurateurs, gangsters, politicians, art dealers, movie moguls, and assorted captains of industry. So selling the "Buttersworth" was just a simple matter of calling up a top designer of luxury yachts, a drinking pal from Max's, and having a little chat. The next day, Tony went to collect six grand, and we met at a fancy French restaurant uptown. After putting an easy three thousand in his pocket, I didn't argue when the check came and Tony astonished me by grabbing it.

"It's almost two hundred bucks!" I said. Tony just smiled and threw down a credit card. It belonged to the yacht designer.

That night, I went out with Alex and her friends. It was noon the next day when the phone rang in my room. "Don't you think it's time you got up already, like some of us who work for a living?" Tony said and then informed me that he'd just sold the "Walker" to Coe Kerr Gallery for four grand and was going to cash the check.

"I'll meet you at Gino's in an hour," he said and hung up.

Over plates of osso buco and a bottle of the best Gattinara Tony could order, he counted out twenty C-notes for me. During the course of our lunch, Tony casually informed me that he had an afternoon appointment with Andy Warhol.

"With who?" I asked.

"With Andy Warhol," Tony repeated with his sly smile. "He's a big collector of Americana. I dropped the Peto off at his place yesterday after I left you, but he doesn't buy anything until his expert sees it first."

"Expert? What expert?" I asked with alarm.

"I don't know," Tony said. "Some guy uptown named Gerdts."

Later that night, we met at Vincent's for scungilli, and once again Tony was all smiles, counting out the Ben Franklins and ordering another bottle of wine.

"He was tickled pink with it," Tony said, laughing.

"And the guy uptown?" I asked.

"No problem," he assured me.

It was early fall, the weather was beautiful, and when I arrived in Piermont Jimmy informed me that he was planning a dinner party that night for Paul, Sandy, and me. This was entirely out of character, and I seriously wondered if he hadn't gone crazy.

"Oh, by the way," Jimmy said, stopping me before I lugged my suitcase up to my room. "Take a look at this." He handed me a Parke-Bernet auction catalog. I opened it up to a place where Jimmy had inserted a marker. Before me were two Buttersworths, each taking up a whole page. I looked in shock at the open catalog. "Isn't the one on the right yours?" Jimmy asked.

"Actually, they're both mine," I said.

That evening, the catalog served as a topic of conversation as Jimmy hosted what was, according to Paul, "the only dinner party he's had since the gallery owners left with their dead dinner guest twenty years ago." We were seated around a magnificent Empire table in the dining room. The room was illuminated solely by light from the fireplace and a single candelabrum on the table. The china was all antique, as was the silverware. Jimmy, who could have passed for the headwaiter at Galatoire's, disappeared into the gloom again and again, only to emerge with a steaming Sèvres tureen one moment and bottles of vintage wine the next.

He had prepared a superb shrimp Creole from a recipe that had been in his family since the Civil War.

The publication of the "Buttersworths" made this a very special evening. Everyone toasted the victory, but it was as much a triumph for Jimmy as it was for me. This was the result of his guidance, and it validated my work in a way unlike anything before. This wasn't just fooling a dealer in a gallery. This was subjecting my work to the scrutiny of an entire body of dealers, collectors, and experts. It had a profound effect on me.

For some time, I'd been investing money I'd made with Paul in antiques and period furniture that he was offered in local estates. That night after dinner, Paul, Sandy, and I planned to do the Miami Beach Antique Show that winter. Not only could we sell our growing inventory of antiques, but it could also serve as a perfect venue to unload an entire collection of fakes.

CHAPTER NINE

Indian Spring

Unknown to one another, both Tony and Sandy were calling me around the clock, begging for more pictures. I worked day and night building my first substantial collection of early-American paintings. By the time the Miami Beach show rolled around, I had sent Tony a box of paintings that included works by "Peto," "Buttersworth," and "Charles Bird King." José and I packed up a blue Corvette convertible we had just bought with a collection of similar pictures, and left Madeira Beach to meet Paul and Sandy in Miami.

It was my first trip to Miami, and I was impressed and found it all very exciting. We got a hotel room right on the beach and went straight to the convention center, where we helped Paul set up his booth.

Sandy—cowboy boots, BMW, and all—conveniently arrived after all the heavy work was done. Predictably, selling antiques was the last thing on his mind. All Sandy wanted to see was the box of paintings we had stashed under a display table. Within an hour after the show opened, he had sold a "Buttersworth" for four thousand bucks by doing nothing except strolling around the show with it until someone approached him and made an offer.

Antique shows, especially major ones like the Miami Beach show, are crawling with pickers (people who roam the show loaded with cash, hoping to find something they can buy one day and sell the next for a profit). Nothing was hotter in paintings than portraits of American Indians. A Charles Bird King could fetch up to twenty or thirty grand in a high-class gallery in New York, so when Sandy pulled the same trick with a portrait of Peskelechaco, it attracted the attention of two interested parties. Sandy immediately found himself in the middle of a heated argument between two men, each claiming to be the first to negotiate for the painting. Sandy calmed down the belligerents and, in effect, held an auction for the painting right on the spot. He walked away with nearly five grand in cash.

The next morning, Paul, Sandy, and I became the pickers. Flush with cash, we decided to visit the upscale antique shops along Las Olas Boulevard in Fort Lauderdale. Once there, we found a shop that boasted an impressive collection of American and European furniture and accessories. The second we set foot in the shop, we

were set upon by a nasty little lady who jumped out from behind a desk and followed us around, continually asking, "Is there anything special you're looking for?"

Even though I was about to make her an offer on a fine little eighteenth-century English writing table that caught my eye, I became irritated with the woman and thought I'd have some fun. "Well, actually, I'm redecorating a house I've inherited," I said. "I'm replacing some of the American with English. I find the American a bit dry for my taste."

"Oh, really? Do you have anything you're disposing of?" she inquired.

"Well, I've already sold most everything except for a few paintings."

"I see. What kind of paintings are they?"

"Well, one in particular is interesting. It's a nineteenth-century portrait of an Indian chief. Another is a beautiful little marine painting, and there's a still life."

"Can you bring them by?" she asked, trying to hide her excitement.

"Well, I suppose so," I replied casually. "Are you interested in that sort of thing?"

"Oh, maybe," she answered. "How about tomorrow? Can you bring them tomorrow?"

The next morning, I arrived back at her shop with one of my "Charles Bird Kings." When her greedy eyes fell upon the painting, she seized it with both hands, stared up into my face, and asked, "Well, what do you have in mind?"

Ten minutes later I was driving south on I-95, back to Miami Beach, with the top down. On the seat I had a fine William and Mary bracket clock, on the floor I had an eighteenth-century

Chinese export bowl, and the legs of an English writing table were blowing in the wind.

As soon as he saw the new items I put in the booth, Sandy wanted to sell another picture. Not willing to chance another sale at the show, he insisted I get some paintings, hop into the BMW, and drive with him to Dania, an antique center just north of Miami. Here he believed he could make a big score using an approach similar to what had worked so well for me the day before.

US 1 was the main drag that went through Dania. Antique shops, many of them in strip malls, lined both sides of the highway. The area was strictly downscale and had nothing that would have interested me, but Sandy was undeterred, and we pulled into a block-long strip of shops. Sandy picked out one of the two "Charles Bird Kings" I had placed on the backseat. The paintings were of similar Indian chiefs, except that one version had a single feather sticking out from behind the Indian's head and the other version had him sporting an entire headdress. Sandy, in a high state of excitement and convinced he was just minutes away from having thousands of dollars in his hand, grabbed the portrait with the single feather, got out of the car, and waddled down the row of shops before disappearing into one near the end.

Five minutes later, Sandy was back in the car mad as hell.

"She offered me fifty bucks!" When I was finally able to stop laughing, I tried to persuade him to forget about the place and head back to the convention center, but Sandy wouldn't give up. "Here, let me have the other one," he said, this time grabbing the chief with the headdress. "I'll try the shop next door. It looks like they got better stuff."

Once again he waddled down the sidewalk to a shop at the end. I sat waiting in the car, bored and wishing I hadn't let him talk

me into this trip, when to my horror I saw the door of the shop fly open and Sandy running toward the car, one hand grasping the painting, the other holding up his pants. Sweat was pouring down his face when he jumped in the car and frantically tried to get it started.

"What the fuck's going on?" I asked, after the car stalled.

"I'll tell you later!" he said breathlessly, while turning the key again. The car started just as two fat ladies came charging down the sidewalk looking for him. Sandy, panicked and cursing, gunned the engine, threw it in reverse, and we tore out backwards into the middle of the road. Then he threw it into first gear, popped the clutch, and stalled out again. At that point one of the women, in a flowing dress and high heels, lunged for the car and grabbed a door handle.

"Wait!" she pleaded. "We want to do business!" But Sandy, in the grip of panic, got the car started, roared the engine, and burned rubber, leaving the woman reeling in a cloud of dust. As he explained it at a nearby McDonald's, where he gobbled down hamburgers and milkshakes to replenish his lost energy, "I should never have used the other Indian!"

Apparently, the two women were partners, and when Sandy walked into the second shop with the other portrait, the woman he had approached first unexpectedly walked into the shop through an adjoining door.

"What the hell is going on here?!" she screamed when she saw Sandy offering her partner the same Indian, who had miraculously grown a full headdress in five minutes. Sandy panicked, grabbed the painting out of the woman's hands, and fled.

"That guy's fucked up," I told José, as I described Sandy's escapade over dinner that night at Wolfie's deli.

"He's dangerous," José said, and we both agreed that Sandy was seriously deranged and had to go.

After the show ended, Paul and Sandy headed back to Nyack. I called Tony. He had been busy making sales around the city. He told me he needed a vacation and had eight grand to give me. I suggested he fly down and we'd meet him at the airport. When Tony arrived, we moved into the Coconut Grove Hotel, he paid me my money, and we spent a week having fun going to the beach, restaurants, and clubs. Between the sales of paintings and antiques at the show and my share from Tony, I'd racked up nearly forty grand in cash.

At this time, two important opportunities developed that established José and me in business. Before we left Miami, I had one last "Buttersworth" to sell. Wandering around Coconut Grove one afternoon, I came across a classy antique shop owned by George Campbell, a retired New York theatrical agent and local bon vivant. As I browsed around, he approached me and struck up a conversation. I introduced myself as an art restorer, formerly from New York. I let it drop that I had been to the antique show and had had the good fortune to find "a fine little Buttersworth." He asked to see it. When I returned with the painting, he offered me three thousand bucks for it on the spot, plus an invitation to a dinner party he was hosting that evening at his swanky home in Coral Gables.

I arrived at eight and was introduced to several of my host's well-heeled patrons and friends. We dined on chateaubriand, fresh asparagus, and Dom Pérignon. The company was interested in my work as an art restorer, and I had a number of requests for my card. As the dinner party broke up and I was about to leave, I was approached by an unassuming man who introduced himself and

gave me his card. He wanted me to come to his home the next day and assess his collection of paintings.

The following day, I pulled into the drive of a beautiful mansion situated on a splendid bluff overlooking Biscayne Bay and within a stone's throw of Vizcaya, the historic Deering mansion. Impressed, I rang the bell and was shown in by a housemaid. She escorted me to a living room decorated with fine eighteenth-century English furniture and antique paintings. The maid asked me to wait there while she called "the doctor." This gave me a moment to take in the beauty of the house. Two large windows and a pair of French doors looked out upon a perfectly manicured lawn that gently sloped down to a seawall and the bay. Not far from the house was a beautiful terraced pool, surrounded by coral-stone balustrades.

Soon the quiet man I'd met the night before descended a staircase that led from one of the wings. Dr. G, the present owner of this wonderful residence, was one of the country's leading plastic surgeons and a fanatical art collector.

"I'm so glad you came," he said as he shook my hand. "We'll have lunch, and then I'll show you around." We passed the next hour poolside, where we were served smoked salmon, salad, and champagne. The house was an easy topic of conversation. Known as Indian Spring, it had once been owned, as the doctor explained it, "by a famous movie star of the 1930s" and was pictured in *Historic Homes of Miami*. Its location, known as the "dead end of Brickell Avenue," was one of the most exclusive addresses in town.

Dr. G had spent a fortune restoring the mansion, modernizing its systems, and decorating it lavishly. He lived there alone in grand style, cared for by a cook, a maid, and a full-time gardener. A shiny Rolls was parked outside the main entrance, but more for effect, as the doctor rarely drove a car, preferring to be picked up each

morning by one of his nurses and chauffeured to his clinic in her little Toyota.

Dr. G's pleasure was hosting society cocktail parties at his home, complete with bands, catering from the best restaurants, and a bar that attracted such luminaries as Arndt Krupp and doomed dictator Anastasio Somoza Debayle. His other enjoyment was flying to New York and combing through the galleries for paintings.

After a leisurely lunch, Dr. G was anxious for me to review his collection. He mainly used only three rooms in the house. The kitchen, with a beautiful picture window looking out to the bay, was his favorite. The living room was used strictly for entertaining and, finally, he had his bedroom on the second floor. The other dozen or so rooms were packed with more paintings than I'd ever seen in my life in a private residence. But unlike Jimmy Ricau, the good doctor bought indiscriminately. He lacked focus and he was certainly no expert. We spent the entire day going from room to room examining scores of paintings. Even the closets held stacks of them. Many were second-rate European old masters.

The doctor eagerly sought my opinion on this one and that one. He was shocked when I pointed out botched restoration jobs on many of them. He was unaware, for instance, that it was not unusual for an entire sky or complete figures to be repainted in early paintings when they fell into the hands of incompetent restorers. Occasionally there was a really fine piece, no doubt purchased by accident. He was greatly impressed with my observations and declared that he would "never see paintings in the same way again."

After we completed our survey, which continued into the early evening hours, we went to dinner at an exclusive Coconut Grove

club to which Dr. G belonged. It was obvious to me that money was no object to him and, after finishing off our filet mignon with a hundred-dollar bottle of wine, we spent the rest of the evening discussing how to improve his collection.

"I don't know if you're interested in early American paintings," I told him, "but that's where people are putting their money these days." Yes, Dr. G was aware that American art was the big new thing in collecting and, yes, he was indeed interested in starting a collection. He asked for my frank opinion of his present collection, and I gave it to him.

"First, I would weed out the inferior pieces," I said. "Second, I would have the better ones properly restored if they are to remain in your collection. And, third, I would strictly confine my future investing to American paintings."

Dr. G appreciated my directness, and had only two questions for me: "Can you begin to restore my collection?" and "Can you help me find American paintings?" On both counts, I assured him that I could.

The next important development occurred as soon as José and I returned home. A local antique dealer for whom I'd been doing some restoration work told me of a charming corner property next to his shop that was for sale. Situated in the old downtown section of St. Petersburg and within walking distance of Tampa Bay, the property consisted of a vintage 1930s coffee shop directly on the corner, with four adjoining shops, two on each side of the restaurant. All this took up nearly half a block. Enclosed behind the shops was a beautiful old courtyard set in antique brick, and each shop had French doors that opened onto it. All this for only fifty thousand dollars!

We spent the next couple of months cleaning, painting, and repairing. The coffee shop was under lease to a Greek family. We

took one shop for a restoration studio, another for an antique shop, and the remaining two we rented out. It was a perfect setup. A restoration studio, we reasoned, could act as an ideal cover trade for my real business, and any extra cash we made could be put into antiques for the second shop. Finally, the trade I'd learned at Sonny's years before would begin to pay off. We bought a truck, and soon we were hauling paintings for restoration from Dr. G's estate in Miami to our new studio.

José educated himself in all the principles of bookkeeping and running a business. He took charge of all the financial matters as well as the paperwork. For my part, I realized that if I was going to expand my abilities, I would have to start painting pictures on canvas, as both academy board and wood panels were too limiting in size and in terms of the artists I wished to imitate. Now that I had a large studio, I could proceed with a program of research and development.

To paint on canvas would pose new technical problems for me. Armed with my camera, close-up lenses, and notebooks, José and I flew up to New York and headed straight to Jimmy's house. Jimmy was excited about our new acquisition and my plans to expand my product line. Paul contributed by rounding up restoration work for us from his tenants, and José helped Jimmy with jobs around the house, while I spent my days examining scores of nineteenth-century American paintings on canvas. Of particular interest were unrestored paintings in Jimmy's collection, many of which had not been touched since the artist applied the final coat of varnish.

I began by lining up several canvases against the wall in an upstairs room, away from any distractions. Pulling up a chair, I studied them carefully and made a list of elements that made these paintings look old to me. I began with the most obvious

and noted that the characteristic pattern of cracks that occur on canvas is very different than those that appear on wood panels or academy board. On board, the cracks tend to run in somewhat straight lines, but on canvas just the opposite is true, with crack patterns often forming concentric circles. These rings or circles also have a secondary network of finer cracks radiating from the center and joining the circles to each other, forming a pattern that resembles a spider web. Also, when I held a painting at an angle against the light from a window, I could see clearly that the cracks were slightly elevated.

Next, I observed that a number of paintings displayed clusters of little pinhead-size black or brown spots. These tiny spots clustered in curious and distinct patterns, mostly around the perimeter of the paintings. I noted that these spots were elevated and fused to the surface of the painting. These, I discovered from Jimmy, were ancient fly droppings. They were unlike anything I had dealt with at Sonny's. Although they deserved further study, for now I just made a notation and photographed several of the clusters.

As I studied the various shades of patina, I also noticed that the surface of each painting displayed a quarter of an inch or so of clear, nonyellowed varnish around its perimeter. This was because the very edge of the painting was covered by the overlay of the frame, thereby shielding it from the ultraviolet rays of natural light that oxidize and yellow the varnish.

By studying the unpainted canvas that was folded around and tacked down over the edge of the stretchers, I saw that the canvas had been preprimed with gesso by some mechanical method, perhaps by spraying.

Many of the paintings displayed a small patch or two on the back of the canvas—crude repairs made years ago to patch up a

puncture or tear. When I turned the painting around, I could see discolored paint that had been applied over some filling material. After I used several rolls of film and filled a pad with notes, I felt I had an excellent understanding of the forensic and aesthetic effects of age on nineteenth-century American paintings.

While I was in town, I tried to avoid Sandy, but it was impossible. He'd find me at Paul's and start angling for another painting. "After that Miami business," I told him, "forget about it!" Still, he persisted, and persuaded me to come to his house to see some antique frames he wanted to sell. After we'd finished our business, we got into his BMW and began backing out of his driveway when suddenly there was a deafening bang as the back of the car leaped up in the air and came down with a thud.

"What the fuck was that?" I yelled at him, convinced a bomb had exploded under the car. When we jumped out and looked underneath, we saw black oil gushing out of the bottom of the car and a huge puddle forming. The next day, the local BMW mechanic gave Sandy the bad news: "You sheared a pin off your rear end and blew the housing open," he told him. The bill was thirty-two hundred bucks. Sandy almost passed out and begged me for another chance. Feeling sorry for him, I relented and gave him a "Peto" and a "Walker" I had at Jimmy's. I warned him to behave himself, and he assured me that he had some dealers lined up in the city and that everything would be okay.

With my research finished at Jimmy's, José and I spent the next few days in the city staying at the Alray, right back in our old neighborhood. We'd shop during the day, meet friends for lunch at Gino's, and go out on the town at night with Alexandra and her friends.

Before heading back to Florida, we drove up to Nyack to see how Sandy was doing and to say goodbye to Paul and Jim, but Jimmy was fit to be tied.

"That fucking nincompoop Sandy!" he yelled. "Do you know what that idiot is doing?"

"What?" I asked, turning white.

"He's going around to dealers posing as my nephew!" Jimmy was so mad, he could hardly get the words out. "And telling them he's helping me sell off some pictures!" When he calmed down, Jimmy explained that he'd gotten a call from a dealer he knew, warning him of the impostor.

This was the last nail in Sandy's coffin. That afternoon when he finally showed up at Paul's shop, I let him know, in no uncertain terms, that his days of selling pictures were over and that from that point on he was persona non grata.

Back in Florida, I was ready to proceed to the development stage of the operation. The next challenge was to reproduce the effects of age I had observed on Jimmy's paintings on modern fakes painted on canvas—and that sent me back to the drawing board.

To make a fake antique painting, you have to start with a real antique painting, so the first order of business was to comb through the local antique shops for antique American paintings of minor value. Dealers were delighted to sell me paintings that they'd had lying around for years, ones that looked as though they'd been painted by lunatics.

Most of the paintings I studied at Jim's had been executed with very little paint thinned out with linseed oil, a technique common to nineteenth-century painting. In fact, when such a specimen is held at an angle to the eye, one can clearly see the weave, or "nubs,"

of the canvas, as though the picture had been painted with nothing more than watercolor.

In short order, I had assembled the most horrific collection of paintings imaginable—but they were nonetheless perfect for my purposes. The stretchers and canvases were all American, thinly painted, and from the correct period. Some even displayed the original manufacturers' labels.

The primary challenge for me was to remove the original painting, resurface the canvas with a coat of gesso, paint another picture on it, figure out a cracking method, and apply a genuine-looking patina.

My objective was not to *simulate* the effects of age on my paintings but rather to *duplicate* the effects of age. If one understood what caused an effect such as cracking, I reasoned, it might be possible to make the same effect occur in an accelerated time frame. Cracking, I came to understand, was caused by the effects of stress building up between the different strata of an oil painting undergoing physicochemical changes. External factors—such as temperature change and humidity, which cause expansion and contraction, and even physical trauma—act as catalysts in the formation of cracks. I needed to set up all the conditions that contribute to that end, and then figure out a way to make the process occur quickly.

I could not accept the long, complicated, and unreliable methods devised by forgers of the past. I intuitively believed that the answer would be found easily. After all, I reasoned, I had achieved the impeccable cracks I had created on academy board by a simple process that I had discovered by accident.

Some facts I knew for certain. The older canvas gets, the more it dries out. The more it dries out, the more brittle it becomes. The

ABOVE: *After William A. Walker, c. 1980.*
BELOW: *After William A. Walker, c. 1978.*

ABOVE: *After John F. Peto, c. 1978.* BELOW: *After James E. Buttersworth, c. 1990.*

ABOVE: *After John F. Herring, c. 1987.* BELOW: *19th century British School, c. 1987.*

ABOVE: *After James Seymour, c. 1988.* BELOW: *After John Nost Sartorious, c. 1986.*

ABOVE: *19th century British School, c. 1987.* BELOW: *After John F. Herring, c. 1989.*

ABOVE: *After Thomas Whitcombe, c. 1988.* BELOW: *After Charles Brooking, c. 1991.*

ABOVE: *19th century British School, c. 1988*. BELOW: *"Shippin' 'em out," 1988*.

1993

more brittle it becomes, the more conducive it is to the formation of cracks. But the question remained: why the characteristic pattern? And how could I ever induce a process to follow a pattern? Then it occurred to me that many indiscriminate reactions in nature manifest themselves in patterns. For example, dried-up riverbeds crack in a certain pattern. Therefore, I reasoned, perhaps if all the conditions were met to produce cracks, the patterns would form automatically.

Acetone is one of the strongest common solvents. It's used by many restorers to break down the discolored varnish on antique paintings. It easily dissolves the varnish, but shouldn't—at least in theory—attack the antique underlying paint, because oil paint becomes "technically hard" or insoluble after twenty-five years. However, this doesn't always hold true. If used undiluted, acetone can, after some time, begin to break down oil paint even though it's technically hard. Therefore, the prudent restorer will usually dilute acetone with mineral spirits to weaken its action.

I discovered that the prolonged use of acetone would remove most, if not all, of the original paint. I developed a method of laying paper towels all over the surface of the painting and then pouring acetone directly over them until they were completely saturated. The paper towels acted as a sponge and held the acetone in place rather than letting it evaporate. After hours of this treatment, even the hardest paint began to dissolve. Fortunately, the undercoat of gesso, which is made up of powdered gypsum and water, is not affected by any solvent in the ketone group. The result, after the antique paint was removed, was an antique canvas that looked as though it had never been used.

It was a tempting idea to simply brush on a thin coat of Jory's special gesso, paint a picture over it, heat it up in the sun as I did

the academy boards, figure out a way to stress the canvas, and produce cracks. The problem with that, however, was obvious. The gesso originally applied in the nineteenth century was rolled or sprayed on by some sort of method that produced a perfectly even and extremely thin coat. Most importantly, the weave of the canvas could be clearly seen when examined carefully. An application like that simply wouldn't be possible with a brush. It would leave telltale brushstrokes over the original gesso and alert the trained eye to a false layer.

I reasoned that if I could reformulate my gesso to a consistency thin enough to spray through a gun, I should be able to achieve a perfectly even coating while preserving the texture of the weave pattern.

I mixed up my gesso with the rabbit-skin glue as usual, but the first couple of tries produced a coating too thick, completely obliterating the canvas pattern. Eventually I got it thin enough and could see the weave of the canvas after it had been sprayed on and dried. When I heated up the canvas in the sun, it became extremely stiff and brittle. Then I used a soft rubber ball to apply pressure to the canvas, and instantly a perfect spiderweb pattern of cracks formed!

I concluded that by applying another stratum of gesso on top of the old canvas, and creating stress within the strata by the use of heat, all the conditions necessary to produce natural cracks were set in place. Finally, the simple application of some gentle pressure acted as the catalyst to release the stress and produce the cracks.

Meanwhile, as word spread from local art collectors and dealers about the fine restoration work we did, we began to get calls from museums throughout the state, including the Ringling Museum in Sarasota and the Norton Gallery in Palm Beach. We were

swamped with work, and the studio looked like a museum store-house. We established a daily work schedule, arriving at the studio every morning at eight and eating breakfast in the café. Then I would work on my fakes until noon while José took care of calls, customers, and paperwork for the business. Lunch was served to us by arrangement with the café at a table in the courtyard. The afternoons were spent on restoration jobs.

I spent weekends at Dr. G's estate in Miami. Almost every trip included a dinner party in one of the Grove's best homes, or the doc himself would throw a lavish poolside party. These affairs often put me in contact with art collectors and new clients, but the doctor insisted that I give him first shot at any paintings I turned up. I didn't want to abuse his hospitality, especially since he gave me a set of keys to the Rolls and another for my own room at the estate, so I thought it only right that I not sell him more than fifty grand worth of paintings a year.

This worked out fine, and he couldn't wait to buy another "Peto," "Buttersworth," or "Walker." And now my recent technical breakthroughs enabled me to expand my repertoire and fulfill his wildest dreams. Soon I was turning up paintings by Antonio Jacobsen, another nineteenth-century marine artist; Severin Roesen, a German-born American still-life specialist; Levi Wells Prentice; and other assorted early-American painters on a weekly basis.

By 1979, José and I were fully established in business. The studio attracted all sorts of characters. A few of them were profes-sional pickers who hunted through junk shops and antique markets in the hopes of finding a valuable painting. One in particular, Mr. X, was an old hand who roamed the East Coast from Maine to Miami and had great success at it. Whenever he came in with

another of his finds that needed some attention, we'd talk shop, and eventually we became friends.

One day over lunch in the courtyard, he mentioned that he frequently came across worthless nineteenth-century paintings in the fifty-to-hundred-dollar price range. In fact, he mentioned that he was sometimes called to private homes "in the sticks" where he might run into a dozen of them. Other times, he would have to buy a group of pictures, all junk, in order to get one "sleeper."

Finally, one day, I showed him examples of my work. I told him I only did it as a hobby, but had a great need for worthless antique paintings. He was smitten on the spot and promised me that if I would sell or swap him some of my work, he would bring me worthless nineteenth-century paintings and frames "by the truckload." So I showed Mr. X exactly the kind of antique paintings I was looking for, and agreed to sell him pictures outright for cash or swap with him when he got together a collection of junk.

José and I were working at a frantic pace, and on one of our trips to New York we were met with sad news. Paul had just been taken ill and was in the hospital. It turned out to be cancer, and the doctors said it was hopeless. He eventually got out of the hospital and back to his condo in Nyack. José stayed and helped him for a while, but not long after that trip, we got the news that Paul had died. It was a blow to everyone.

Sandy, we heard from Jimmy, was beside himself, not from grief but rather from self-interest. Sandy's world was steadily crumbling around him, especially so since he was cut off from any further dealings with paintings. And Jimmy forbade him to come around anymore. Now Paul, the only person in the world who would still give him any employment, was gone!

According to Jimmy, Sandy appeared to be losing his mind. Jimmy heard through the Nyack grapevine that Sandy had gone from deep depression to a state of euphoria in which he announced that he and his dogs were moving to Colorado, where they were all going to "live in a canyon." Sandy invested the last of his money in a 1960s Volkswagen camper with an open back. It looked like a cross between a pickup truck and a bus. It was said you could see flowers and peace symbols bleeding through a faded paint job. Sandy, witnesses reported, attached a wood framework of two-by-fours across the open back and then stretched an old canvas tarpaulin over the framework as a cover. Here he imagined his beloved dogs would ride in comfort on an old, dirty mattress while he piloted the contraption in the tiny cab.

Supposedly the last anyone ever saw of Sandy, he was headed west out of Nyack late one afternoon. Sometime later, word got back to town that he had never made it past Passaic, New Jersey, where a terrific thunderstorm blew the top right off the back of the VW, panicking the dogs. Sandy, viewing this through the mirror, lost control and slid into a mud-filled drainage ditch where Sandy, Kook-a-poo, and Pook-a-noia were stranded for the night.

For us, Paul's death was the closing of a chapter. I still visited Jimmy and always kept a stash of paintings at his house. But if I wasn't working at the Florida studio, I spent most of my time in Miami or New York City.

In the late seventies, Miami was *the* place to be. The city was awash in money. Ostentatious displays of wealth were everywhere, much of it drug related. Clubs, chic restaurants, and high-end boutiques were popping up overnight, and Coconut Grove was one of the hottest spots.

I even ran into Roy and Dave one day on the street. We'd meet occasionally and have lunch at the Coco Plum, a café they owned in the Grove. George Campbell's business was booming too. It wasn't unusual for his high-society patrons to stop in on a Saturday afternoon and drop fifty or sixty grand for paintings and antiques. It didn't take long for old George to figure out that the amazing finds I made for his buddy Dr. G were in fact paintings I'd created myself, but he wasn't interested in the details: all he wanted was paintings to put in his shop, and I was happy to oblige. Between the two of them, the money kept pouring in.

With Dr. G's estate serving as my base of operations, I discovered that the Miami area was one of the best places to find early-European furniture, in particular sixteenth- and seventeenth-century Italian and Spanish pieces that had once decorated the rooms of the old Mediterranean-style mansions that were built there in the 1920s.

Profits from my paintings went straight into an inventory of rare furniture for our antique shop. I kept in touch with dealers I knew in New York City who dealt in these items. Some, like Piero Corsini, were Italian. They would buy pieces from us and then ship them to places like Florence or Milan, where, due to the pitifully weak US dollar, they sold at tremendous markups.

One afternoon, I got my hands on a few auction catalogs from Sotheby's featuring sales of early furniture in their London salesrooms. "Check out these prices," I told José at the studio. José was astonished when he flipped through the catalog and saw many pieces just like ones we had in our inventory, estimated at prices several times more than we were asking.

"Wow!" he said. "Maybe we could get some of our stuff over there."

"Exactly what I'm thinking," I said.

At that time, we were loaded with inventory. Seventeenth-century tables, cassones, and credenzas were stacked in piles. We both agreed it was time to call Sotheby's.

CHAPTER TEN

Sotheby's Chump

Auction houses are notoriously devious institutions and should never be trusted. However, most auction houses do not rig bids as some believe. They leave that to the dealers, who form buying combines, called "pools" or "rings." There are many variations on these schemes, but basically several dealers who have agreed not to bid against each other conspire before the sale and decide upon who bids on what. They also agree that if the bidding dealer is successful, he pays a percentage of the hammer price into a pot, which is divided among the other

members of the ring. Thus they buy off the competition among themselves and divert money that would otherwise go to the seller into the pockets of their fellow dealers.

Such schemes are highly illegal, but they flourish openly. The ring is a fact of life in the auction-house business, and the savvy seller hopes there are enough private bidders present at the sale to bid against the ring. Herein lies the problem.

Some sales assure a good crowd and vigorous competition. These are usually on weekends. Sales scheduled on weekday mornings often attract nothing but dealers who form a ring or, if you're lucky, two rings, and a few private bidders. If your items are thrown into one of these sales, get ready to bend over and drop your drawers.

Dealers manage to book *their* goods into the best sales before anyone else by wining and dining auction-house employees at "21" and the Four Seasons. Midweek sales are automatically reserved for suckers whose goods are sacrificed to the dealers' "knockout." However, to outwit the experienced seller, they often employ a bait-and-switch routine.

Having shipped a planeload of furniture, estimated at seventy-five thousand dollars by Sotheby's, to their London salesrooms, and having been assured by the head of the furniture department, Mr. Hinchcliff, that our goods were to be included in a "very important" early European furniture sale, I was not even afforded the courtesy of a letter or phone call concerning a change in schedule. By the time I received my complimentary copy of the catalog, my goods had already been dumped in a Monday morning sale, which netted a mere fifteen thousand pounds. All the yelling and cursing in the world only earned me a cool Cambridge-accented "I beg your pardon, sir" from an unperturbed Hinchcliff. The moral of

the story was clear. Always, especially when dealing with auction houses, *Get it in writing.*

I called New York and complained, but the most Sotheby's New York branch was willing to do was to issue me a check in dollars at a favorable exchange rate, if I sent them my check written on Barclays Bank, which had been issued in pounds—a very small consolation considering the hosing I'd taken. I sent them the check and received one in exchange for thirty-two thousand dollars.

A month had passed when a letter from Sotheby's, postmarked London, arrived at our studio. Inside was the Barclays check originally issued to us for the fifteen thousand pounds.

"What's this?" José asked.

Because of some incomparably splendid accounting snafu, the Sotheby's check in pounds sterling that we had sent to New York to be reissued in dollars had been returned to London, where, incredibly, it was simply rerouted back to us.

"It can't possibly be good," I told José. "They must have put a stop on it."

"Well," he replied as he lifted the telephone receiver, "why don't I just check it out with Barclays in London?" Amazingly, the check was good, but our local bank said it would take at least two weeks to clear.

Twenty-four hours later, jet-lagged and blurry-eyed, I walked into the Bond Street branch of Barclays Bank, cashed the check without a hitch, and wired the funds back home.

To offset expenses, and remembering how, years ago, I had sold my first pictures in London, I had brought along a "Buttersworth," just in case. It didn't take fifteen minutes before I was walking out of Omell Gallery on Duke Street with a thousand-pound check and making another visit to Barclays.

Two sublime months with an extra thirty-two grand in the bank had sailed by when a phone call disrupted an afternoon lunch in the courtyard. José answered from the studio and called out "Sotheby's London" and stretched out the receiver to me.

"Hinchcliff here," began the snob. "I'm afraid there's been a bit of a mistake, Mr. Perenyi. . . ." I let him ramble on about the mix-up before delivering a perfunctory "Go fuck yourself, sir" in my most polished English.

Five minutes after I'd slammed down the phone, it rang again. A frantic Hinchcliff implored me to "consider that people's jobs are in jeopardy over this!"

"Look," I said, stopping him in his tracks, "let *me* make this perfectly clear. First of all, you're never gonna see five cents of that money and, secondly, I'll show you the same consideration you showed me when you switched me into that fuckin' Monday morning sale. As for anyone losing their job, good, let them go out and earn an *honest* living for once!"

—⁂—

When Tony first started making money with my paintings, he treated me like gold. He insisted I stay at his apartment and spend every night out on the town with him. He was the consummate insider. You wanna see gangsters, he knew where to go. You wanna see movie stars, he knew the spot. You wanna meet Bobby De Niro, no problem. These days, he strolled the Upper East Side in a hand-tailored sports jacket (lifted off a hook in some café), a pair of expensive sunglasses, and Gucci loafers. The very embodiment of an Italian aristocrat, Tony oozed Continental charm. Gallery owners and maître d's would throw themselves at his feet when he walked in.

As time went by, though, and as Tony sold more and more of my pictures, I began to notice the Masaccio metamorphosis, whereby Tony transformed from a broke but good-natured friend into an insufferable tyrant when his fortunes changed. The pathology progressed in direct proportion to his accumulation of money. The catalyst in this particular episode of the metamorphosis was a wad of hundred-dollar bills totaling over fifty thousand dollars that he kept in a tin can hidden behind his refrigerator. As the roll got bigger and the transformation took its inevitable course, I went from the talent and brains behind the operation to a mere employee while he assumed, as he saw it, his rightful role as mastermind!

After lunch at La Goulue one cold winter afternoon, we decided to stroll up Madison Avenue and visit the galleries. Tony wanted to see a collection of gouaches and paintings by Alexander Calder at Perls Galleries. After we reviewed the collection, as we were leaving, Tony was carrying on about what a genius Calder was.

"Oh, come on, Tony," I said, just to shut him up. "I could paint those things blindfolded."

"Well, then, why the fuck don't you? Do I have to think of everything around here?"

"You mean you could sell those things?" I made the mistake of asking him.

"Sell them?!" Tony yelled right out on Madison Avenue. "What the fuck is wrong with you?! I could sell them all over the country!" Ten minutes later, we were at Rizzoli's buying up every book we could find on Calder and, right after that, we were at a table at Gino's studying the books over a bottle of wine.

"The compositions," I explained to Tony, "are easy enough. Just a bunch of squiggles, spots, and circles on paper. The trick is to get exactly the right kind of paper with the watermark Calder uses."

That mystery was solved by a visit to one of Tony's friends, who had several Calder gouaches hanging in his SoHo loft. Tony had sold him artworks (stolen) in the past, for bargain prices. Beholden to Tony, he put the gouaches at our disposal. After extracting two of them from their frames and holding them up to the light, I had all the information I needed. The next day, I ran around the neighborhood visiting every art-supply shop, but with no luck in locating the rare paper. Finally, someone sent me to Central Art Supply on Third Avenue, and they had it, watermark and all, for fifteen bucks a sheet.

Next, I loaded up on paints, brushes, and palettes.

Meanwhile, Tony was transforming his apartment into a factory, with easels, drafting tables, flood lamps, a clothesline, and hair dryers. I spent the next two days studying all the examples of Calder's gouaches I'd cut out of the books we bought. Then I sat down and composed my own "Calders" on large sketchpads laid out on the drafting tables. After working up thirty or forty ideas on the cheap paper, we selected around twenty that Tony considered to be on the "right wavelength." Using the sketches as a guide, I was ready to transfer the ideas onto the real paper.

Just then, the weather was turning nasty and the city was bracing for a winter blizzard. I had to make one more trip to get a few more supplies on Third Avenue, but the storm had already begun with a fury. So violent was the freezing wind and snow that by the time I was heading back, I could only see a few feet in front of me. Clutching my supplies, I could barely breathe the icy-cold air. I lunged into a doorway to catch my breath before pushing on.

For two days, I worked at an exhausting pace. When I ran out of sketches, we worked up some more. Tony was ecstatic as he

hung gouache after gouache, each bearing the scrawled signature of Calder, on the clothesline stretched across the apartment. I could see the dollar signs in his eyes as he gleefully blow-dried each one. Despite the weather, Tony braved the storm and returned with an endless stream of my favorite things—pastry from Veniero's, stuffed artichokes from Balducci's, bread, cheese, salami, and, of course, the best wine—anything to keep me happy and working. But no matter what he brought me, nothing could make up for the freezing cold of his apartment. Even with logs blazing in the fireplace, the antiquated heating system couldn't keep the place warm.

Finally I couldn't take the cold and exhaustion anymore and retreated uptown to a warm bedroom at the Alray. I soaked in a tub of hot water for an hour before getting into bed and felt I was in heaven. Tony, deeply concerned, called to make sure I hadn't headed for the airport instead.

"Yeah, I'm okay," I told him.

"Okay. Well, I got a little something I'm gonna send up to you tonight," he said, and abruptly hung up. A couple of hours later, the front desk called to say that there was a delivery for me. Assuming that Tony had actually found a way to deliver a box of pastry, I told the desk clerk to send it up.

When I opened the door, I was confronted by a beautiful dark-haired girl with olive skin and dreamy brown eyes. She was dressed in an army fatigue jacket, camouflage pants, and combat boots. My first thought was "I'm going to be assassinated!" But when I caught sight of the bottle of Courvoisier in her hand and she announced with a smile that she was Orly, a friend of Tony's, I asked her in.

As we guzzled down the bottle of brandy, Orly confided to me that she was an Israeli and a committed Communist revolutionary.

"So am I," I promptly assured her, immediately getting down on my knees to unlace her boots. She then spent the rest of the night indoctrinating me under the covers.

The next day, back at Tony's gulag, I added the finishing touches, which included soiling and polishing the edges of the paper on more than thirty gouaches, before I packed up and flew back to Florida.

For some time I had been experimenting with various formulations of varnish mixed with amber-colored dyes to apply to my paintings as a final patina. A light patina on a painting has the effect of mellowing the colors and is a desirable enhancement to an antique painting. Only when the varnish becomes too dark over the course of time does it overwhelm the colors, at which time it must be removed. It was therefore my practice to apply a light yellow patina that would add charm to the painting but wouldn't necessitate a cleaning.

The risk of subjecting my paintings to a cleaning was obvious. As I said, oil paint requires at least twenty-five years to become technically hard and not break down when attacked by solvents such as acetone. An antique painting that begins to dissolve during a cleaning would be suspected of being modern.

Although I achieved a certain amount of hardening of the paint by laying the paintings out in the courtyard and exposing them for weeks to the hot Florida sun, the solubility gap between the varnish and the paint was much closer in my paintings than in genuine antique paintings. Therefore, if my paintings were cleaned, at least in the short term, there existed the possibility that the paint could begin to dissolve along with the varnish. It was imperative to make paintings with just the right patina so that no one would even think of cleaning them.

One day, while working on an antique painting for a client, I made a discovery that was beautiful in its simplicity and breathtaking in its effect. Years ago, when I had worked at Sonny's, I'd learned about the use of ultraviolet light in the examination of antique paintings. One of the first things a restorer might do with an antique painting would be to take it into a darkened room and expose it to the rays of an ultraviolet light. In that way, a number of important observations could be made.

First of all, the varnish that was applied to paintings in the nineteenth century was derived from organic compounds. As years passed, the varnish was bombarded by the ultraviolet rays that are present in natural sunlight. The varnish, as well as slowly discoloring, underwent a unique oxidation process. After a hundred years or so of such oxidation, the surface of the painting would give off a strange greenish fluorescence when viewed under the rays of a UV lamp in a dark room.

Modern varnish will not fluoresce. This reflection or coating of green fluorescence, which I'd heard described as "green slime," can be quite opaque under the lamp, actually obscuring the image of the underlying painting. Sonny had once stated categorically, "You can't fake this effect." A restorer uses UV light to allow him to see how much old varnish is overlaying the surface of the painting.

UV light is also very useful in detecting any previous repairs or retouching and is an important tool in detecting a superfluous signature. This is because any paint—whether in the form of retouching or as an added signature that was applied *on top* of the antique varnish—will appear jet black against the green fluorescence.

It's also common practice for restorers to examine an antique painting under UV light after a cleaning, to see if any residue of old varnish still remains.

As I leaned over my client's antique painting, which I had just cleaned, I turned on the ultraviolet light at my side to make a final examination, and I noticed that a small puddle of solvent had formed around the cotton swabs I had just used to clean the painting. This rapidly evaporating little pool of solvent was fluorescing telltale green. The thought came to me that I might wring out the solvent along with the dissolved antique varnish from the swabs I had used in the cleaning into a beaker. Then, I reasoned, I might find a way to reconstitute it and apply it to the surface of one of my paintings, thereby transferring the antique varnish, "green slime" and all, from an old painting to a new one.

In a flash, I scooped up the pile of brown-colored swabs on the table and squeezed every drop of the liquid I could into a jar. Next, I ran the precious fluid through a fine-mesh filter and then mixed it up with some modern synthetic varnish. The two substances blended together and formed a transparent amber liquid. I loaded a spray gun with the new concoction and sprayed it all over the surface of a recently painted "Charles Bird King." After drying it out in the courtyard for a few minutes, I placed the painting on the worktable, pulled the shades, and turned on the ultraviolet lamp. To my everlasting delight, not only did the painting have a beautiful mellow patina, but it fluoresced a perfectly even layer of "green slime," just as if that varnish had been lying on the painting for a hundred years.

It would be hard to overstate the implications and possibilities of this simple discovery. The knowledge of what the UV lamp reveals was rapidly passing from restorers' workshops to dealers and experts, who had even begun carrying around new pocket-sized UV lamps that enabled them to better examine and assess a painting anywhere and at any time. This was crucial because, for

many experts, seeing true antique varnish under the lamp established an uncontested provenance.

The reasoning was simple: if a painting appears to be by the hand of a particular nineteenth-century artist *and* the varnish on the painting fluoresces under UV, *and* since it takes a hundred years before varnish will fluoresce, the painting *must* be genuine. QED. Furthermore, it could be assumed that the varnish in all probability had been applied by the artist himself.

Spurred on by enthusiasm from my new discovery, I decided to scale up and paint some pictures by Martin Johnson Heade, an artist of considerably more value and whose paintings might very well be subjected to a higher degree of scrutiny.

I had recently invested in a fine 35-millimeter camera fitted out with a special lens, filter, and film that enabled me to visit museums and look like any other tourist taking photos of paintings from a reasonable distance. In fact, the camera zoomed in on a few square inches of the painting, giving me accurate photographs of signatures, brushstrokes, and other significant technical details unique to the artist.

My primary interest now was to observe and photograph the elements in Heade's paintings that he copied from painting to painting. Two weeks later, after visiting museums in Washington and New York, I was back in the studio with a collection of close-up photos of hummingbirds, orchids, and signatures of Martin Johnson Heade. When I studied my photos, along with examples of Heade's paintings reproduced in a book on the artist written by Theodore E. Stebbins Jr., the premier Heade expert, I came to the conclusion that so precisely were the orchids and hummingbirds copied from painting to painting that Heade must have had a collection of stencils that he used to trace the models onto each painting.

I raced to the nearest copy machine with prints and photos of orchids and hummingbirds, calculated the scale, and ran off the copies. Back at the studio, I breathlessly grabbed an X-Acto knife, cut out the "models," and had my own set of stencils.

Two weeks later, the courtyard was littered with a collection of "Heades," their iridescent hummingbirds and vivid orchids shimmering in the bright sunlight. Some were painted on academy board, others on period "reconstituted" canvas, precisely the type Heade used himself. After the cracking process and an application of my new "antique" varnish, we were ready for business.

A neighborhood hotshot, who frequently dropped by in his new Ferrari, spotted one of the "Heades" in the studio and wanted to see it. This guy hunted locally for paintings; whenever he found something, he'd take it to one of the big dealers in New York. He was having problems with alcohol and cocaine and was hungry to make some cash.

"You gonna sell that?" he asked, recognizing what it was.

"Yeah," I told him. "But I just found it, and I'm not sure if it's right," I said to cover myself, but he didn't want to hear any stories.

"I could move that painting in New York fast," he stated flatly.

"Well," I replied, "I can't guarantee the piece, but I gotta get twenty-five grand if you want to give it a try."

The next day Mr. Certainty and the painting were on a flight to the city. When he arrived, he checked into the Plaza Hotel and called me to let me know that he had an appointment the next day with one of the dealers on Madison Avenue. By the end of the following day, I hadn't heard a thing from him. I called the hotel and learned that he'd checked out. Finally he called, telling me that he

couldn't sell the painting. In fact, he never tried. Suspecting something was up with the piece, he had lost his nerve. Unfortunately, he had been high on drugs. He had left the painting under his bed when he vacated the Plaza, and he was already at the airport about to catch his flight back when he called. At least he'd had the presence of mind to call the hotel. The painting, he said, was safe and residing in their storage room.

I called the hotel and, using his name, explained that I would send a friend with a signed letter to pick up the painting. A couple of days later, Alexandra presented a letter at the Plaza, retrieved the painting, and FedExed it down to me.

The next opportunity to test-market a "Heade" was preordained in heaven by a situation that had transpired some months previously. Mr. F, a particularly obnoxious young art dealer who had heard about us and needed someone to take care of his paintings, showed up at our studio. He brought along a couple of poor nineteenth-century paintings that needed cleaning. He tried to impress me by showing how much old varnish was on their surfaces with a small pocket UV light he'd brought along.

He was pleased with the result, and I assumed we had another customer. In the course of time, Mr. F brought us more paintings to clean and promptly paid his bills. Finally, he showed up one day with several paintings that needed a considerable amount of work. After we completed the job to perfection, not only did Mr. F persuade us to deliver the paintings to his client, who lived twenty miles away, but then stiffed us for the bill! When I called him to discuss the matter, he told me to "go call a lawyer," and hung up.

With a little checking around, I discovered that cheating partners and tricking uninformed people out of their paintings were among his specialties and that everyone who had done business

with this asshole got screwed. I also learned that he ran ads offering to "purchase old paintings" and give "free appraisals" in the local newspapers in hopes of finding another sucker. I *also* learned that when all his tricks failed, he'd been known to lay out large sums of hard cash to get a painting. Under these circumstances, I couldn't imagine a better guinea pig to spring a "Heade" on than Mr. F.

I had recently made the acquaintance of a lawyer in Tampa who spent his every waking minute in Tampa's innumerable nude bars. So addicted was he to that atmosphere that he even met clients in these dives to discuss their cases. I discovered his magnificent obsession one evening after dining with him in a respectable restaurant, where we discussed an accident case.

I made the mistake of allowing him to show me around Tampa after dinner. For the next four hours, I was dragged from one lap-dance emporium to another along the Dale Mabry strip. In the course of this odyssey, I was introduced to a tall, leggy blonde, who, I was assured by my legal friend, was really a struggling college student working on her PhD in nuclear physics and only humped fifty guys a night to pay her tuition. Apart from her professional duties, my friend informed me, Jasmine could be called upon for just about any kind of moneymaking enterprise.

The idea came to me that if I could use someone untraceable, a "cutout," to approach Mr. F with a "valuable" painting, I might just even the score with him, and Jasmine might just be the right girl for the job. We met at a diner in Tampa and, as promised, Jasmine didn't care if a painting was hot, a fake, or radioactive. As long as she could make a score, she'd gladly sell it to the pope. When I told her that we had to get her some false ID so when the deal was done nothing could be traced to her, she was way ahead of me. Not only did she have more than one phony driver's license, she actually had

come equipped with a stolen license plate that she slapped over her real one when making house calls to sensitive clients.

The trick of this particular gig, as I explained it to her, was to get paid in hard cash.

Given the fact that M. J. Heade was such a hot commodity, and given the fact that Mr. F advertised "Cash Paid" in all his ads, I didn't see a problem. The cover story we concocted was simple. Jasmine would check into a motel, one she hadn't used before. From there, she would call Mr. F, claiming to be in town to sort out some things left to her by a recently departed aunt. Among the items would be the painting, which her late aunt had told her ten years ago was worth fifteen thousand dollars. Concerned about handling such a valuable item, she thought it a good idea to seek some professional advice—and had seen his ad for "Free Appraisals" in the local papers. She wouldn't mention that she wanted to sell the picture, just that she wanted to verify its value.

Mr. F's ads for free appraisals were nothing but bait to lure suckers to his shop in the hope that he could steal their paintings. I planned to turn the tables on him. I told Jasmine that by mentioning that her aunt had once told her the painting was worth fifteen thousand dollars, she would prevent Mr. F from snowing her. This way, he'd know right off the bat that if he didn't talk serious money, he'd lose her.

We discussed a few more details. If asked, Jasmine would claim to be from Fort Lauderdale, as her phony driver's license stated. Her home phone number would be a call box next to a Lauderdale strip club where she sometimes worked. "If he tries to persuade you to sell the picture to him," I said, "ask him how much he'd pay. Do not name a price. When he makes an offer, act tempted, but then decline. If he ups the offer, think hard for a while and then say,

'Would that be in cash? I wouldn't want to have to pay inheritance tax.'" This, I explained, would justify the request.

The following morning, I met Jasmine at a local motel and gave her the "Heade," and the trap was set. Hours dragged by, and I could only imagine what was happening. Then the phone rang. Jasmine told me to meet her at a diner and hung up. When I arrived, she was alone at a booth. Our eyes met. I walked over and sat down.

"Thirty thousand," she said coolly and slipped me a thick envelope under the table.

According to Jasmine, Mr. F had taken the bait—hook, line, and sinker—never once questioning her story. As she explained it, "When I described the painting to him over the phone and spelled out the signature in the corner, he insisted on coming to wherever I was to give me the free appraisal. It took some doing, but I assured him I'd bring the picture to his house. I waited around for over an hour just to make him suffer."

When she finally arrived and pulled the painting out of a plastic garbage bag, Mr. F could hardly contain his excitement or, to put it in her vernacular, "He got a hard-on a mile long." According to Jasmine, it went down exactly as predicted. Mr. F was forced to concede that the picture was worth, in his "expert opinion," twenty-two thousand dollars, and then he claimed, conveniently enough, to have "a client who collects just such paintings." Then, as Jasmine explained it, "He delicately broached the question of whether I had plans to sell it, and I told him I might.

"At that point," Jasmine said, "he suggested he might be able to get twenty-five thousand for me. I reluctantly refused but assured him I would think about it. Then he asked, 'What if I could get you thirty thousand?' At first I acted a bit stunned, but after pretending

to think for a while, I asked him if that would be in cash, and gave him the spiel about the tax. Before he answered, he got out this small thing that looked like a flashlight and studied the picture under the light from it for a while. Then, after pretending to call his so-called client, he said, 'It's a deal.' He took me to the bank himself, withdrew thirty big ones, and paid me off." Jasmine said that the whole thing had taken about an hour.

I discreetly counted out eight grand in hundred-dollar bills and passed it back to her under the table. She promptly left for New Orleans and established a whorehouse. From that moment on, an application of my organically enhanced varnish became standard operating procedure on every painting that left the studio.

In only a few short years, José and I had come a long way. From being penniless, we now had a thriving business, a hefty stock portfolio, and valuable real estate. Unbeknownst to us, however, a dangerous situation was developing. I still wasn't experienced enough to know that no matter how far afield my pictures were sold, they would eventually gravitate to New York City, the market hub. The first tip-off that this was occurring came one afternoon when I was visiting the galleries along Madison Avenue. Stopping in at a gallery that handled marine paintings, I inquired if they had any Buttersworths they could show me. The gallery owner asked me to wait a moment while he got one. A minute later I was staring at a "Buttersworth" that I had sold in Miami many months before.

And word on the street was that Mr. F, the dealer who was fortunate enough to find *one* Heade in his lifetime, had taken a trip to Atlanta, where he bagged another one. The only problem was, it was one of mine too.

Some time after that, I was back in Manhattan having lunch with Alexandra King's father, Bayard, who enjoyed chatting about art and antiques. He was very impressed with my knowledge of art, but a little puzzled by my encyclopedic knowledge of Charles Bird King, who turned out to be his great-grandfather! It just so happened that Sotheby's was having an exhibition of nineteenth-century American paintings, and Bayard suggested we go over and have a look. As we entered the main showroom, we drifted apart to study the paintings on our own. After a while, Bayard caught up to me and wanted to show me the "marvelous colors" in a painting in the next room. I followed him through a doorway and suddenly found myself face-to-face with a "Martin Johnson Heade," the very one Jasmine had sold to Mr. F and that Bayard's lovely daughter had rescued from the Plaza Hotel!

Bayard noticed the blood drain from my face. "Are you all right?" he inquired.

Meanwhile, my friends in Miami were keeping me busy day and night. Apart from turning up paintings for them, it was dinner parties in Coconut Grove, weekends in New York City, and even masquerade balls in Oyster Bay. It had been months since I'd left Tony and the "Calders." He'd been gallivanting around the country, making calls from his little black book and "takin' care of business." At first, he faithfully wired me my money as he made sales. But after a few months the payments slowed, and then, predictably, they stopped altogether. Calls to his number went unanswered.

"I'd just like to know where the fuck that fat ginny is," I told José over lunch in the courtyard. I got my answer when I called friends in New York and discovered that Tony had been on the West Coast for the past two months "on business," and was currently "shacked up with two blonde bimbos" in the Beverly Hills Hotel.

When Tony finally came back to New York, I tracked him down. He was in a TriBeCa bar having drinks with John Belushi. As soon as I got him out on the street, I attacked him, desperately trying to get my hands around his neck. He pleaded and begged, admitting to leaving a trail of "Calders" from New York to LA, but explaining that he'd been holding my money for me when he'd met the two blondes while drunk in a bar.

He confessed to making twenty grand with the "Calders," and another twelve from a "Peto" sold to Meredith Long & Company in Houston and a "Buttersworth" to Stevens Gallery of Beverly Hills. Of course he didn't have a penny to show for it. I demanded my share from the tin can behind the refrigerator, but he claimed it had all been "invested" (loan-sharked out).

Back at his apartment, we were yelling at each other until dawn. He swore on his mother that if I gave him some pictures, he'd sell them and give me every penny, and he confessed that he was an asshole. That settled the matter. We went out and had breakfast.

Back in Florida, José took care of business matters while I went on painting marathons, knocking out one picture after another. Sometimes these sessions could result in a dozen new pictures drying in the courtyard. We had "Petos," "Buttersworths," "Antonio Jacobsens," "Heades," "Charles Bird Kings," and works by lesser-known still-life painters like De Scott Evans and John F. Francis, many of which didn't take me more than a day or two to paint. My main problem was that no matter how many paintings I sold in Miami, and no matter how many I sent to Tony, I still had mountains of them piling up. On one occasion, the house was broken into while we were in New York, and a collection of pictures, including two "Heades," was taken.

The solution to this mountains-of-paintings problem was eventually solved by my friend Mr. X, the picker, and a local dealer who I took into my confidence. Both these guys began purchasing packages of paintings from me wholesale. Envelopes stuffed with cash ranging from ten to twenty grand were laid down on the table as a dozen or so paintings were wrapped up in brown paper and taken out the door to their open trunks. Where these pictures went, I had no idea. But one thing was for sure: they added to a growing critical mass of fakes accumulating in New York City.

I finally realized the danger of the situation that autumn of 1980, when I was back in the city for an extended stay with José and made an accidental sale. The city was crowded, as it usually is in late fall. The Alray, my usual haunt, was totally booked, so in what turned out to be a major stroke of luck for me, we had to settle for the Blackstone, a busy hotel in the East Fifties where I wasn't known. We had planned to do some Christmas shopping and go out on the town with friends. Although I had brought a couple of paintings along, I didn't have any plans to sell them. Instead, I was toying with the idea of placing them in auction myself, as Jimmy, more than once, had suggested I do.

Meanwhile, Tony was putting in overtime to work off his debt and redeem himself with a number of paintings I had left with him. He was paying calls to every stockbroker, advertising director, doctor, architect, or literally anyone else in his little black book he thought might possibly buy a painting. Whenever he made a score, we'd have dinner at the Russian Tea Room, where he'd pass me the cash.

Emboldened by one success after another, I decided the time had come to pay Sotheby's a visit. Slipping a little "Buttersworth" into a shopping bag (Hermès), I strolled up to 980 Madison Avenue.

Upon entering Sotheby's, I was directed to a counter where several people were waiting to have their paintings evaluated. When my turn came, I pulled out the picture from the bag and placed it on the counter, but I was informed by the lady in charge that the expert on American paintings was out to lunch and that I'd have to come back later for an opinion. As I placed the painting back in its bag, I saw an oily-looking young fellow standing nearby casting a glance at the painting. As I was leaving the building, he caught up with me and asked: "Excuse me, but are you selling that picture?"

"Well, I'm not sure," I replied. "I really wanted to get an opinion."

"Can I take a look at it?" he asked.

"Well . . . ," I said hesitatingly, and reluctantly took the painting from the bag, but kept hold of it. The look in his beady eyes told me he was already hooked, and easy cash is hard to resist. I let him drag it out of me that I had been "told by a friend" that it could be worth six thousand dollars. To that he replied: "Well, how about I give you six thousand?" I ruminated and acted as if I'd been taken a bit off guard.

"I live right nearby," he said. "We can go to my apartment, and I can cut you a check. You can cash it right away."

I thought for a moment and finally agreed. To satisfy his curiosity, I told him I had found the painting in an antique shop in Jersey, where I lived. I went on to explain that I was visiting in the city for a few days, staying at the Blackstone, and thought I'd bring the painting along for an opinion. When we arrived at his apartment, he wrote me a check. He revealed that he owned Revere Gallery, a new establishment in the neighborhood, and that he and his partners were buying American paintings. In the course of the

conversation, he mentioned that he often drove out to the country to hunt for paintings in antique shops and admitted that he was new to the business.

"But what the hell," he said. "All you have to do is look up the artist's name, see what he brings at auction, and you can't go wrong—right?"

"Right," I answered just as the phone rang. It was a long-distance call, and he quickly shook my hand and bid me good-bye.

"Perfect timing," I thought on my way out of the building with plenty of time to get to the bank. But when I got outside and looked at the check, there was a snag. I always assumed that any checks I received from galleries in Manhattan would be drawn on local banks. Using my collection of passbooks, I could instantly cash any check with nothing more than my name on the back of it. But this check was drawn on a small savings and loan in Far Rockaway!

Now I had a problem. I certainly didn't have an account at that bank, and you had to take a whole bunch of subways to get out there.

After every sale, my first priority was to cash the check immediately. It was 1:00 p.m. and I could still make it to Far Rockaway. I looked in my wallet. I still had my voter's registration from 35 East Sixty-Eighth Street. I'll take a chance with that, I thought, and hailed a cab. An hour later and a forty-dollar fare got me to the front door of the savings and loan. There was no way I was going to cash the check with my Florida driver's license, which would be recorded on the back of the check, thereby revealing my Florida address, and there was no way a bank would cash a check, especially a large one, with only a voter's registration card. But, I thought, I might be able to pull something off.

I always carried a roll of cash with me, so I went in and sat down at a desk where I was greeted by a pleasant young man. I began by introducing myself and explained that I lived in Manhattan but had some business with relatives in the neighborhood and needed to open a savings account. I discreetly placed ten hundred-dollar bills on the desk before me. He liked that and lost no time pulling out an application and asking me my name, address, etc. Amazingly, he didn't even ask to see any identification. I gave my old Upper East Side address and volunteered my voter's ID.

That was fine, but then he wanted to see my Social Security card. All I could do at that point was to give him a phony number and promise to bring the card in the next week. He wasn't prepared to let the C-notes walk, so he opened the account and reminded me to bring in the card. Fifteen minutes later, I was presented with a shiny new passbook with a thousand-dollar balance. I thanked him, but before leaving, as a calculated afterthought to deflect any suspicion, I nonchalantly asked, "By the way, what time are you open until today?"

"Till four," he answered.

"I have to go see my uncle," I said. "If I get a check, can I deposit it right away?"

"Sure, no problem," he said with a smile. I thanked him and left.

I hung around the neighborhood until it was close to 4:00 p.m. and went back to the bank. My intention was to deposit the check and return in a day or two to get the cash, but the young man who had opened the account for me wasn't around, so I thought I'd take a chance. I filled out a deposit slip for the check, but when I handed it to the lady behind the counter I asked her if I could cash it as well. After verifying that the check was good, and looking at my

passbook, she told me I could. A minute later, I was walking out of the bank with six grand in cash, and all it took was my signature on the back of the check. As for the grand I'd used to open the account, I planned to retrieve that another time.

Two days later, I returned to the hotel after lunch and approached the front counter to check for messages. I stood at the counter waiting for the clerk, who was talking with two serious-looking men in dark overcoats, one of whom was holding a briefcase. I heard the clerk say, "Yes, sir, I rang his room but there's no answer."

"Room 214?" one of the overcoats asked.

"Yes, 214," the clerk replied. A shock wave ran through me when I realized that that was *my* room number.

The clerk then turned to me and asked how he could help me. My first impulse was to admit that number 214 was my room and to find out what they wanted, but it was as if an invisible hand covered my mouth. Instead, I just asked directions to Rockefeller Center. I lingered for a few seconds, pretending to read a brochure by the counter. Then I heard Overcoat No. 1 say, "Okay, we'll come back later" to Overcoat No. 2. I followed at a distance and watched them leave the lobby and disappear down the street. "Who were those guys?" I asked myself. "Who sent them, and why?" They must be detectives, I concluded, but they just didn't look like cops.

In a state of alarm, I raced up to our room and started grabbing clothes, stuffing them in our bags. But now I faced another dilemma. It was 1:00 p.m. and I had agreed to meet José, who was out shopping, at five. There was no way to contact him and no way I could risk waiting around until five. I was trying to figure out a plan when I was startled to hear the door lock being opened. In a third example of amazing luck in the past couple of days, it

was José. He'd come back to drop off some shopping bags from Bloomingdale's.

"We gotta get out of here!" I told him and explained what had just happened. "I don't know who they were, but they didn't look good." In the next couple of minutes, we were packed and ready to leave. "Look," I told José, "you take the bags and grab a cab downtown to the Gramercy Park Hotel. Take any room you can get. If they don't have any, then just wait there for me."

José left the hotel without a problem, and I approached the counter. Now came the tricky part. Fortunately, there were several clerks on duty and I went to one at the opposite end of the counter from the one who had dealt with the overcoats. I told him that I wished to check out. When he asked if I chose to leave the charge on the credit card, I pulled out my roll of C-notes, said, "No, I'll pay in cash," and took the open charge slip from him. After he counted out the hundred-dollar bills and gave me my receipt, I still had another problem to take care of. Lying in the folder from which he had taken the charge slip was the card I had filled out upon my arrival. It had my name and Florida address on it.

"Could I have the card too, please?" I casually asked, hoping he'd just slide it over, but no such luck.

"Sorry, sir, we have to keep those," he said matter-of-factly. Then, with the wad of bills still in my hand, I discreetly peeled off two Ben Franklins and slid them toward him, whispering that I couldn't afford to have my wife find out I'd been there. To my great relief, he slid the card my way.

Twenty minutes later, I walked into the lobby of the Gramercy Park Hotel and was informed that José had checked into a suite on the tenth floor.

It took hours for my nerves to settle down. We walked around the Village and sat down in a café. We could only speculate who those guys were, and what they would do when they returned to the hotel and discovered that we'd checked out right under their noses.

I strongly suspected that the two overcoats were connected with Revere Gallery. It had to have been my foolish slip of the tongue in giving away my location to the gallery owner that sent them to the Blackstone. But why? And how could he have found out the picture was a fake in just two days?

Perhaps, I reasoned, Jimmy Ricau, who was always informed of the latest gossip among the Madison Avenue dealers, could shed some light on the subject. It had been some time since I'd last spoken to him. He'd had an operation for cancer and had become even more reclusive, but when I called him and related the events at the Blackstone and mentioned the name of the Revere Gallery, he knew at once what had happened.

"Revere Gallery!" Jimmy yelled. "That place is a Mafia front! It's backed by one of the godfathers. The young guy you met is their front man. The dealers say he doesn't know his ass from a hole in the ground and has been running around the city buying up American pictures and paying crazy prices. He's supposed to be making them money with the gallery, but it's really a front to launder drug money."

As to how this novice dealer had discovered the "Buttersworth" to be a fake, Jimmy guessed the answer to that as well. Jimmy had recently been down to Sonny's studio, where he spotted a Buttersworth that he knew to be one of mine lying on a worktable.

"Nice little Buttersworth," Jimmy remarked, baiting Sonny.

"Yeah," replied Sonny. "But the dealers uptown say there's fake Buttersworths all over the place, and this is supposed to be one of them."

Then Jimmy paused and said, "And you're gonna love this. Sonny had examined the picture and said, 'It's impossible for that painting to be a fake.'"

Jimmy speculated that the guy from Revere wasn't in the loop and that after he bought the "Buttersworth," he probably showed it around to one of the dealers on Madison Avenue, who tipped him off. Hence the two overcoats.

After receiving this valuable intelligence, I knew it was time to stop all sales and just lie low until everything blew over. But it was too late. The critical mass had already hit meltdown. As more and more of my paintings suddenly started turning up in New York, suspicion soon turned into rumors of fake Buttersworths, Petos, Heades, Kings, Walkers, and Jacobsens being "all over the place."

Indeed, it seemed that every time I looked at an auction-house catalog, I found another one of my "Buttersworths," complete with "provenance."

Tony was the first to be rounded up by his old buddies from the FBI. And then the picker who'd sold literally dozens of my paintings. And the word was that after Mr. F realized that his luck was a little too good to be true, the feds were looking for a "young lady posing as an heiress who passed off a fake Martin Johnson Heade."

We shut down the studio and dismantled it. Photos, research material, books, and even, to my eternal regret, a collection of letters from Jimmy Ricau were all destroyed. There seemed to be nothing to do except to keep Roy Cohn's telephone number handy and wait for the inevitable.

CHAPTER ELEVEN

The British School

Although it was rumored that the FBI's New York offices had enough of my paintings to open a gallery of their own, nothing was traced back to me. Apparently the paintings had passed through too many hands. The closest they got was to Tony and the picker, but that was bad enough. Tony was on the hook for a "Peto" he'd sold to a Wall Street stockbroker. According to Tony, who kept in touch with me by pay phone, "She tried to sell the painting uptown and found out it was a 'bazooka.'" He explained, "She had a fuckin' cow and called the cops!" And

223

as for the picker, he was sunk when he tried to float yet another "Buttersworth" at an antique show in New York City. Word spread about the painting, and he was paid a visit.

Fortunately, neither of them was easily intimidated. Both claimed the paintings had been found at flea markets. The feds filled out their reports and let them know, "There's an investigation going on" and "We will be getting back to you."

Months passed, and nothing happened. José and I kept the doors locked and quietly ran the restoration studio and antique operation. But every time there was a knock at the door or the phone rang, I thought it was either the feds or the "overcoats."

Only after a year passed without incident did I begin to relax. Life for us had undergone a change. For one thing, we had no more easy money to burn, no more trips to Miami, no more nights on the town in New York. For the first time, I realized how dangerous my occupation was, and I swore off forgery for good. Thanks to the money we had invested in real estate and stocks, we were in good shape. After we were convinced the heat was off, I thought it would be therapeutic for me to shut down the business for a while and do some traveling. We left for London.

A friend had given me a tip on a discreet little hotel tucked away in a quiet street behind Kensington Place, not far from Notting Hill Gate. The Vicarage Gate Hotel was run by an English family and was very traditional. It maintained an "early morning call" in which loud bells rang throughout the old town house, rousing the guests out of bed for the hearty breakfast served in the dining room.

We spent our time shopping along Regent Street, visiting antique markets, and hanging out at cafés. After a few weeks, we decided to get away to someplace quiet where I could relax and

make a plan for the future. We rented a car, took the M4 west, and headed for the city of Bath.

Bath is one of the most beautiful cities in the world. It was built in the eighteenth century by British aristocrats seeking a private paradise away from London. Influenced by the Grand Tour, they adopted a Palladian design for the architecture. Two hours later, we were pulling up in front of the Royal Crescent, a breathtakingly beautiful row of columned town houses arranged in a crescent overlooking their own park. Once the private residences of aristocrats, the town houses had been divided into flats and were now inhabited by ordinary people. A local woman told us that number 22 was one of the few town houses of the Crescent that was still intact as a private home, and that it was owned by an eccentric old lady who, she said, "might rent a room to you if you look presentable."

All forty-three town houses that make up the Royal Crescent have white doors. The owner of number 22, Miss Wellesley Colley, a descendant of the duke of Wellington, had decided one day to paint her door yellow. The Bath Historic Society demanded she paint it white as before. Miss Colley told them to piss off, and a novel legal battle ensued. The residence was dubbed "the Scandal House" in the newspapers, and the case gained national attention. It caused a deep divide among the residents of the Crescent. Two years and tens of thousands of pounds in lawyers' fees later, Miss Colley prevailed and maintained her yellow door.

We rang the bell and were greeted by the notorious Miss Colley herself. A woman of about eighty, she was very British, very old-fashioned, and very direct. Without hesitation, she offered us the grand drawing room complete with an adjoining bedroom, marble fireplace, eighteenth-century furniture, and views of the park.

Number 22 had been in the Colley family for generations and was virtually unchanged since the eighteenth century. Much of the furniture was original to the house, and even the bathrooms had hardly been modernized. Occasionally I sat down and had tea with Miss Colley as she recounted for me her life in the grand old house. But these days, it was showing its wear, and Miss Colley was the last in her family line.

The more we stayed in Britain, the more we liked it, especially Bath. For the next two years, we only went back to Florida briefly, to check on our property and take care of any pressing business. We divided our time between London, where we stayed at the Vicarage Gate Hotel, and Bath, where we stayed at the Royal Crescent. The countryside around Bath is very beautiful, and I tried, as part of my rehabilitation, to paint scenes of the rolling hills and the River Avon. But something was missing. I was unfulfilled. I felt like a professional poker player forced to play for toothpicks.

Back in London, I began to spend time at the auction houses, just to look at the paintings and sit in at the sales. Then, one fine day, I strolled into Christie's just as an exhibition of British sporting pictures had gone on view. Although I'd seen examples of the genre before, I'd never taken much interest in paintings of horses, dogs, and fox chases. However, in my new Anglophiled state, I began to develop an appreciation of these pictures. How easy they would be to paint, I thought, after studying a few of them closely. I also noted the old antique frames that surrounded them.

I caught the attention of a department expert and asked him the estimate of a picture of a foxhound that caught my eye. Probably in the hope of cultivating a new American client, he gave me my

first lesson in the school of British sporting paintings. He pointed out the highlights of the exhibition, taking me from painting to painting. He showed me a Stubbs, a Wootton, and a Herring. He explained what to look for in a superior painting and then, as a parting gesture, gave me a complimentary copy of the sale catalog to study at my leisure.

I had a couple of hours to kill before meeting José for dinner, so I strolled over to Ponti's at Covent Garden, ordered a cappuccino, and studied the catalog. I began by flipping through the pages and glancing at the illustrations of paintings with the artists' names directly beneath them. This exercise would familiarize me with the artists and what each was noted for. As I scanned the pictures, though, another issue presented itself. I noticed that the name of almost every artist was preceded by an interesting collection of phrases, such as "Attributed to," "Signed," "In the circle of," "Studio of," and others. My curiosity piqued, I searched the catalog and found an explanation of the cryptic phrases in the back pages under the heading "Explanation of Cataloging Practice." In small print under the heading was an explanation of what each phrase meant.

"Attributed to" meant that, in Christie's opinion, the work was created in the period of the artist and might be in whole or part the work of the artist.

"Signed" meant that, in their qualified opinion, the signature on the painting was the signature of the artist.

"Bears signature" meant the signature might be that the artist.

"Manner of" meant the work was in the style of the artist, but *of a later date* (emphasis mine).

"Signed/dated/inscribed" meant that, in their opinion, the work was signed, dated, or inscribed by the artist.

"With signature/with date/with inscription" meant that they believed the signature, date, or inscription was by a hand other than the artist's. Only when they printed an artist's name all in uppercase, without a preceding qualification, did they believe the work to be by the actual artist, and even then they made it clear that it was *only an opinion*.

All this I found interesting, to say the least. But as I read on, I was amazed when I came to paragraphs in even smaller print entitled "Conditions of Business." Pulling out my pocket magnifying glass, I dropped down to "Limited Warranty." It began by stating that "Christie's warrants the authenticity of authorship on terms and conditions to the extent set forth herein." All that sounded fine and good until I proceeded to read the "Terms and Conditions" set forth. In what can only be described as a masterpiece of duplicity, the terms and conditions made it clear (that is, if one had a law degree) that they warranted and guaranteed absolutely nothing. However, farther down, a paragraph entitled "Guarantee" made it plain for even the most thickheaded. It stated: "Subject to the obligations accepted by Christie's under this condition, neither the seller, Christie's, its employees, or agents is responsible for the correctness of any statement as to the authorship, origin, date, age, size, medium, attribution, genuineness, or provenance of any lot."

With that settled, I read on, and came to a paragraph dealing with forgeries. It stated that if within a period of five years after the sale the buyer could establish scientifically that the painting purchased was a fake, the "Sole Remedy" would be a refund of monies paid. It further stated that "this remedy shall be in lieu of any other remedy which might otherwise be available as a matter of law." God, I thought, if this Limited Warranty were any more

limited, it wouldn't exist! So, after reading these conditions and realizing that:

A) Virtually nothing sold here was guaranteed to be what it claimed to be,

B) Neither the auction house nor the seller assumed any responsibility whatsoever,

C) Even if a buyer discovered a painting to be an outright fake, all he could do was ask for a refund,

I came to the conclusion that this was an engraved invitation to do business.

Two hours later, I was at the Sea Shell of Lisson Grove having fish and chips with José. After recounting my experiences at Christie's and briefing him on the subject of British sporting pictures, I pulled out the auction catalog, pointed out the different designations Christie's used to place paintings in various degrees of authenticity, and drew his attention to the so-called guarantee.

"Do you realize what that means?"

"What?" he asked.

"It means that I could put paintings in these salesrooms all day long and it's perfectly legal! It means that no matter what designation they use, they still offer no guarantee. And neither does the seller!"

"I thought you were reformed!" José said, and I assured him I was. "So, what now?" he asked.

"Tomorrow we are going to work," I informed him. We spent the next two days at Foyles buying up every book on sporting art we could find, plus any back issues of auction catalogs on the subject. Then, posing as a novice collector, I paid visits to the Bond Street dealers who specialized in sporting paintings. They were happy to educate me on the finer points of equestrian portraiture

and gave me copies of their catalogs. Finally, after buying a couple of worthless old paintings, some brushes and paints, and of course some rabbit-skin glue, we called up Miss Colley and headed for Bath.

The Bath and Bristol area of Britain, known as the West Country, now held a new meaning for me. As I began to study the pile of research material we had brought from London, I was surprised to learn that the West Country I'd come to love was in fact the very birthplace of British sporting art.

During the first decades of the eighteenth century, wealthy aristocrats began building grand Palladian-style mansions in the West Country of England. They were attracted by the country's beautiful rolling hills, hidden valleys, and numerous streams, and by the River Avon. There they could indulge in fox hunting and horse racing. By midcentury, during the reign of George III, the West Country was steeped in sporting culture, a way of life that carried a decadent stigma.

Rich young aristocrats could chase foxes by day, have dinner parties at night, and then go to Bath for the theater or gambling. They soon created a social controversy by having their favorite horses or dogs painted by local artists and then hanging the paintings in their drawing rooms!

In time, a number of artists began to cater to the demands of these new patrons and specialized in what we call "sporting art." George Stubbs, one of the most talented, tried to put a respectable face on the genre, depicting the country gentlemen all decked out in their finery for a day at the hunt. Others, such as John Wootton, James Seymour, John Nost Sartorius, and Thomas Spencer, portrayed the sporting life the way it really was, capturing the dirty stables, brutish trainers, wily jockeys, and greedy gamblers.

I was fascinated by the history of sporting art. To enhance my understanding of the subject and get into the spirit of the project, we visited a number of the local estates open to the public, such as Longleat House, famous for its collection of Woottons.

With a little improvisation, I managed to prepare an "antique canvas" and then paint a red-coated gentleman atop a hunter as they jumped over a fence. It was painted in the style of Sartorius, one of the early sporting artists. After the picture was dried and aged with a light patina and fitted up in an antique frame found at a local flea market, I slipped it into a shopping bag (Harrods) and took the morning train to London. I strolled down Bond Street and went straight to Sotheby's. I found the valuation counter and got in line with half a dozen other people carrying their treasures, some in shopping bags like mine, others wrapped up in old blankets and twine.

It was all very routine. Experts were called from various departments to examine items if the screeners at the counter spotted any potential. For me, though, it was a very important moment. My turn came, and a lady carefully removed the painting from the bag, looking closely first at the front, then the back. "I'll call someone down from the picture department," she said, and invited me to have a seat on the side. Then an astute-looking man in a pin-striped suit appeared, gave me a nod, and picked up the painting. "Hmm, looks like circle of Sartorius," he informed me. "Maybe five hundred quid." I gave him a nod. And with that he handed the picture to the lady at the counter, instructed her to write it up, and left.

Five minutes later, I was back out on Bond Street, my first auction-house contract in hand. It wasn't much. They had only estimated the painting at four hundred pounds. But it wasn't the

money that counted. "Is it possible," I asked José that night at dinner after our second bottle of wine, "that we could fool the British at their own game?" We were laughing too hard to take it seriously. But the answer came a month later, when a check arrived for six hundred pounds, two hundred pounds over the estimate.

This changed everything, and soon we were back in Florida.

The studio was cleaned up, a new stock of antique pictures for reconstitution was collected, a load of research books on the topic of British sporting paintings shipped from London was arranged on the shelves—and the "factory" was back in business. Just as important was what this meant to my psyche. I was incredibly happy, electrified—as if I'd been given a new life, a new direction, a new future.

As I began to study the many books and auction catalogs I'd accumulated, I was surprised to discover patterns in many of the British painters' works similar to those that I'd found in the work of the nineteenth-century American painters. Identifying these patterns, isolating and organizing them for quick comparisons, was one of the essential keys to creating a successful fake. Many of the British sporting artists, beginning in the eighteenth century with painters such as John Wootton and James Seymour, and continued by the likes of John Frederick Herring Sr. and John E. Ferneley in the nineteenth century, made exact or nearly exact copies of their own paintings in order to meet the demand of the local gentry to own portraits of famous racehorses. Just as Buttersworth placed the exact same yacht in different settings, and just as Heade copied the same flower or bird from painting to painting, so it was that many of the sporting artists copied the exact horse—or horse and jockey—from painting to painting in different settings while simply varying the colors.

The sporting genre wasn't confined to horses and jockeys but also included portraits of prized bulls, foxhounds, and even hogs. Any one of these subjects painted against the rolling hills of the West Country could be another "original."

I began by creating a collection of twelve paintings using a mix-and-match technique of composition. The assortment consisted of fox chases in the "manner of Sartorius," "nineteenth-century school" portraits of bulls and hogs, portraits of horses on landscapes "after Ferneley," and finally horse and jockey portraits in the "circle of J. F. Herring," my favorite among the nineteenth-century sporting artists.

Herring was one of the most sought-after equestrian painters of his time. He was famous for his bright, crystal-clear portraits of well-known jockeys astride champion racehorses. Herring often set his subjects in an open field with a landmark racetrack such as Doncaster in the distance.

The paintings varied in size, but couldn't exceed twenty-four by thirty inches so that they could fit into a large suitcase. I picked out six of the paintings, packed them into a suitcase, and booked a flight to London. My only worry was being stopped at customs, but I passed right through and went straight to the Vicarage Gate Hotel. The next day, I visited the local antique frame dealers. Each piece was fitted up with an antique frame complete with chips, scrapes, and missing pieces so they'd be right at home in the sales-rooms. The next step was to distribute the paintings. I took one to Christie's, one to Sotheby's, and another to Bonhams. In each case, it was as simple as the first time I'd taken the "Sartorius" to Sotheby's.

I waited a few days and went back to the same houses with other paintings. "I can't believe how easy it was," I reported to

José over the phone. "I could do this all day long. They just look at the painting, give me a price, and then write it up. No questions asked."

I flew back to Florida, packed up the other six paintings, and it was tallyho. A few days later, I was back in London. We didn't have to wait long before checks issued in pounds sterling and written from banks like Lloyds, Barclays, and National Westminster started arriving in the mail.

José and I were busy day and night hunting for old canvases, planning out the next collection for export, and thinking of ways to perfect the routine. For instance, to avoid becoming too familiar a sight at the auction houses, I studied the different types who routinely appear at the valuation counter and altered my appearance accordingly—sometimes showing up in a flat cap and wax coat, just in with a find from a country market. Other times, especially after arriving in the UK with a deep Florida suntan, I'd play the glamour role, complete with cashmere overcoat and Hermès scarf, just another society playboy discreetly parting with a family heirloom produced from a Dunhill shopping bag. I even worked on perfecting a British accent. These measures, along with the fact that I often got different experts to evaluate my pictures, kept me way below the radar.

London, I was convinced, held a special magic for me. I felt at home there, as though it was where I had always belonged. I loved the history, the streets, the shops, cafés, and pubs. José felt the same. Professionally, London offered me all I could ask for.

To this day, London is still the center of the antique print trade. For me, these shops served as an important source of research material that was soon translated into new paintings. In the eighteenth and nineteenth centuries, it was common for engravings to

be copied from paintings. It can also work the other way around. A painting can be copied from a print of the period.

Tucked away in a mews near Covent Garden was Grosvenor Prints, one of the oldest shops in town, boasting one of the largest accumulations of period prints in the world. Housed in a fine Georgian building with high ceilings and tall windows, it had walls lined with long, shallow drawers. Within the drawers were portfolios, worn with age and tied with ribbons, encompassing prints of every imaginable subject. The proprietor, a large, portly man dressed in a dark suit, looked like an Oxford professor and rarely moved from a complex of antique desks piled with books. Instead, he directed an assistant, a pretty French girl, to the drawer that might contain the portfolio on the subject I required. The aproned assistant would then roll up an old wheeled library ladder to the desired drawer, climb up, locate the portfolio, and, with a sweet smile, deposit it on a table for my undisturbed inspection. The place looked as if it hadn't been touched since the nineteenth century and, if the ghost of Hogarth is anywhere to be found, I'm certain it's haunting the Grosvenor Print Shop.

Another major attraction for me was London's antique-frame dealers. I spent days hanging out in their musty old shops, making friends with the proprietors and often rolling up my sleeves and helping out. The weekly antique markets like Portobello, Camden Passage, and Bermondsey assured me an easy and steady supply of artifacts destined for reconstitution.

Culturally, London offered us everything we could want and more. We went to the opera, symphony, theater, and museums. And with plenty of money, we were frequently to be found along Jermyn Street, where one can find the finest men's specialty shops in the world. We bought our shirts at Hilditch & Key, cashmere

sports coats at Dunhill, and country outfits at Cordings. Indeed, Samuel Johnson's famous saying "When a man is tired of London, he is tired of life" rang totally true.

As I continued to study the work of artists like Seymour, Wootton, Herring, and Ferneley, I began to understand their way of thinking, their way of visualizing, the way they set up a painting, the way they designed cloud patterns, the rolling hills of the landscape with hedgerows, and the colors of their palettes. Designing new paintings in their styles came effortlessly to me. I also enjoyed inventing original sporting pictures—not based on the style of any particular artist of the period—just to see if the British would buy them. They did. But the more I spent time in the West Country and the more my love and enthusiasm for sporting art grew, the more I believed I'd finally found myself artistically.

What a pity I hadn't been born in the eighteenth century! I lamented. I was certain I could have done well. Here I was in Bath, in the land of Jane Austen, right on Milsom Street, a street no doubt familiar to artists and the aristocrats who commissioned their work. The grand houses were still here and many of the paintings too. But, alas, I had arrived a couple of hundred years too late. I loved Bath and the country life so much that I felt misunderstood, victimized by fate, and stuck in a century where I didn't belong.

As paintings "In the style of Sartorius," "In the manner of Herring," and "In the circle of Ferneley" began hitting the block at Sotheby's, Christie's, Phillips, and Bonhams, I was averaging around three thousand dollars for each one. My pictures almost always doubled or tripled the house's estimates. It was an intoxicating thrill to see my pictures hanging in the exhibitions and

watch the experts examine them. I remembered the first time I'd visited Sotheby's and stood in the exhibition rooms, never dreaming that one day my own pictures would hang there too. It was an even bigger thrill to attend the sales and watch them sell. We always celebrated with a night at the theater and dinner at Simpson's-in-the-strand. Afterward, we often walked around Leicester Square. I was drawn to the artists who sat there and did portraits for a few pounds. I liked to watch them work, but sometimes it frightened me, and I wondered if one day I'd wind up there too.

This routine went on for about a year but it was not without its problems. First, there was the matter of customs. If I had been stopped in a random customs check, like they often made in Britain's airports, I would have had to explain away a couple of suitcases loaded with British paintings. And using suitcases limited the size of the pictures to a maximum of twenty-four by thirty inches.

I reduced the risk of the first problem by finding out how people were selected for a search by the customs agents. A travel book published for college students went into the subject at some length. The book described several profiles the sharp-eyed agents look for in flagging down a traveler. For instance, single young men with long hair and an unkempt appearance, wearing jeans, could be targets for a marijuana search. Nervous-looking people in a rush could be smugglers of some kind.

The book pointed out that to avoid being stopped, one should dress conservatively and neatly. Be clean-cut. Don't be in a rush. Don't look around as you are waiting for your bags. And, above all, never look at the agents. In other words, just blend in with the crowd and go with the flow, ignoring the agents completely. So my standard outfit was khaki pants, a blue Oxford shirt, a Baracuta

jacket, and penny loafers. As an added touch, I always carried along one of those thick British travel guides that I conspicuously displayed in my hand as I pushed my cart along.

After a year or so, the suitcase maneuver gave way to Phase II. In the mideighties, the English country look became very popular. Fashion designers such as Ralph Lauren and Laura Ashley, who copied English design in their clothing, now moved into English home furnishings. Top decorators were in the salesrooms, buying up all the English furniture and paintings they could find. The auction houses snapped up my pictures as fast as I walked in the door with them. But the more paintings I placed in the London market, the more I had to diversify them in size and subject matter in order not to raise suspicions. As I became ever more familiar with the market, I learned that British marine paintings, which included those of James and Thomas Buttersworth, went hand in glove with the sporting pictures. In fact, the two genres were often featured together in the sales catalogs.

Once again, I was running around London buying up every book I could find on the subject. The genre of British marine painting stems from Britain's glorious maritime history. From the mid-eighteenth century to the end of the nineteenth, a progression of artists specialized in painting everything from the majestic battleships that protected the island fortress to beautiful clipper ships that imported goods from faraway places like India and China.

During the eighteenth century, British marine painting was dominated by such artists as Thomas Whitcombe and Charles Brooking. Later in the nineteenth century came artists like Thomas Buttersworth and Nicholas Condy. Since no respectable English drawing room is complete without a painting of a ship on

the sea with the white cliffs of Dover on the horizon, it was essential that I include these paintings in my repertoire as well.

The problem of transporting larger paintings into Britain was solved one afternoon after I had dropped off a few paintings at the auction houses. With some time to kill, I decided to view a collection of nineteenth-century European paintings on display in Sotheby's exhibition rooms. Always ready to learn more, I recognized the expert in charge and struck up a conversation with him about the condition of a painting on display. He remarked that the canvas was extremely dry and brittle and would soon require a *relining*.

Relining is a process whereby an antique painting is rebacked with a new canvas. The antique painting is carefully removed from its stretcher. Then it is placed facedown on a table with a perfectly flat surface. Next, a special glue or wax is spread all over the back of the antique canvas. Then a sheet of new canvas is pressed down over the antique canvas and flattened down under pressure by various methods until the two pieces of canvas fuse together as one. The painting is then remounted onto a new stretcher. The procedure reinforces the original canvas, which has become fragile with age, and restores a flat, even surface to the painting. It is a common procedure, and nearly every painting found in a museum has been relined. While I pretended to be ignorant of a process that I routinely performed on customers' paintings back in Florida, the kind expert was eager to show me an example of what he was talking about. He removed a painting from the wall. Relining, he explained, is nothing new. In fact, relining antique paintings became common over a hundred years ago, but the particular relining he wanted to show me was of special interest.

Leaning the painting against the wall, we each got down on one knee and took a close look. It was an example of an old type of relining that I'd seen many times before—but about the history of which I had known nothing. This particular technique was called a "screw-press lining," the expert said as he proceeded to point out its unique characteristics. He estimated that the example we were studying was from the first decade of the twentieth century.

The canvas used for the relining had a common broadcloth weave. The stretcher used to replace the original was about three inches wide and had sturdy square joints at the corners. It was a standard stretcher used at the time, sometimes referred to as an "English stretcher." The keys used to expand the joints had rounded heads, and there was a cross brace for added strength. Another important characteristic was the beveled edge of the stretcher over which the flap or border of the relining canvas was wrapped and secured, first with a row of tacks placed along the very edge of the stretcher and then with glue to hold down the last inch of fabric to the beveled edge.

The expert went on to explain that the Industrial Revolution had produced a great demand for British paintings and old masters. The paintings were needed to fill up the mansions of a new class of wealthy industrialists in search of an instant pedigree. There existed at that time a huge reservoir of antique paintings that had never been restored. In order to make these paintings salable, large restoration mills sprang up around London and processed literally thousands of paintings. Art dealers like Duveen made millions selling these pictures to their nouveau riche clients.

Before the screw press, the adhesive used in the relining process had been beeswax. A layer of hot liquefied wax was applied

between the old and new canvases, and the two were then pressed together with a hot iron. It was a long and tedious process, one that left a messy coat of wax on the back of the canvas. To speed up the relining process, the screw press was invented. It resembled a large book press. The antique painting was placed facedown on a steel bed. The back of the painting was then painted with a coat of water-based glue. Then the new canvas was placed over it. Finally, a large, flat sheet of steel was lowered down by turning a series of screws until the antique and new canvases were pressed together under great pressure. The result was a very flat relining. When viewed from the back, all that could be seen was a clean, dry sheet of canvas.

The relined painting was then mounted onto the standard three-inch-wide, square-jointed English stretcher. Although years of oxidation had turned this stretcher and canvas dark brown, thousands of these relinings are still holding up fine today, creating a characteristic appearance familiar to collectors and experts.

When my expert was finished, I helped him lift the painting back onto the hook and thanked him for a most enlightening afternoon. I walked over to Ponti's and over a cappuccino reviewed the contracts I had collected from the day's deliveries. But my mind kept wandering back to the expert's dissertation on relining. If I could simulate a screw-press relining, I thought, I could solve a number of problems at once. First of all, if I relined my paintings, I might no longer have to hunt up antique specimens to reconstitute. Instead, I could find cloth of the same weave used by the artists of the period, apply gesso, and use it as my canvas for the painting. The challenge would be to make it crack properly, and the relining would have to be "aged" in a way that would make it appear that it had been done a long time ago.

If I could paint a picture on modern cloth, which is pliable, and then reline it, I should have no problem rolling it up. And, I reasoned, if I could roll them up, I could easily bring larger paintings into Britain. The only problem would be that I would have to mount them onto the stretchers after I got to London. The idea fascinated me. Would it be possible to make fakes out of entirely new materials and fool the auction-house experts with them? I would have to revamp my whole operation.

Before I left London, I stopped and bought a legal pad. I spent the flight home in a state of excitement, drawing up a step-by-step plan to manufacture fakes out of modern materials.

Back in Florida, I searched through my inventory of old paintings and found a perfect example of a screw-press relining that had been applied to a second-rate eighteenth-century British portrait. In the privacy of my studio, I took the painting completely apart. The stretcher went straight to an accomplished woodworker. I had him make me a dozen stretchers and keys in varying sizes, constructed exactly like the old one. The tacks were no different from carpet tacks still used in upholstery work. A handful of them bought at the local hardware store went into a jar of saltwater for some quick rust.

Next, I had to find canvas that would resemble the type used by artists in the eighteenth and nineteenth centuries. I also needed heavy broadcloth of the type used in early relining. My search led me to upholstery-supply houses that carried a variety of cotton and linen weaves used as underlining in the upholstering of chairs and sofas. Some of these weaves came from places like India and China. One cloth, known as osnaburg, had all the irregularities of the cloth commonly used by artists in the eighteenth century. In fact, I learned that its manufacture hadn't changed in

hundreds of years! The question remained, could I make the cracks on a modern canvas resemble antique ones? Once again, I turned to rabbit-skin glue. After working with this unique substance for years, I had become an expert in its use and its properties.

I began by tacking a piece of canvas onto a stretcher. Next I made up a thinned-out solution of glue and water, which I spread evenly over the canvas. Then I mixed up the gesso using my usual formula and, with a four-inch-wide brush, painted the gesso directly onto the impregnated canvas, using even, horizontal swipes of the brush. After a thorough drying, I observed that when held at an angle to the eye, the canvas displayed a perfect surface "signature" consistent with hand-applied gesso on canvas commonly seen on eighteenth- and some nineteenth-century paintings. Also when placed out in the sun and allowed to heat up, the tensile strength increased and stiffened the canvas. Finally, it only took the slightest pressure with the palm of my hand to send a shattering pattern of perfect cracks throughout the canvas.

For the relining, I employed a new heat-activated glue developed for restorers. The glue, which has the consistency of rubber cement, is simply painted onto the back side of the antique canvas after it has been removed from the stretcher. Then the new canvas is laid down over it and pressed on with a hot iron. The beauty of this system is that it produces a "dry" relining, without the use of wax, and the appearance is identical to a screw-press relining.

The "oxidation" of the stretcher and the relining canvas was achieved with the use of cheap poster colors thinned out with water. These earth-toned stains were brushed, sprayed, and blotted onto the stretchers and canvas, creating a mottled effect. Then, to even out the finish and simulate a layer of dust, a solution of

rotten-stone powder and water was sprayed on and allowed to dry in the sunlight of the courtyard.

Once again José and I were traveling to Britain. This time, we were carrying duffel bags. One bag would carry a collection of as many as ten of my larger and improved sporting and marine pictures, all relined, varnished, and rolled up into a single bundle. Two other bags carried the "antique" stretchers, all broken down, taped together, and marked with the names of the paintings they belonged to. Indeed, the risks of being noticed by customs were increased but that just made it all the more thrilling.

Back at the Vicarage Gate, the bundle of paintings was unrolled and assembled. Then each painting was taken to a framer. A few days later, the paintings were distributed to the various auction houses around the city. With the addition of the marine paintings, I was able to consign two, and sometimes three, paintings at each house.

All the pictures were enthusiastically accepted at the valuation counters. I watched carefully as the experts looked over each painting, first the front, then the back. Although the paintings were created entirely of modern materials and assembled only days before, at no time did any of the experts show any suspicion.

After all the paintings had been placed, we packed our bags, rented a car, and headed out to Bath. The next month was spent exploring Cotswold villages that could have been drawn by Thomas Rowlandson, and hunting through antique markets for period frames.

For the next year, we shuttled back and forth to Britain with our cargoes of paintings in duffel bags. But to avoid suspicion, we had to keep spreading the paintings out to different places. Soon we were traveling around the countryside to place pictures in Phillips'

regional auction houses in cities like Cambridge and Oxford, but our best connection was the Phillips right in Bath. Rich tourists, many of them American and eager to take home a piece of British history, often bid up prices to three times the high estimates. At one sale, I was seated next to a wealthy woman from Boston. She was buying up half the paintings. We chatted a bit, and she asked me, "Do you think it's an original?" as a "Herring" hit the block.

The auctioneer in Bath, a handsome Cambridge-educated Englishman, welcomed me with open arms every time I walked in with more paintings. My works were doing very well in his sales, and in time he realized that I was the artist as well. But he wasn't interested in the provenance; in fact, he usually gave me a hint of what he would like to have for his next sale.

Sotheby's, I discovered, had converted a fine old country place in Surrey, Somerset House, into salesrooms. For me it was a delightful day trip out in the country, especially if I was in London alone. With a painting all wrapped up in brown paper, I'd leave the Vicarage and catch a morning train to Billingsgate. Usually I sat outside between the cars in the fresh air, watching the beautiful countryside roll by. When I arrived at the station, I'd catch a cab for the short ride to Somerset House. I loved going there. It was a place where gentlemen could do their business at their leisure, a place to chat with the country squires attending an exhibition or meeting the local trade. Sometimes it served as a back door to Bond Street. "Yes, a very interesting painting indeed," I was informed once by the resident expert. "Perhaps with your permission we could send this up to London?"

More than once, the painting never made it to the expert at all. On one occasion, I was unwrapping a lovely portrait of a bay hunter à la J. E. Ferneley outside the entrance so as not to make any noise

inside. As I was doing so, I noticed, as had happened once in New York City, that I'd become the object of attention—this time of a group of men standing nearby and sporting Barbour jackets and flat caps. I guessed that they were country antique dealers. One gentleman in a tweed sports coat and ascot slipped away and went into the house. A second later he emerged, walked right up to me, and cheerfully asked, "Well, what have we brought today?"

I realized he was passing himself off as Sotheby's staff. Playing along with the ruse, I presented the unwrapped painting for his inspection. "I would like to have an opinion on this," I said. Instead of offering an estimate, he asked me how much I was hoping to get. "Well, I've got seven hundred in it, but I was hoping it might be worth a couple thousand," I replied. With that, he asked me if I'd mind, and took the painting over to his waiting colleagues. The next instant, they were hustling me over to the car park, out of Sotheby's view, and offering me fifteen hundred quid, cash. "Oh, I thought you were with Sotheby's!" I declared with feigned astonishment. "*Haw, haw, haw,*" laughed the squire. "He thought I was with Sotheby's!" he declared to his friends, and then went on to explain, all in good humor, why I would be much better off taking the fifteen hundred now instead of consigning the painting to Sotheby's and waiting months to get paid. "And besides," he assured me as his mates looked on with glee, "they're just a bunch of thieves anyway!" Twenty minutes later, fifteen hundred pounds richer and confident the Mafia wouldn't be chasing me, I was enjoying a lunch of Cumberland sausage and a pint at the local pub.

Back in Florida, José and I began to notice an interesting phenomenon. Paintings that we'd gone to so much trouble to get into Britain and sell in the auction houses there were turning up

in the United States! "Look at this!" I said over breakfast in the courtyard one morning, and handed José a decorator's magazine I was looking through. "We put that painting of a bull in a sale last winter in Ipswich! Hell, that's near the North Pole, and now it's hanging in a millionaire's home in Texas!"

"Yeah," José said, "we could have just driven the painting over there." Other paintings that we had sold in Britain turned up in New York auction houses as well. It was this boomerang effect that gave us the inspiration for the third and final phase of the British School.

I went into the studio and came back with a number of auction-house catalogs from New York salesrooms. As I had once done in London, I turned to the backs of the catalogs, and, with the help of a huge magnifying glass, we searched through "The Conditions of Sale." Again and again we saw the phrase "Neither Christie's nor the consignor make any representations as to the authorship or authenticity of any lot offered in this catalog."

"Hell, they don't guarantee anything here either!" I said.

"True," José said. "Well, maybe we could save people the trouble of going to England and sell them right here!"

Within days, a packet of photographs was sent up to Christie's in New York. It didn't take them long to send us a reply stating that they "would be delighted" to include the paintings in their upcoming sales.

A week later, we packed up the car with paintings and headed back to the Upper East Side of New York. We pulled up to Christie's, and José waited in the car while I carried in the paintings. Minutes later, I was back in the car with a contract, and we headed downtown to Katz's for hot dogs. Thus began the domestic distribution of my British paintings.

In this phase of the operation, we needed to establish a production line and limit our personal deliveries. I was working harder than ever, often turning out two or three paintings a week. The studio was packed with pictures and it became impractical to fit each painting with an antique frame. Our solution to the problem was to order high-quality frame moldings from the best frame maker in the country. We ordered the moldings finished in real gold leaf in simple but elegant eighteenth- and nineteenth-century patterns.

After each painting underwent a "screw-press relining," we cut and assembled a frame for it. The next step was to photograph all completed paintings. Then packets of photos were sent to auction houses in New York, New Orleans, Philadelphia, Washington, London, and Bath. As soon as the inevitable reply came back, we built our own crates and shipped them out. The demand was insatiable, and we soon had paintings being sold simultaneously on both sides of the Atlantic.

The phones never stopped ringing. Christie's New York would call one minute and Sotheby's London the next. Occasionally they asked if I could offer a provenance on any of the paintings they'd received. "What a joke!" I said to José after getting off the line with someone from Christie's. "She actually asked if I could shed any light on the history of the 'Herring.' She should see this place!"

Sometimes the situation became embarrassing, because I couldn't keep track of which pictures had gone to which auction house. When someone called to discuss estimates, illustrations, reserves, or other details, I'd often confuse the paintings being referred to. To remedy this problem, José set up a bulletin board on the wall above the desk. On large index cards, he wrote

Christie's London, Sloans DC, Phillips New York, etc. with a felt-tipped pen.

These cards were tacked across the top of the board. Then photos of all pictures currently in the hands of the auction houses and awaiting sale were tacked under the houses that had them. Thus I was able to see at a glance how many pictures were out and where they were. The photos were removed as the pictures were sold, and new photos took their place. By avoiding the need to look up correspondence, this system also allowed me to continue painting while I was on a speakerphone talking with experts at the auction houses.

By the late eighties, our distribution had been fine-tuned. We judiciously selected and sent out a continual stream of British paintings from an ever-expanding repertoire to auction houses in the United States and Britain. The paintings were routinely attributed to such artists as James Barenger, Samuel Spode, James Seymour, George Stubbs, John Boultbee, J. E. Ferneley, J. F. Herring, John Nost Sartorius, Sir Edwin Henry Landseer, and others of the sporting genre, and Thomas Whitcombe, Thomas and James Buttersworth, Charles Brooking, and others among the marine painters. José had set up accounts with each auction house with standing instructions to wire the sale proceeds into a number of British and American accounts held in his name. To ensure that we always had plenty of spending money for shopping, we set up a joint account in Harrods Bank, a swank little facility in the store's basement. Now when we traveled to London, we no longer took chances with customs. Instead we went to pick up cash and go on shopping sprees.

On one of our trips to Bath, we went to see a beautiful first-floor flat in the Circus. Built in the eighteenth century and just a

block away from the Royal Crescent, the Circus is an architectural masterpiece inspired by the Coliseum in Rome. As its name suggests, the town houses, all thirty-two of them, form a large circle. Palladian in design, they face a common green. The understated elegance of the Circus appealed to me even more than that of the Royal Crescent. The flat was part of the estate of Barling, a famous antique dealer on Mount Street in London, recently deceased. His personal weekend retreat, it was composed of a drawing room, a study, a marble bathroom, and a sunken kitchen with a balcony reached by a hidden staircase. The entire flat was appointed with magnificent architectural details.

It didn't take us five minutes to make up our minds, and José signed a contract that very day. From a business standpoint, it was a good move in more ways than one. We could save a fortune in hotel bills, use it to store the antiques and picture frames we bought, and of course set up a studio. We left it in the hands of a local solicitor and returned to Florida, excited about getting our own place in Bath.

It was all too good to be true. Everything tumbled down soon after we got back home. José began feeling ill and went to the doctor. It was the worst news possible. He had contracted AIDS, and it had already progressed to a serious stage. It was devastating news for both of us. I was determined not to lose my best friend and insisted we fight it with all we had. For the next year, we tried every experimental drug that came along. But every visit to the doctor and every blood test only confirmed that the situation was getting worse. The deal for the flat in Bath had to be scrapped, and the studio was shut down. As a last-ditch effort we decided to fly to Kinshasa, Zaire (now the Democratic Republic of the Congo), where it was reported that a clinic was having success in treating

Sampling of more than three decades of publications containing Ken's paintings.

THE TIMES

No. 64,576 | WEDNESDAY FEBRUARY 24 1993

Car boot painting set to make £34,000 profit

Long-term jobless goes over a million

By ALAN HAMILTON

SOMETIMES it happens on *The Antiques Roadshow.* Some dusty and unregarded artifact that has languished for generations in the family attic is identified as being a genuine Stradivarius or Hepplewhite or Constable. Sharp intake of breath by gobsmacked owner. Dream come true. Envy of neighbours.

But car boot sales? Hardly. A nationwide Sunday morning institution for the exchange of naught but the dregs of family junk. Trios of flying ducks, and yet another framed print of that ghastly green woman from Boots.

There had, by the law of

Unexpected booty: detail from the picture bought for £2 at a car boot sale

averages, to be a gem among the dross sooner or later. An anonymous American holidaymaker found it recently on offer from a car boot near Bristol. He bought it for £2. Cheap at the price. But some-

where in the back of the American's mind, an alarm clock went off. Something distantly familiar about the painting, 12in. by 10in, of humming-birds. Had he not seen something vaguely simi-

lar in, oh where was it, a gallery in Washington perhaps? Dammit, he couldn't remember. So he went back to London and took it to Christie's.

Aha, said Nicholas

Lambourn, the auctioneers' resident American art expert. This is *Ruby Throats with Apple Blossoms,* by the American painter Martin Johnson Heade, 1819-1901.

The picture goes up for sale in New York next month, and is expected to make more than £34,000.

"This gentleman was driving down there and told me he just happened to come across a boot sale. He wandered round and spotted this picture, which rang a bell with him but he didn't know why," Mr Lambourn said yesterday. "I saw him and was able to say it came from a series of humming-bird pictures, all of which are similar. I expect he

would have seen one of them when he was somewhere like the National Gallery in Washington."

Heade specialised in humming-birds. He brought his paintings to London in the 1860s, but could not find a printmaker equal to the task of reproducing his brilliant colours, so he sold his originals to Sir Morton Peto, whose descendants live near Bristol. Only four prints were published.

Another Heade original, *Brazilian Humming-birds I,* was also discovered near Bristol recently. It will appear in the same sale, with an auctioneers' estimate of between £62,000 and £82,000.

By PHILIP BASSETT
INDUSTRIAL EDITOR

JOHN Major acknowledged yesterday that long-term unemployment is now too high as the number of people out of work for more than a year rose above a million for the first time in five years.

The passing of the million barrier marks a doubling of long-term unemployment since it began to rise again in 1990.

In reply to an accusation in

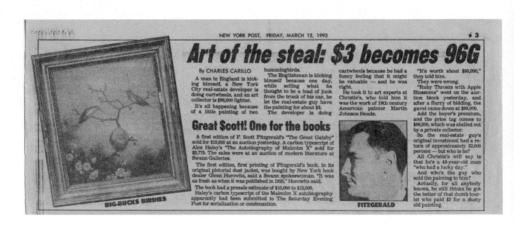

Art of the steal: $3 becomes 96G

By CHARLES CARILLO

A man in England is kicking himself, a New York City real-estate developer is doing cartwheels, and an art collector is $96,000 lighter.

It's all happening because of a little painting of two hummingbirds.

The Englishman is kicking himself because one day, while selling what he thought to be a load of junk from the trunk of his car, he let the real-estate guy have the painting for about $3.

The developer is doing

cartwheels because he had a funny feeling that it might be valuable — and he was right.

He took it to art experts at Christie's, who told him it was the work of 19th century American painter Martin Johnson Heade.

"It's worth about $50,000," they told him.

They were wrong.

"Ruby Throats with Apple Blossoms" went on the auction block yesterday, and after a flurry of bidding, the gavel came down at $88,000.

Add the buyer's premium, and the price tag comes to $96,800, which was shelled out by a private collector.

So the real-estate guy's original investment had a return of approximately 32,000 percent — but who is he?

All Christie's will say is that he's a 42-year-old man "who had a lucky day."

And who's the guy who sold the painting to him?

Actually, for all anybody knows, he still thinks he got the better of that dumb tourist who paid $3 for a dusty old painting.

Great $cott! One for the books

A first edition of F. Scott Fitzgerald's "The Great Gatsby" sold for $19,800 at an auction yesterday. A carbon typescript of Alex Haley's "The Autobiography of Malcolm X" sold for $5,775. The sales were at an auction of modern literature at Swann Galleries.

The first edition, first printing of Fitzgerald's book, in its original pictorial dust jacket, was bought by New York book dealer Glenn Horowitz, said a Swann spokeswoman. "It was as fresh as when it was published in 1925," Horowitz said.

The book had a presale estimate of $10,000 to $15,000.

Haley's carbon typescript of the Malcolm X autobiography apparently had been submitted to The Saturday Evening Post for serialization or condensation.

BIG-BUCKS BIRDIES

FITZGERALD

ABOVE: *The Times of London headline.* BELOW: *NY Post "Big Bucks Birdies."*

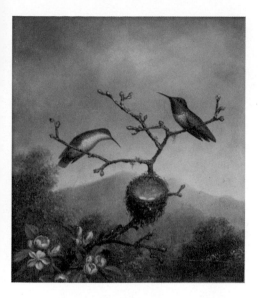
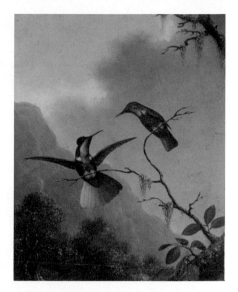

ABOVE LEFT and RIGHT: *After Martin Johnson Heade, "Gems of Brazil," c. 1992–93.*
BELOW: *Rear view of one of the "Gems of Brazil," c. 1992–93.*

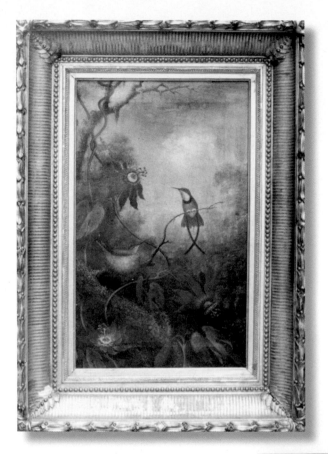

ABOVE: *"Fat Boy," 1994.* BELOW: *"Fat Boy," rear view, 1994.*

"Roman senator," fictitious 19th century French painter, c. 1997.

WESCHLER'S
March 1997 Newsletter

Come see two of Weschler's many faces: each month we display a different countenance of fine objects in each of our catalogue auctions. In March we feature *American & European Paintings, Drawings and Sculpture*, including this splendid portrait of Osceola of the Seminole Indians, as well as a wonderful selection of exquisite *Jewelry & Watches*. Show *your* face at Weschler's: the preview for these auctions begins on March 2.

Circle of Robert John Curtis. *Portrait of Osceola of the Seminole Indians*, painted c. 1838-1845, oil on canvas, *30 x 25 in (76.2 x 63.5 cm)*. Estimate $4,000-6,000.

Portrait of Osceola.

ABOVE: *After James E. Buttersworth, c. 1997.* BELOW: *The Bonhams promotional postcard that triggered the FBI investigation.*

19th century British School, c. 1987.

the disease with a new drug. The treatment consisted of a series of injections administered over the course of forty days.

As we could have predicted, the treatment was worthless and the situation only got worse. Our last battle to save José's life was fought at the National Institutes of Health in Bethesda, Maryland. He got every experimental drug they had in their arsenal, but nothing could halt the progress of that awful disease. Finally we came home defeated, and José passed away in his bedroom, surrounded by his family.

CHAPTER TWELVE

The Gems of Brazil

In 1863, the American artist Martin Johnson Heade traveled to Brazil to study the flowers and hummingbirds that flourish there. He journeyed into the mountains and was able to observe many species of rare hummingbirds in their natural habitat.

Heade went to work and produced a series of small paintings portraying the iridescent birds in beautiful tropical settings. Some of the paintings show the tiny birds fluttering around exotic flowers; others show them guarding their nests and precious eggs. He titled the collection of approximately twenty paintings *The*

Gems of Brazil. An exhibition consisting of twelve of the paintings was held in 1864 in Rio de Janeiro. It received enthusiastic praise from Emperor Dom Pedro II, and Heade was awarded the Order of the Rose.

Heade returned to America with his collection of paintings in 1865. He did not intend to sell the paintings, but instead planned to reproduce them as colored lithographs in a book titled *The Gems of Brazil.* As it turned out, he had to travel to London to find a publisher willing to take on the project. But the process of chromolithography failed to capture the beauty of the birds to the satisfaction of the artist, and the project never was completed. Nevertheless, Heade profited from his efforts and received many commissions for copies of his *Gems* when the collection was displayed in London. The original collection was eventually purchased by Sir Morton Peto, a prominent art collector who lived in Bristol (and was no relation to the American painter John F. Peto).

When I first began painting pictures in the style of Heade, I had read a book Jimmy had given me, *The Life and Work of Martin Johnson Heade*, by Theodore E. Stebbins Jr., the world's expert on the artist and the curator of American paintings at the Museum of Fine Arts in Boston. As I read the story of Heade's making copies of his *Gems* in England, I took particular note of the statement "Several of *The Gems of Brazil* have been discovered in England."

It was bad enough to have lost my best friend, but we had spent so much money in the battle to save his life that I was almost broke as well. The situation was desperate, and I had to come up with a plan. The idea of "finding" a Martin Johnson Heade in England had crossed my mind more than once. Through the years, I had put together a file on the subject, as was my habit with any artist or

situation that caught my interest. Whenever an example of a *Gem* was published in a magazine or turned up in an auction catalog, I would cut it out and add it to the file. Now, when I most needed it, the material was there.

Before I could consider anything so ambitious, though, I had to do something for immediate cash. I went to work painting "Buttersworths," "Charles Bird Kings," "Antonio Jacobsens," "Petos," "Walkers," and others, all on reconstituted period supports. Even though a decade had passed since the close call with the FBI, I knew I was still taking a big chance, but I had to do something.

I made calls to my old friend the picker and to some of the same dealers who had bought American pictures from me years ago. I let them know that I could offer packages of paintings, high-class American fakes, at bargain prices. Though so much time had passed since I had painted my last American pictures, my skills had greatly improved, and the new generation of paintings was better than ever. One old customer bought ten to twenty paintings at a time, for a thousand bucks apiece. Gradually, I built up some cash reserves, but, to my chagrin, it wasn't long before I noticed some of these paintings turning up at auction houses for ten times what I had sold them for.

In the meantime, I was methodically working on a collection of *The Gems of Brazil* on the side. They were perfect in every respect, and I had complete confidence that I could walk into any auction house, show them to any expert, and no one would suspect a thing.

In the spring of 1992, I packed a bag, threw in a *"Gem,"* and took off for London. The next day, I was back at the Vicarage and back to my usual routine of shopping and hanging around Notting Hill Gate until my jet lag wore off. When I was ready for action,

I slipped the "Heade," a lovely little picture of two ruby-throated hummingbirds checking each other out on a branch, into a shopping bag (Burberry) and headed to the Notting Hill tube station. I planned to pose as an American tourist and present the painting at the valuation counter of an auction house. The story I had concocted was that I'd found the painting at a car boot sale near Bristol, and that I thought I'd seen something similar once in an art magazine back home.

I took the Central Line and got out on Bond Street, just steps away from Phillips Auction House, so I thought I'd give them a try. I went to the valuation counter and produced the painting. An expert was called from the picture department. A moment later, a bored-looking young man appeared and introduced himself. "I have a painting I found at a boot sale and would like an opinion," I said. He daintily picked it up, twirled it around once or twice, and stated definitively, "It's just some kind of study, perhaps worth fifty quid." Then, as a final insult, he added: "You'd be better off trying to find an antique dealer to sell it to."

Although I very much wanted to, there was no way I could enlighten him as to the painting's importance, because I was supposed to be as dumb as he was, so I thanked him and left.

Back out on Bond Street, I was seized with the feeling that this whole idea was absurd and that there probably wasn't a person in England, art expert or otherwise, who had ever heard of *The Gems of Brazil*. Well, let me go to Christie's, I thought: they usually know what they're doing. At Christie's valuation counter, I pulled out the painting. An astute woman behind the counter picked it up and looked it over carefully. She interrupted a department expert who was engaged with another customer. They whispered to each other and then informed me that they suspected it to be American. She

asked me to have a seat while they called down their resident expert on American paintings. Five minutes later, an important-looking man arrived at the counter, picked up the painting, and declared: "This is a Martin Johnson Heade." The women then directed the expert's attention to me.

"Well, this is a very interesting painting," he said. "Tell me how you came by this."

"Actually, I found it in a boot sale near Bristol," I answered, and went on to explain. "I thought I once saw something like it in a magazine back home in the States." It all added up for him, and he proceeded to give me a brief history of Martin Johnson Heade and how *The Gems of Brazil* had wound up in the collection of Sir Morton Peto. "Well, it's quite valuable," he said. "But we'd have to take it in for research before we could give you an accurate estimate. For now, however, I would place a provisional estimate of ten thousand sterling." Pretending to be flabbergasted when in fact I was elated that the picture was recognized, I put out my hand for a shake, and he instructed the lady behind the counter to draw up a contract.

Half an hour later, I was sitting at my usual spot at Ponti's, sipping a cappuccino. I really love Britain, I thought, as I studied the document on the table before me, which included instructions to pay my account at Harrods. Well, so far, so good, I thought, but I was still short of cash, and there was no telling when or if they would put the "Heade" up for sale. There was nothing to do now except to go home and get back to work.

It had been two years since José passed away, and I was still struggling to get by. A friend of mine who lived in New York City called one day and told me that he knew of an antique dealer who wanted to hang some of my British pictures in his shop,

"no questions asked." I loaded the car with paintings and headed north.

Paul H. was a young Englishman whose mother owned one of the biggest antique businesses in Britain. It operated out of a manor house outside London and boasted a helicopter pad for the convenience of its exclusive clientele. Paul had wanted to strike out on his own, so he'd come to New York to start a business. Unfortunately, his art and antique shop in the Village wasn't doing well, and he was looking for something to juice up the bottom line. In fact, he was a step away from closing down when I pulled up to his shop on Eleventh Street.

Almost as fast as we got the paintings hung, they started selling. It kept his business going and put nearly twenty thousand badly needed bucks in my pocket. With this new outlet in place, I was busy painting pictures and traveling back and forth to New York. Almost a year had passed, and I still hadn't heard a word from Christie's concerning the "Heade." Discouraged, and convinced that for one reason or another the deal had gone bad, I showed some of my American pictures, including several "Heades," to Paul. He was immediately interested and agreed to buy them and others I could supply for cash. This arrangement worked out well and enabled me to extend my visits to the city. What he did with the paintings, I didn't ask.

One freezing February night, I was walking along Sixth Avenue in the Village when I stopped dead in my tracks, turned around, and went back to a newsstand I had just passed. I thought I had caught sight of one of my paintings on the front page of a newspaper. Sure enough, there on the front page of the London *Times* was my "Heade." The headline read: "Car boot painting set to make 34,000 pounds profit." Apparently Christie's had been amused by

my story and had given it to the press. The article described how an American tourist had made the lucky find in a West Country boot sale. It stated that the picture was set to be sold in a couple of weeks in their New York salesrooms.

I had never expected the picture to be sent to New York. When I called my answering machine back home, there were several messages from Christie's informing me that the picture was scheduled for sale in New York, along with desperate pleas for me to send them the two hundred bucks they had paid Theodore Stebbins for his authentication. The next day, I went to Christie's to see the painting and buy a catalog.

When the elevator doors opened on the second-floor exhibition rooms of their Park Avenue establishment, I was suddenly face-to-face with my old friend the dashing young auctioneer from Phillips in Bath, the very one who promoted my work in the West Country. Having come up in the world, he was now at Christie's New York, but under the circumstances neither of us was anxious to catch up on old times. Instead, we just smiled and passed each other with a wink.

On the day of the sale, the picture fetched ninety-six thousand dollars, nearly doubling its fifty-thousand-dollar estimate. The story of the "lucky find" followed the picture across the Atlantic and was picked up by the Associated Press. Apart from the sale being shown on the local six o'clock news, the story got in almost every major newspaper in the country. The *New York Post* titled it "Big Bucks Birdies, The Art of the Steal." Even my mother read about the sale in a local Florida newspaper and called to tell me to "look around for paintings of little hummingbirds next time you go to England." Indeed, a month later, I was sitting in the bank at Harrods, battling the flu and collecting my ninety g's in cash.

Thanks to "Big Bucks Birdies," the pressure for money was relieved, at least for the time being, and I could concentrate on my next project.

I was in my studio one day reviewing files and trying to decide what to paint next when inspiration walked right in through the door. My old buddy Mr. X, the picker, came by carrying one of the most beautiful nineteenth-century American frames I'd ever seen. It was a deep-fluted cove frame with a palm decoration in each corner, a common pattern up to the Civil War, but the quality of the carving, the beauty of the patina, and the weight of the frame set it apart as an outstanding example. An expensive frame made expressly for an important painting, it was about five inches in width and would accommodate a painting only twelve by twenty inches in size.

Ever since my friendship with Old Man Jory, my love for antique picture frames had never waned, often leading me to prefer to hang empty frames about the house rather than my own pictures. Antique frames frequently served as inspiration for me, and as soon as I laid eyes on my friend's frame, I knew exactly what belonged in it.

Mr. X knew it was an outstanding frame, and wanted to swap it for a painting. I offered him a beautiful little "William Aiken Walker" that was hanging on the wall. He took it, and the frame became mine. My friend was barely out the door before I lunged for the filing cabinet and pulled out a folder marked "Passionflowers."

The original collection of *The Gems of Brazil* painted by Heade was a series of small canvases, approximately ten by twelve inches each, depicting pairs of hummingbirds in tropical settings. As time went on, he expanded the series to include exotic flowers

along with the birds. These paintings were larger than the original *Gems*, some as large as eighteen by twenty-four inches. Heade used three or four different orchids, which he repeated in painting after painting, but he only used the passionflower in a few known paintings.

The passionflower series is regarded by many collectors as Heade's most beautiful, rare, and mysterious work. To find a passionflower Heade would be the dream of any collector. In these beautiful paintings, the deep red of the passionflower contrasts dramatically against the lush green background, and once again the colorful little hummingbirds are carefully placed about on branches and vines.

I knew that Heade had painted a number of these pictures in a vertical format, and my guess was that that format was close to the size of the frame before me. I opened the file and spread out prints of every example of these pictures I had found over the past decade. A quick check of the sizes confirmed my belief. More than one was executed on a twelve-by-twenty canvas. This initial observation also revealed another important point. Just as Heade used the same orchid in painting after painting, so it was with the passionflower. Obviously painted with the use of a stencil, the same red passionflower down to the smallest detail appeared in painting after painting. This repetition was also true of the birds. In fact, my choice of a bird was made easier by a print of a surviving sketch Heade had made of a passionflower study. Heade had placed a little crimson topaz, a bird he used over and over again, on a vine with the passionflower.

The next step was to check my inventory of antique paintings. The twelve-by-twenty canvas was a common size in the nineteenth century, and I had more than one example to choose from.

I took it as a good omen that everything was falling into place so rapidly. By the following day, I was making paper cutouts of the flowers and birds, just as Heade himself had done. On a sketch pad, I traced out a twelve-by-twenty rectangle, the same size as the canvas. After drawing in a tropical background in the typical Heade style, I arranged the paper cutouts of the flowers and birds in just the right positions, traced them in, and then connected everything together freehand with a tangle of twigs and vines.

Generally, one of my "Heade" paintings could be completed in two sessions: one day for the background, which consists of the sky, foliage, and landscape, and then, after that is dry, the flowers, birds, vines, and other details are added. Before the week was over, I had a perfect example of Heade's rarest paintings.

It would need a month to dry in the Florida sun before I could begin the aging process. But the temptation to place it in the frame was irresistible.

I locked the doors, turned off the phone, and sat back in a chair, entranced by the painting hanging on my wall. I would never know what type of painting the frame had once held, but I couldn't help but feel that this masterpiece of carving, made perhaps a hundred and fifty years ago, had been waiting for just this moment and for just this painting.

Now that my picture was finished, I turned my thoughts to strategy. If I were to present the painting as "restored," it would be highly unlikely and even suspicious if such a painting had not been published in a catalog or book in the past. Therefore, I decided that, even though the risks might increase, my master-piece would be a "long, lost Heade" that hadn't seen the light of day since it was painted. The rule among savvy dealers and collectors was that if you found an important picture, you sprang it

on the auction market in its original unrestored condition without showing it to anyone.

Indeed, many important paintings fetched more unrestored—with all their dirt, holes, and tears—than if they had been cleaned up and presented in pristine condition. The reasoning behind this peculiarity of the art market is that the presentation of an uncleaned picture attests to its "freshness"—that is, it has come straight out of a dusty old attic. Psychologically, this condition will excite potential buyers to pay a premium price.

When at last I felt that the paint was sufficiently dry and hard, I was ready to begin the aging process—and prepared to use every trick in my book.

The cracking went perfectly, forming a pattern that would fool even the most seasoned expert. And the caramel-colored varnish, stripped off the surface of several nineteenth-century paintings, was transferred onto the "Heade," giving it an impeccable, albeit heavy, patina.

It is common for antique paintings that might have incurred minor tears or punctures to acquire a number of crude repairs through the years. So for the benefit of any connoisseurs who fancied themselves forensic experts, I added two small patches, cut from antique canvas, to the back of the painting.

Astute experts might examine these repairs carefully and note if the paint used for the touch-up on the front of the painting had been applied on *top* of the old varnish or *under* it. If the retouching had indeed been applied on *top* of the surrounding varnish, and if the repair was of considerable age, it could be added proof that the discolored varnish might well be the original coat applied by the artist.

Next, since the time I first observed accumulations of fly deposits on some of Jimmy Ricau's paintings, I'd realized that

these can act as another convincing piece of forensic evidence establishing the age of a painting for the trained expert. It could take seventy-five years or more for an undisturbed accumulation of these droppings in their peculiar characteristic patterns to become visible on the surface of a painting. Transparent when first deposited by common houseflies attracted to the surface of a painting by the sugar present in the varnish, they eventually turn brown and then black with the passage of time. The tiny nubs ultimately become insoluble and can *only* be removed with the sharp point of a scalpel.

For some time, I had been perfecting the simulation of these deposits by mixing up some epoxy glue with an amber-colored powered pigment, dipping the end of a pin in the glue, and then touching the surface of the painting with the pinpoint covered with the glue. The result was a small elevated globule virtually indistinguishable from the real thing. It was tedious work, but in this manner I was able to arrange the droppings in their characteristic clusters. Flyspecks go hand in hand with dark, discolored varnish and are usually found on lost and neglected paintings that have been relegated to an attic or barn for storage long ago. On this occasion, when I was ready to apply my flyspecks, I realized that I had just used up the last of my epoxy glue, but I found that thickened linseed oil, which I kept in a bottle nearby, had a viscosity similar to the epoxy and worked just as well. A week later, after the "flyspecks" had dried, a final dusting of rotten stone finished the job.

From the moment it was fitted into its frame, with the use of some nineteenth-century nails, the painting took on a life of its own. It was the perfect fake. I decided to hang it in the house above the fireplace and enjoy it for a while. One evening a friend came

over for dinner and was greatly impressed with the painting. He dubbed it "Fat Boy."

All that was left now was a plan. A "flea-market find" was simply out of the question. The last thing I needed was to have another story in the press and have someone get suspicious. I wanted a discreet but plausible story. There was, however, a "provenance" I had been keeping in reserve for just the right situation. I decided this *was* the situation, and that *now* was the time to play the Ricau card.

In June 1994, I wrapped Fat Boy in a blanket, strapped it in the backseat of the car, and drove up to New York. When I got there, I shoved it under the bed in a friend's apartment in the Village and hung out around the city, deciding on how and when I would make my move.

I was having lunch one afternoon in a café on Madison Avenue, contemplating a photo of the painting. Well, what the hell, I thought, let me give it a try. I paid my bill, walked to Seventy-Second Street, and hung a left. Sotheby's is housed in a tasteless glass-and-steel building situated on the corner of York Avenue and Seventy-Second Street. There wasn't much to distinguish it from the New York City Hospital complex next door, except the name Sotheby's in bronze letters above the doors and, of course, the usual black limousines double-parked outside. I strolled through the glass doors, entered an elevator, and pressed the button for the American Picture Department on the third floor.

Here goes, I thought, as the doors opened. This was very different from London. The New York operation didn't have time for the riffraff and no longer had a valuation counter to encourage walk-ins. I stepped into the reception area and approached a young man sitting at a desk who was involved in some paperwork. "Can

I get an opinion of this painting?" I asked as I laid the photograph of Fat Boy on his desk.

"Have a seat and I'll have someone take a look," he said, and disappeared with the photo through a doorway. Several minutes passed, and he returned with a young lady who, after introducing herself, stated: "If you'll follow me, Dara Mitchell would like to discuss your painting with you in her office." With that, I got up and followed her. In her office! I thought. "That's quite a painting you have," my guide remarked with a smile as we walked along.

This was the first time I had gotten behind the scenes at an auction house. We passed by a large open area where people were leaning over layout tables, perhaps organizing the sales catalogs. After working our way through a maze of hallways, we arrived at Ms. Mitchell's office. She was VP of the American Picture Department: tall, blonde, attractive, the very embodiment of a high-class New York executive. Standing behind her desk, she extended a hand, introduced herself, and said, "A painting like this only comes in once a year!" I thanked her, introduced myself, and sat down in the comfortable chair she offered me. At this point, we were joined by Peter Rathbone, president of the department. Introductions were made, and now it was time to get to business.

"Well, how did you come by such a marvelous painting?" Dara asked.

"Actually, it was a gift, given to me years ago by Jimmy Ricau. He was a collector. Perhaps you've heard of him?"

Jimmy had been dead nearly two years. His collections had been bequeathed to a number of museums. The rest of his estate, including his magnificent house, had been left, as the story that was circulated went, "to a young man from Pennsylvania."

"So you knew Jimmy?" Peter asked.

"Oh, yes, we were good friends. Years ago, I used to spend summers up at his house and help him work on it."

"Up in Nyack, was it?" Peter asked.

"Piermont, in fact," I responded. "I collect antiques, and Jim taught me everything I know. He gave me the painting as a gift, and I've been sitting on it ever since. I live in Florida now. There's a piece of real estate I've had my eye on that just came on the market. I have to raise some cash fairly soon if I want to get it."

"Well, this could certainly do that," Dara said, with her eyes on the photograph of Fat Boy.

"Exactly. So that's why I'm here. I'd like your opinion on what it could fetch and how long it would take to get it sold."

"Obviously it's a very important painting, but you realize that we have to examine its condition before we could give you an accurate estimate. But I would say at the very least it's probably worth three or four hundred thousand, perhaps more." Then after a pause to gauge how that sat with me, she asked, "Where is the painting now?"

"Oh, it's just downtown at my friend's apartment," I casually replied, and noticed how that perked them up.

"I hope it's in a secure place!" Dara said, slightly alarmed.

"Oh, yeah," I said. "It's under the bed. The only problem I would have is the time frame—when could it be sold?"

"The first sale we could put it in would be September," Dara said, then added: "But we have a more important sale where you might do better, in November."

Now I felt confident enough to spring the trap. "Well, I'll have to give it some thought, whether I want to go the auction route or

see what I could get from one of the dealers on Madison Avenue for an immediate sale."

Dara cringed. "Oh, they'll never pay you what you want. Look, if it's a matter of immediate cash, we can easily arrange an advance, say a hundred thou?" I pretended to be mildly impressed, when in fact I was in an acute state of ecstasy.

"Well, I'll have to check with the broker, but that might do the trick," I said.

"Yes, well, we're in the business of instant gratification here," Dara said, and the meeting took on a more humorous tone.

"So you stayed up in the old house with Jimmy?" Peter asked, obviously intrigued.

"Is it true that even the dust in the house was nineteenth-century?" Dara jokingly asked.

I replied in the affirmative, and for the next half hour I entertained them with Jimmy Ricau stories. We covered everything from the black one-eyed cat to the marble-bust cemetery in the basement.

"So, when could you bring the painting in?" Dara asked.

"Well, if you want, I could go now and be back with it in an hour."

"Please, by all means!" she gushed.

We all shook hands, my escort was summoned, and I was led back out through the maze. With my bona fides established and the promise of a hundred grand in cash, I was deliriously happy as I walked toward the subway. When I got to my friend's apartment, I pulled Fat Boy out from under the bed, wrapped him in a black plastic garbage bag, slipped the whole thing into a Bloomingdale's Big Bag, and headed back to the Fourteenth Street subway station.

This time when I got out on the third floor with my package, the young man at the desk was on the phone before the elevator

doors closed behind me and my pretty escort was out in a split second with an even bigger smile. Once again we passed the layout tables, only this time the employees' eyes followed me.

Dara warmly greeted me at the door of her office. She made a call and we were joined by Peter and another young lady I assumed to be an assistant. Dara suggested I use the countertop above some cabinets in her office to rest and unwrap the painting on.

For me, it was the moment of truth. I once read that the second an expert lays eyes on a painting, he knows whether it is genuine or fake. If anything is wrong with the painting, be it compositional, technical, or aesthetic, he'll catch it on his first impression, and it could doom the sale.

My audience silently took their positions behind me as I placed the wrapped painting on the counter. Carefully feeling the edge of the frame, I made sure the back of the painting would be facing them as I pulled off the covering. Certain that they had glimpsed the period stretcher, canvas, and patches, I turned the picture around. All three zoomed in for a close look as they studied Fat Boy in silent admiration.

"That's the finest passionflower I've ever seen painted by Heade," Peter said.

Compliments and nods of approval came from the other two. I made for the chair and got comfortable. Dara sat down behind her desk, and Peter relaxed against the counter with his eyes on the "Heade."

As the tension lifted, Peter made an observation. "Do you know what those little black specks are?" he asked rhetorically, pointing to the tiny clusters on the painting. "They're fly droppings. For some reason, flies love paintings and leave those tiny specks. Some paintings are covered with thousands of them."

I confessed that I was puzzled over those little spots and thanked him for sharing that interesting bit of information. Peter then went on to observe that although the picture was quite dirty, it was in remarkably good condition.

"Well, then," Dara said, "I'm sure we could have an advance arranged for you in just a couple of days. Shall we write up a contract?"

"I guess so" was my reply, and we all shook hands. With that, Dara handed some notes to the assistant and asked her to prepare a contract.

"Have you considered having it cleaned?" Dara nonchalantly asked.

"Well, actually, no," I responded. "Jimmy always told me it was best to sell pictures in their original condition and never tamper with them."

"Yes. That used to be true," she said, "ten years ago when dealers dominated the market, but that's all changed."

"These days you have wealthy private collectors who go head-to-head with dealers, and they want everything in restored condition," Peter said.

"I can see a catalog cover here if it was cleaned," Dara added in an attempt to persuade me.

"No, no, I really don't want to fool with it," I said. "I'd rather leave well enough alone. Why risk it? What if we ran into problems?"

They both nodded, and that seemed to settle the matter, but then I stuck my foot in my mouth by saying, "Besides, I don't think it's all that dirty: after all, you can easily see the picture just fine."

"Oh, no, no, no," they sang in unison. "It's very dirty." And to demonstrate just how very wrong I was, Peter seized the painting

and told us to follow him to the "darkroom." We marched down a hallway and entered what I took to be a technician's room with a large worktable in the center. Peter placed the frame facedown on the table and, with a pair of pliers, removed the antique nails, which, I noted, he studied for a second. When he removed the painting, Peter was quick to point out how clean the paint was around the edges, a common occurrence with period paintings. A simple application of masking tape along the edges of the canvas before I sprayed on the "antique" varnish had taken care of that.

Suspended above the table was a large lamp. Peter placed the picture on the table, drew an enormous curtain across a wall to block out the light from a window, and then turned on a switch. For my part, I assumed the role of the studious novice as the ultraviolet light came on and Fat Boy took on a strange greenish glow. For the next fifteen minutes, I was treated to a dissertation on "the effects of ultraviolet light on antique paintings."

After Peter made an airtight case proving that the painting was smothered in old discolored varnish most likely "applied by Heade himself," we returned to Dara's office, where a contract was waiting. Thankfully, this trumped the issue of the cleaning, and the subject wasn't mentioned again. The papers were signed amid handshakes and smiles. Fat Boy was whisked away, and I took my leave with a promise of an advance in a couple of days.

On the morning of my appointment, Dara called. "Can we push back our appointment until two o'clock this afternoon?" she asked. "The financial officer will be here then, and we'll discuss the situation concerning the advance." I agreed I would be there and hung up. I didn't want to ask any questions on the phone, but I didn't like the word "situation."

When I arrived at Dara's office that afternoon, the word "situation" was clarified for me by a bald-headed man with wire-framed glasses in a Brooks Brothers suit. Peter was also present.

"Dara explained to me your need for an advance on your painting," the moneyman said, getting right to the point. "We would certainly like to give you the funds against the sale. However, we've had a change in our policy. We now require a proof of ownership, a purchase receipt, or a copy of a will, for instance, before we can make an advance. In your case, perhaps you have some correspondence from Mr. Ricau acknowledging the gift to you?"

"You see," Dara chimed in, "we recently paid out an advance of two hundred thousand dollars to a gentleman who brought us a number of paintings to sell. Then when the paintings went up for sale, we were served with an injunction secured by his relatives forbidding the sale. As it turned out, he really didn't have the right to sell the paintings." Dara paused and added, with great gravity, "We never recovered the two hundred grand."

Peter solemnly nodded in affirmation. The way Dara said this gave the impression that it had brought the auction house to the brink of bankruptcy. I expressed my disgust at the incident, but thought, What a great guy!

I was caught off guard by this development and had to make a fast decision. It had always been against my principles to prop up any of my pictures with phony documentation. I had read books about art forgers of the past who relied on false documentation to dupe amateur collectors. When the paintings eventually came under the scrutiny of experts, they were recognized as fakes. I, on the other hand, preferred to subject my works to the scrutiny of experts first, and then the sale would follow, so my answer was that I didn't think I had any such document.

"Not even a card or note he might have written to you?" Dara pleaded.

"I don't think so," I said and deliberately looked perturbed to see what Dara would do. After all, she *had* made me a promise.

"Well, if you can't come up with something," Dara offered, "we would be willing to waive the thirty-day hold on the funds at the time of the sale. As soon as we get paid, you will be paid."

Once again, I learned the hard way that when you made a deal with Sotheby's, *you should get it in writing!* I reluctantly accepted her offer, but let her know that this could be a real problem for me. Dara reiterated that I would get paid as soon as they received payment.

Now that that was settled, Dara dove right into the next issue, and the subject of the cleaning reared its ugly head again. After seeing my hundred grand evaporate, I needed this like a hole in the head.

"Well, have you thought about the cleaning?" she asked.

"No, I haven't," I answered, looking a bit puzzled. "As I said, I really don't want to take any risks."

That was no good with Dara. "You really are doing yourself a great disservice. It could mean an extra hundred grand in the price!"

"Well, I don't know about that," I said. "Jimmy always told me not to tamper with valuable pictures."

"We have the very best restorers," Peter said. "This would be routine for them."

"Yes. I really must insist," Dara said. "There isn't any reason it shouldn't be cleaned, unless there is some problem."

"Some problem," I thought. What exactly did she mean by that? I knew I was now in a delicate situation. If I became too adamant

in my refusal to have the picture cleaned, "some problem" might blossom into her full-fledged suspicion. My instincts told me to play the novice.

"You have to understand, selling this picture was a big decision for me. I probably won't ever get another chance to make this kind of money again, and the thought of fooling around with it terrifies me. I really would prefer to leave it alone."

Dara seemed to understand that, and Peter nodded. It was clear to me that Peter really didn't care, one way or another.

"And besides," I added, in what I thought was a brilliant stroke, "I would hate to deny the new owner the excitement of seeing this picture cleaned for the first time since it was painted."

This apparently struck a chord with Peter, and he agreed. Dara, exasperated, finally gave up and wanted to discuss the reserve price. On her desk, she had the department's file on Heade's passion-flower pictures (not as extensive as my own), which gave the prices they had brought and the dates of the sales. A figure was agreed upon, and at last our business was finished. We all shook hands again, and I left.

Crestfallen about the hundred grand, and uneasy with my disagreement with Dara, I went to a nearby café to get a glass of wine and think things over. Suddenly this deal had taken on a whole different configuration. The hundred grand was out the window, but it was replaced with a promise of immediate payment when the buyer settled. The timing of the payment and the timing of the inevitable cleaning were both critical issues. It was imperative that I get paid before the picture was cleaned, as I had planned, but now Dara's insistence on having the painting cleaned prior to the sale threatened everything.

Normally, auction houses hold the proceeds of a sale for thirty days before releasing them to the seller. For me, this

waiting period would be the danger zone. After a buyer settles on the lot he purchased, it becomes his property, and he can do anything he wants with it—have it analyzed, examined, restored, etc. Occasionally, a serious problem is discovered, such as the revelation of extensive restoration that wasn't disclosed before the sale, or the fact that the property was not correctly attributed to either the period or artist listed, or the discovery that the property is an outright fake. If the purchaser returns the property to the auction house before the house settles with the seller, and the claim is valid, the sale will be rescinded and the money held by the house will be returned to the buyer. If a purchaser discovers a problem with a property after the house has settled with the seller, he *can* still get a refund, from the auction house, but it's a lot harder and sometimes impossible.

Because I had created my picture to appear as though it had never been cleaned, it was a foregone conclusion that it would go from the auction house to the restorer. The only thing I could *not* foresee was the timetable of the events that would follow. If, for instance, the buyer waited two weeks to settle on my picture, which isn't unusual, that would only leave open a sixteen-day window for the buyer to go to a restorer, discover it to be a fake, and get a refund within the thirty-day period.

In the auction game, some big spenders will settle on the day of the sale, and others will wait a month. It's all up to the individual and how fast he wants to get his hands on the property. Some might have a picture cleaned immediately, while others might leave it alone indefinitely. I had to plan on a worst-case scenario and assume the picture would be settled on immediately and go straightaway for restoration. Although an antique picture can be cleaned on the spot, as Dara was so anxious to prove, it would

have been breaking the rules of professional protocol and indeed subjecting the picture to a certain, albeit limited, amount of risk.

In the hands of a professional restorer, an antique painting—especially a valuable painting—is always removed from the stretcher first. This is accomplished by carefully extracting the old tacks that secure it around the edge. The painting then undergoes the relining process. It is only after the relining that the painting is ready for cleaning.

The reason for this sequence is easy to understand. The restorer must, above all things, cause as little damage as possible to a picture during the course of the restoration process. Antique paintings are cleaned with powerful solvents such as acetone. When acetone is applied to the surface of a painting that has not been relined, the solvent will immediately soak down right through the cracks in the painting and saturate the old dried-out canvas. This might, in some instances, have an undermining effect on the undercoat of gesso. This could destabilize the gesso layer and cause tiny pieces of it to separate from the old canvas. These loosened pieces would in turn be caught and pulled up by the cotton swabs used for the cleaning. These dislodged pieces are referred to as "losses," and enough of them can result in serious damage.

The relining process greatly minimizes the risk of losses by reinforcing and stabilizing the gesso undercoat by the impregnation of the adhesive used, be it hot wax or heat-activated glue, which is spread all over the back of the original canvas before the new canvas is pressed onto it.

The paint on Fat Boy would not be able to sustain a prolonged cleaning. True antique oil paint becomes extremely hard over time and insoluble to acetone. However, modern paint will quickly dissolve under a swab of the solvent. This would alert the

restorer to the fact that something was wrong. Assuming, there-
fore, that Fat Boy would be dispatched for restoration shortly
after the sale, I had come up with an idea that would delay any
cleaning—indefinitely.

After Fat Boy had received his coating of "antique" varnish, I
filled a hypodermic needle with epoxy glue and injected a bead of
resin behind and between the stretcher and the canvas. Hidden
by the stretcher and virtually impossible to see, it literally welded
the canvas to the stretcher. Nothing short of a jackhammer would
ever separate the canvas from the stretcher again.

Although it's rare, a restorer will occasionally run into a painting
that has become fused to the stretcher. This can occur if a painting
has been lying around in a damp area over a prolonged period of
time. The rabbit-skin glue used in the gesso has been known to leach
out in damp conditions and can fuse the canvas to the stretcher,
especially if the canvas is being pressed against the stretcher by some
external means. Sometimes a separation is achieved by the simple
action of slipping a spatula down between the canvas and stretcher
and sliding it along, but, occasionally, a separation can be very
difficult. And in certain instances, the stretcher has to be literally
ground away from behind. A complication like this could delay the
relining and subsequent cleaning for months.

The only other defense I had against a premature cleaning
was a coat of catalyzed lacquer I had sprayed on Fat Boy before he
received the final coat of "antique varnish." Catalyzed lacquer dries
to an extremely hardened state. It is usually used for commercial
purposes and is very toxic. The user must wear a gas mask when
applying it, and it requires the use of a special gun. In my experi-
ments, I found that a thin coat, impossible to detect visually, can
add a measure of resistance to acetone and delay the breakdown of

the paint underneath. However, it was nothing one could entirely depend on.

If Dara was going to waive the thirty-day waiting period, though, the risk of discovery before I got paid would virtually disappear. Nothing could replace the feeling of a hundred grand cash in my pocket, but after I got over my disappointment and had time to think it over, I realized that anything could happen during the thirty-day holding period, and that maybe this new policy concerning advances and the subsequent concession given was a blessing in disguise. I thought, Well, maybe this wasn't such a bad day after all.

I was hoping that the next time I heard from Dara would be at the time of the sale. But after several days, she called me. "I have some exciting news!" she said. "I took the liberty of cleaning a small area in the corner of your painting, and you simply will not believe the difference!" The only thing I couldn't believe was what I was hearing. "I'm sure," she said, "when you see this, you'll reconsider the cleaning."

Yeah, right! I thought. It was Friday and she asked if I could come in the following Tuesday. I agreed, trying to be as pleasant as possible, but after we hung up, I was livid.

I concluded that she was completely out of control, and now anything could happen. All weekend long, I was tortured over this latest development. Had this just been a ploy on Dara's part to test my reaction? Perhaps I should have gotten indignant. Perhaps she would take my complacency as a green light to finish the job off. All weekend long, I imagined scenarios in which Dara, armed with a can of acetone in one hand and a wad of cotton in the other, reduced Fat Boy to a puddle of swirling colors.

Tuesday morning, I was back at Sotheby's at the appointed time. Once again the smiling assistant escorted me through the maze

and straight into Dara's hot seat. Fat Boy, minus his magnificent frame, was waiting in the middle of Dara's cleared desktop. She greeted me with a smile of victory on her face. With a wave of her manicured hand, she invited me to have a look. An area the size of a dime in the upper-right corner had clearly been cleaned. The bright-blue sky shone out in contrast to the surrounding area. Right on cue, the door opened and Peter appeared. "So, what do you think?" pushy Dara asked. "Is it a go?"

Stalling for time, I pretended to study the cleaned area, but my mind was racing to come up with a way to handle this.

Dara broke the silence. "I was very careful," she said. "I used a Q-tip and some acetone." Then, as an afterthought directed toward Peter, she said: "Interesting, but the flyspecks dissolved as well."

Peter just shrugged. I pretended not to hear, but my heart skipped a beat. I was taken aback by Dara's technical knowledge. Flyspecks are indeed insoluble. They have to be removed with a scalpel, one by one. Had I used epoxy glue and powder pigment to make the flyspecks, they would have stood up to the attack of acetone. However, having used up all my glue on the "welding job" and never imagining that they would be tested in this way, I gave in to the temptation to make flyspecks with the thickened linseed oil, out of sheer convenience. Unfortunately, the thickened oil breaks down, just as recently dried oil paint would, with acetone.

Still pretending to appreciate Dara's handiwork, I was in fact carefully studying the corner and assessing the damage. Indeed, a few of the flyspecks that had once resided in that corner were gone, along with the "antique" varnish, but the blue paint of the sky was still intact. The barrier coat of lacquer had done its job—but just barely. I could see the glossy surface of the lacquer, but right in the center of the cleaned area, I could also see a dry patch, a sure

indication that the membrane was breaking down. Another second, and she would have been into the paint.

That, in combination with the anachronism of the dissolving flyspecks, would most likely have started a chain reaction of suspicion in Dara's mind.

Then, as I was studying the corner that Dara had cleaned, I got an idea. There was simply no way I could allow Dara to have Fat Boy cleaned. Instead, I thought of a ploy in which I could, without arousing suspicion, take control of the situation and perform the "cleaning" myself. It would be a risky gamble, but I had to do *something*.

"Maybe we could offer the picture with a test spot in the sky," I said. It was not uncommon to see antique pictures offered in the salesrooms with a spot the size of a half dollar cleaned in a prominent area like the sky in a landscape painting. The purpose was to demonstrate the difference a cleaning would make to the prospective buyers. The practice was more commonly seen in London than New York.

"This way," I continued, "we can show the buyers the true colors without a full cleaning." Dara was unimpressed, but Peter agreed that it wasn't a bad idea. Seizing the moment, I pressed on before Dara could protest. "Do you have the acetone handy?" I asked her. "I'll try it myself," I declared, confident that I could control the action of the solvent.

Dara called in her assistant and asked her to bring in the can of acetone. A couple of tense minutes passed. Dara began grousing about the idea of a test spot when the girl finally returned. "I can't find it," she informed Dara, and then added, "but we have a can of mineral spirits."

"No, no, no, keep looking," Dara said. "I just had it the other day," and then she directed the girl to a specific cabinet. Another

minute passed, and the girl returned. "It is not there, only the mineral spirits," she reported. Dara, exasperated, directed her to yet another cabinet.

Before the girl left, I stopped everything. "Wait, bring me the mineral spirits. That works just as well," I said.

Dara dismissed my request, and told the girl to go look again. "Mineral spirits can't clean a painting," Dara informed me once the girl had left.

"Oh, yes they can," I good-naturedly said. "Jim and I used to clean small pictures with it all the time, and it worked."

Dara wouldn't hear of it. In fact, Dara was for the most part right. Generally speaking, mineral spirits are too weak a solvent to break down old varnish, but on rare occasions they can.

What Dara didn't know was that mineral spirits would certainly clean *this* painting. The antique varnish I had dissolved from the surfaces of period paintings was diluted with acetone. Before it could be sprayed onto the surface of my painting, I'd had to give it some body or viscosity. This was accomplished by blending it with a clear synthetic varnish. The synthetic I chose was thinned with mineral spirits, and mineral spirits would easily dissolve my "antique varnish" after it had been applied and dried.

I tried again to correct Dara on this point, but she wouldn't concede. I was on a razor's edge. Again I was shocked by Dara's understanding of technical matters. The thought flashed through my mind that she already knew the painting was a fake and was just tormenting me. I wondered if I had at last met my match in her, when the door behind me opened. A long, slender arm extended over my shoulder and placed a can on the desk right beside Fat Boy.

In bold letters, I saw the words "Mineral Spirits" written across the front of the can. "I'm afraid we've looked everywhere, and this is all we can find," the assistant said. Before Dara could say a word, I asked for some cotton and seized the can.

Careful not to demonstrate too much technical experience, I pretended to be the "amateur restorer" and explained as I opened the can that "I used to watch Jimmy do this all the time with mineral spirits. It just takes a little longer than acetone." Dara was skeptical.

I soaked a small ball of cotton with the solvent and went to work in a small area of the sky. Round and round I went with the cotton, but nothing was happening.

"I told you!" Dara said. Then, finally, the cotton began turning amber as it dissolved the old varnish and blue sky appeared. The small area was perfectly clean, and the mineral spirits were no match for the barrier coat. At last, Dara lightened up and conceded that I had been right, but she still wasn't satisfied and I wasn't off the hook yet.

"Well, if we're not going to clean the whole picture, we should have three test spots. One in the sky, one in the landscape, and another on part of a flower," Dara politely demanded.

Hiding my exasperation, I readily agreed, knowing this would finally put the issue to rest. Without any prompting, they each grabbed a ball of cotton, soaked it with mineral spirits, and claimed their own spots to clean, while I sat back in the chair and watched in triumph.

When I got back out on Seventy-Second Street, I felt like I had just escaped the guillotine. I went straight to Gino's and ordered a glass of wine. Between the vanishing flyspecks and Dara's experiments with acetone, I had come within a hairsbreadth of being

exposed! After my second glass of wine, I was convinced that the girl who couldn't find the acetone and brought the mineral spirits had to be an angel in disguise.

The rest of the summer passed agonizingly slowly. In order to get my mind off things, I packed a few small paintings and took off for London. For the next two months, I hung out at museums, went out with friends, and drove to the West Country and hunted for frames in the Cotswolds, but nothing could dispel my anxiety. I was tormented with thoughts of what Dara might be doing with Fat Boy. I had to remind myself that it was summer. Sotheby's was closed, and Dara was probably out in the Hamptons going to dinner parties and sailing on yachts.

Then one night as I was lying in bed, I was struck with the worst thought of all! Jimmy's old friend Bill "Mr. Nineteenth-Century America" Gerdts was a consultant to Sotheby's. I had never thought of that. Surely, I reasoned, he would be shown the painting by virtue of his friendship with Jim. He would never accept the idea that Jimmy had had a passionflower Heade in his collection and had not shown it to him. And Gerdts would know better than anyone that the idea of Jimmy's ever giving away such a painting was preposterous. Worse yet, Gerdts was a good friend of Theodore Stebbins, the world's expert on Heade, whose authentication would be needed before the sale. I was sure that when I returned home in August, I would find an ominous message from Dara on my answering machine. I hated myself for not thinking of these possible complications beforehand and not demanding the hundred grand up front.

By the end of August, I had placed the small pictures I had brought along in a number of regional auction houses. At least, I thought, I'll have a few bucks coming in if Fat Boy bombs out.

When I finally got home to Florida, I tiptoed up to my answering machine, held my breath, and pushed the button. There was nothing from Dara. That was a good sign, but I could not imagine that someone would not raise a red flag in light of the Gerdts-Stebbins connection.

Next was the pile of mail. My eye caught the familiar sight of a thick Sotheby's catalog envelope. Ripping it open in a frenzy, I grabbed the catalog and fanned through the pages. On the second try, Fat Boy went by in a flash! I backed up to the page and there he was, sporting a three-hundred-thousand-dollar estimate, fly crap, patches, and all! He'd been authenticated by Stebbins, and the provenance stated: "acquired by the present owner from James H. Ricau." For the moment, I was greatly relieved. Another important hurdle was cleared. But my anxiety soon returned. There was still the exhibition ahead. The painting and the provenance would be exposed to the scrutiny of everyone. Perhaps, I feared, for one reason or another, Gerdts hadn't connected with the painting, but he, or for that matter anyone else who knew Jimmy, would certainly see it now. If eyebrows were raised and rumors started to circulate, the picture could be withdrawn from the sale.

The exhibition ran for ten days. Each one seemed like an eternity. Every time the phone rang, I dreaded it might be Dara. I was afraid the anxiety was beginning to affect my mind. Never before had I jumped through so many hoops or had such close calls with a painting. Was fate playing a cruel joke on me? I wondered. After coming this far, would Fat Boy be shot down just when I could practically smell the money?

The night before the sale, I had a very strange dream. In it, I was sitting at a kitchen table with a friend. Before us on the table was a stack of *Town and Country* magazines and a pile of

Mickey Mouse watches. We were laughing hysterically as we flipped through the magazines in search of ads for Patek Philippe wristwatches. With scissors, we were cutting out the faces of the expensive watches from the advertisements. Then we were opening up the Mickey Mouse watches and gluing the paper cutouts over the watch faces.

"It will never work!" my friend pleaded, doubled up with laughter. But I insisted it would, as we feverishly worked on. In the final sequence of the dream, we were busy walking through a beautiful residential street in what appeared to be London, carrying a bag of the watches. We passed the white façades of town houses in Belgravia until we arrived at the one I was searching for. "Here it is," I said to my friend, and pointed to a plaque above the door that had the number seventy-five prominently embossed upon it.

The next day, by three in the afternoon, I couldn't stand the suspense anymore. I dialed Sotheby's automated auction results number and punched in the sale code and lot number. An emotionless electronic voice stated that Lot 22 had sold for $717,500.

A week passed and not a word from Sotheby's. Then, ten days after the sale, Dara called. Payment had been made, and, true to her word, she directed the settlement department to wire the funds to my account immediately.

CHAPTER THIRTEEN

Checkmate

At this juncture, I felt that any misunderstandings I might have had with Sotheby's in the past, any perceived slights, any bad feelings, should be laid to rest. Yeah, I got a kick out of reading about Fat Boy in the press:

"Yes indeed. Every dealer from Tom Colville to Howard Godel took a crack at this filthy, untouched, obviously prime Heade. The bids quickly zoomed to $400,000, where the battle continued between Vance Jordan and an anonymous collector bidding by telephone, who finally won out at $717,500 (including buyer's premium),

more than double the $200,000/$300,000 estimate" (*Maine Antique Digest*, November 1994).

Rumor had it that the buyer was Richard Manoogian, a billionaire collector who had assembled the finest collection of Martin Johnson Heades in the world. Curious thing, though: around a year after the sale, a rumor hit the street that "an important Heade sold at Sotheby's last year *disintegrated* during restoration."

Oh, well, such is life, I thought, I just hope they don't call me for a refund, because I'd become accustomed, or rather addicted, to a new way of life.

Everything I owned was paid for, and I hadn't a nickel of debt. Between my last score and savings, I had around a million, all cash, and that didn't include my stock portfolio. All my monthly bills for the house in Florida were paid a year in advance. When I got tired of painting, I just locked the door, took a cab to the airport, and headed to New York or London.

In New York, I had an arrangement with a girl I'd met through Tony years ago. For a painting now and then, I had a home in the West Village. In London I still stayed at the Vicarage. I hung out at cafés, read the stock reports, and of course placed paintings in the salesrooms, but most of all I loved the ambiance of the auction world. The fascination never wore off. I moved with ease in the salesrooms. I enjoyed getting dressed in a tailored suit and mingling with the collectors and dealers at the exhibitions. I chatted with familiar faces and discreetly observed people examining my paintings and marking their catalogs.

In Florida I had met Beverly, a beautiful twenty-three-year-old law student. We had great fun together and took weekend trips to South Beach. We went on shopping sprees, spending thousands

on Versace couture, and we went to all the best restaurants and clubs at night.

During this period, I had so mastered the hand and style of Martin Johnson Heade that I began to "evolve" *The Gems of Brazil*, as I believe Heade would himself have done in time. I began making alterations, improvements, and innovations on the original collection of paintings. I was convinced that Heade would thank me, if he could, for carrying on the development of his work. Even though prudence dictated that I should not spring another "Heade" on the market just yet, it didn't stop me from selling them privately to collectors and dealers who understood what I did.

Another item on my agenda was a more long-term project. I was intrigued with the idea of expressing myself through an alter ego and inventing an entirely "new" and up to this point undiscovered early-nineteenth-century artist and establishing a market for his works, a market that I would control. The idea came to me while I was knocking off paintings by Giovanni Panini and Hubert Robert, two of the greatest decorative painters of the eighteenth century. They specialized in the capriccio—beautiful, romantic, and sometimes fantastical paintings of Italian ruins. They sold their paintings to wealthy English aristocrats visiting Rome on the Grand Tour. Many of their paintings still hang on the walls of the treasure-houses built by their wealthy patrons in the West Country of England, where I first saw them. I very much revered these artists and was training myself in their technique. I was particularly fascinated with the exquisite way they painted stonework, which figures prominently in their paintings, be it in the form of ancient temples, sculpture, or artifacts lying about.

As I was learning to think and see things in stone, the idea came to me: Why not paint an ancient Roman marble bust of a senator in

trompe l'oeil style, illuminated against a dark backdrop? Instantly I saw one in my mind's eye. Yeah, I thought, I'll bet the English tourists would have bought them too.

I was very excited about the project, and on my next trip to London I combed through all my usual print shops and assembled a collection of eighteenth- and nineteenth-century engravings of Roman busts, many of which were of obscure personages—known perhaps only by scholars. What better examples, I reasoned, as plausible models for my paintings? The next step was to visit the British Museum to study actual examples and fix in my memory all the details such as color, patina, and the play of light on the ancient stone. From there, I headed to Oxford and spent a couple of days visiting the Ashmolean Museum, founded by the Ashmole family, British aristocrats who not only amassed one of the greatest collections of ancient Roman sculpture, but owned paintings by Giovanni Panini as well.

Back in Florida, using the engravings as models and what I'd observed in the museums as an aesthetic guide, I created a collection of prototypes. Instead of a portrait painted to appear as flesh, I painted a portrait that appeared to be a marble bust of a person mounted on a pedestal so real that it seemed one could reach out and touch it. And the painting looked in every way early nineteenth century. All it took was aging each painting and setting into a period frame to complete, in more ways than one, the illusion.

I remembered reading how an observant art dealer had strung together a number of unattributed primitive portraits that had been published in catalogs and sold in various sales at different times and places. He had been convinced that he'd identified the work of an important yet hitherto unidentified eighteenth-century artist. Keeping that story in mind, the next step in my plan was to

begin a program of strategically placing examples of my "mystery artist" into the art market, where they could eventually catch the attention of a sharp-eyed collector-scholar.

Using a pseudonym, I planned to be the scholar who made the discovery. Situations like this are perfectly plausible and, like finding a Heade in Britain, happen all the time in the art world. Art journals and magazines are always interested in publishing exciting new discoveries. The uniqueness of the subject matter and the quality of the paintings would certainly make it a fascinating find, sure to get published in New York or London. Such an article would naturally result in an appreciating market for the artist's work. After all, once he'd been discovered and identified, it was only logical that other examples of his work that had been lying around in attics would be brought to market in sort of a Rip van Winkle effect. For me, it couldn't be simpler. All I'd have to do was paint them, "discover" them, and feed them into the market. And what better place, I reasoned, to start the ball rolling than Sotheby's?

Back in London, I was elated when the expert at Sotheby's thought the painting "most interesting" and said he would be delighted to include it in the next sale as a "French nineteenth-century trompe l'oeil painting of a Roman bust."

A few months later, I shipped a magnificent pair of paintings, measuring twenty-five by thirty inches each, in matching Empire frames, to Butterfield & Butterfield in San Francisco, the West Coast's leading auction house. With three paintings in the pipeline and set to be published in catalogs and two more that I casually sold at antique markets in New York and London to float around, I stopped there and planned to feed a few more into the market in about a year.

Painting pictures had totally consumed my life. I lived to paint. The more pictures I turned out, the better they became, and that just inspired me to paint more. I lived in a perpetual pursuit of another subject. Indeed, I had trouble falling asleep at night in anticipation of starting another picture in the morning.

One day while I was hunting for antique paintings in some Florida junk shops, I stumbled across a perfect situation to exploit. As I was paying the proprietor for a hideous nineteenth-century painting depicting Joan of Arc slaying a dragon, I noticed a pile of free promotional magazines on the counter. As I flipped through it, an unusual portrait of an American Indian caught my eye. The painting was part of a collection of local interest that would be going on display in a number of museums in Florida.

The portrait was of Osceola, a leader of the Seminole tribe in the nineteenth century. He was magnificently portayed in an embroidered robe with silver ornaments displayed on his chest. On his head was a colorful bandanna with a great plume protruding from it. I was fascinated at once and read the short history of the painting.

The portrait was painted by a little-known artist named Robert Curtis who had lived and worked in Charleston, SC in the 1830s. The story went on to explain that Osceola had found himself imprisoned in Fort Moultrie in 1838. When Robert Curtis heard about the famous Indian leader's imprisonment, he went over to the fort and painted a stunning portrait of him. No doubt it was the best thing he ever did, and the portrait attracted much attention. But it was the next line in the story that really got my attention. It stated that Curtis put an advertisement in the *Charleston Chronicle* offering to make copies of the portrait for $2.50 each. The portrait

in the current exhibition was in fact one of the copies; the original, as the article stated, was in the Charleston Museum.

So 156 years after Osceola's death, I got in my car and made the trip to Fort Moultrie. But all I could so was visit Osceola's grave and take in the view of the original portrait painted by Curtis.

I was deeply impressed when I saw the painting in the Charleston Museum. It was far superior to the copy displayed in the exhibition in Florida. Osceola, a warrior who was never beaten in a fair fight, looks out proudly, arrayed in all his splendor. There was a certain majesty to the portrait, and I knew at once that I wanted to paint one just like it.

My curiosity piqued, I decided I would find out more about the life of Osceola before I attempted to paint him. In 1835, the US government decided that the Seminole Indians living in Florida were an inconvenience. The fact that the Seminoles had been there first and that it was their land meant nothing to the government, which demanded that they remove themselves to a designated territory west of the Mississippi.

The problem was exacerbated by the Seminoles' habit of taking in runaway slaves. By the mid-1830s, many of the slaves had integrated into the tribe, taking wives and raising families. Andrew Jackson would have none of it and demanded that the slaves be returned to their masters. The Seminoles had no intention of complying with the order. In 1835, Jackson sent the army down to take care of the matter. Osceola, the acknowledged leader of the Seminoles, was a courageous warrior with a charismatic personality, a master of battlefield techniques and guerrilla warfare. When Jackson's army arrived in 1835, he wiped them out. Thus began the Seminole Wars.

Jackson sent down more troops, but the result was always the same. The army was simply no match for Osceola and his braves,

who attacked at night and hid in the swamps by day. Osceola, besides being a legend among his own people, was now becoming a legend in Washington as well. The government decided that a new approach had to be taken.

General Thomas S. Jesup was dispatched with orders to call a truce and discuss a treaty. In 1837, Osceola, under a flag of truce, met with General Jesup at Fort Moultrie in South Carolina. But in one of the most disgraceful acts of treachery in US history, instead of sitting down to peace talks with the Seminole leader, Jesup had Osceola arrested and thrown into prison.

The Indians, who had a high sense of honor and had trusted the word of a US Army general, were shocked. Many Americans were also outraged at Jesup's betrayal and sympathized with Osceola. Soon, artists began journeying to Fort Moultrie to paint Osceola's portrait. Even George Catlin interrupted his work out west to come and paint the great warrior. How humiliated and envious Jesup must have felt, I thought, that artists came to paint his captive and ignored him. Unfortunately, Osceola died from malaria just three months after being imprisoned. He was buried outside the walls of the fort.

General Jesup went down in history as a disgrace to his uniform and his country, but Osceola was honored, having towns, counties, streets, and schools named after him.

Now that I knew the story of this remarkable man, I no longer viewed the project in the same way. Instead of seeing another situation to exploit, I wanted to paint Osceola again in all his glory as a tribute to one of history's great freedom fighters.

Back in Florida, I developed the photos I'd taken of the portrait and went to work. Ten days later, I had two copies of the original, both executed on early-nineteenth-century canvases measuring

the standard twenty-five-by-thirty-inch portrait size. To honor Osceola's memory, I decided to fit him out in one of the finest portrait frames I had in my collection, one I had found at a shop in Cirencester years before and had been saving for a special picture. As a final tribute, I felt it only fitting to take the painting to Washington, DC, where I was sure Osceola would appreciate having his famous portrait sold.

Adam Weschler & Son is DC's oldest auction house and is close to Capitol Hill. In order to save me the trouble of lugging the painting and its heavy gilt frame into the auction house, the expert in charge, a pretty twenty-something-year-old, insisted on coming out to my car. Together, we slid the painting out the back door and propped it, right out on the sidewalk, against the front of the building. The sight of such an interesting portrait decked out in a dazzling gold frame soon attracted a crowd of passersby to witness the valuation. Ironically, while this was going on, I looked up and noticed that several people were looking down at the spectacle from an office window at the FBI headquarters just across the street. Weschler's expert wasn't so impressed with Osceola, but she did concede that the frame had some value. Then, after puzzling over the picture for a while, she asked: "Would you be happy if we could get you twelve hundred bucks?"

"Sure!" I replied, and a contract was written up on the spot. A porter was called out to remove the portrait. I caught sight of Osceola's gaze one last time as the doors of a freight elevator closed—and he was gone forever.

Still, no matter how many paintings I produced, no matter how many paintings I sold, and no matter how much money I made, there was a big empty space in my life, some unfinished business that someday would have to be addressed. Perhaps, I thought, now

that I had the time and freedom—not to mention an extra seventy-five grand in the bank compliments of my old friend Osceola—I could once again start my work on the lost collection that I had begun in the loft at Union Square and fulfill my lifelong ambition to become an artist.

The idea took hold, and I felt inspired, driven, and excited. I could hardly sleep at night from nervous energy and the desire to start immediately. Again I felt like a new person, reborn into another life with yet another future. I could build the collection. I had friends in New York. And I could finally have a show.

For this project, I wanted to be completely undisturbed. I unplugged the phones and was incommunicado for weeks on end. It was a tremendous job just to assemble the paints, brushes, canvas, and stretchers, not to mention the fabrication of the Plexiglas and sheet-metal boxes.

At last, when I was ready to paint, I experienced a strange sensation: I picked up right where I'd left off, as though there had only been a snap of the fingers since Union Square and everything in between had never happened. As the collection took form, it looked just as I'd always envisioned it and just like those pieces that had last been seen being taken from the Ferguson Club. Months went by and the collection kept developing. But now, instead of surviving on bagels and hamburgers, I ended my day with a fat steak on the grill, a glass of wine, and a long walk on the beach.

After thirty years of painting pictures and selling them in New York and London, and after thirty years of conditioning myself to forget the fact that I'd painted them, I'd come to believe that my business in the auction world was just as legitimate as anyone else's. So when, one day in the spring of 1998, Special Agent Monty Montgomery (for real) and his sidekick from the FBI showed up at my door, my immediate reaction was: Whatever could they possibly want with me? However, after Agent Montgomery stuck his

shiny badge in my face and said he would like to talk to me about some paintings, it occurred to me what this might be about.

"Don't worry," he said, after noticing the blank expression of shock on my face, "you're not in any trouble. We just have a few questions and we'll be gone." he assured me as we sat in my living room. Yeah, right! I thought.

It seemed that some months back, a curious thing had happened in New York City. An unscrupulous art dealer, whom I'd never heard of, and who had once lived in Florida, had been arrested for selling fake paintings. Two "Buttersworths" (obviously mine) were among the collection that made up his inventory. In the course of the subsequent investigation, it was discovered that both "Buttersworths" closely matched two others that had appeared and been sold nearly a decade ago, one at Sotheby's and the other at Christie's in London. Further investigation revealed that both paintings had been consigned by one Ken Perenyi. This remarkable coincidence demanded an explanation.

My guests proceeded to make themselves at home, and, opening up a sinister-looking black-leather briefcase, they began to spread out photocopies of pages taken from auction-house catalogs that pictured the two "Buttersworths." Fortunately, due to my long absences from home and the robbery years ago, I never kept more than a few paintings in the house, instead preferring to fill up secure storage units with piles of them. It didn't bother me that decorating my living room where we were sitting was a "Gilbert Stuart" above the fireplace, an "Antonio Jacobsen" on the opposite wall, and a couple of small sporting paintings lying about, because it soon became apparent to me that art was neither of my guests' strong suit.

No matter how uninformed they might be on the subject, however, I was still uncomfortable knowing that just upstairs in

my bedroom was a beautiful pair of "Buttersworths" flanking my bed and that behind the door of another room that served as my studio were several masterpieces in progress. For the time being, at least, the Feds stayed put on the couch. Pulling out pens and a form from the nasty-looking briefcase, they explained, "We have to write down a few facts. It's just routine, and we'll be leaving in a minute." Then, after spending half an hour filling out vital statistics about my life that covered everything from where I was born to whether I suffered from hemorrhoids, they began an interrogation disguised as a friendly conversation.

"Well, exactly what do you do for a living, Mr. Perenyi?" they inquired.

After I explained to them that I was simply a harmless antique dealer and stock-market investor, they explained to me the awkward situation involving the "Buttersworths." They wanted to know how I'd come to own them, and how they came to be placed in the London auction houses. The second I looked at the dates of the sales, one nearly ten years ago, I pretended bewilderment.

"I don't remember where I bought these," I said, as though it was absurd that they should even ask. "I go all over Britain buying art and antiques. Then I turn around and put them in auction sales for a quick profit. Probably I found them in some London market or an antique show in the country."

As one of them was writing down every word I said, the other broke in and asked: "Can you show us receipts for the purchase?" After dismissing the question as ridiculous, I explained that sales at antique markets were always "cash-and-carry."

Still, they tactfully let me know that the matching of these paintings was an extraordinary coincidence. Then, looking at me intently and referring to a list of names, they told me the name of

298

the dealer in New York City and wanted to know if I knew him. I stated emphatically that I knew no one by that name. The same was true for the others as they ran down the list, until they named my old friend Mr. X, the picker. A chill ran down my spine, but again I denied knowing him. I confessed to being as baffled as they were, but I could offer nothing more. Convinced that I couldn't or wouldn't make any more comments on the paintings, they sought to keep the dialogue going by pretending to be fascinated about how I bought and sold antiques in Britain.

Finally they packed up their papers and rose to leave. Now that we were all the best of friends, I walked them to the door, but just as they were leaving the living room, one of them stopped, glanced around the room, and remarked: "Those are beautiful paintings you have here. By the way, do you paint yourself?"

"Actually, I do," I admitted, "but strictly as an amateur."

I had a lot to think about after they left. How, I asked myself, had they tracked down those two "Buttersworths" and had they discovered them to be fakes like the ones in New York? It was a good thing, I thought, that those paintings had been sold a long time ago, and also that I hadn't seen Mr. X in years. No matter what their suspicions might be and no matter how incredible the coincidence, it didn't prove a thing. All I had to do, I reasoned, was just stick to my story.

But how had they connected the dots? Only a Buttersworth expert who tracked the sales of his works could possibly have matched up those paintings. Someone, I concluded, had to be helping them. Needless to say, this was an investigation that was being conducted from New York. Whether it would end with the interview I had just given or expand, only time would tell. But one thing was for sure: this unnerving event caused me to radically

change the way I did business, and I wasted no time in retaining the services of a local law firm—just in case.

For the time being, I stopped putting any more paintings into the auction houses. Instead, I made private and technically legal sales. Just as always, I had a few friends in the business—dealers, collectors, and now even some high-end decorators—who were willing to buy my pictures for "strictly decorative purposes."

Nearly a year passed without my hearing any more from the FBI and, indeed, I probably would never have heard from them again had it not been for the continual and uncontrolled third-party sales of my pictures. Just as in the 1970s, another critical mass of paintings had been building up, and the stage was set for meltdown number two. The catalyst in this circumstance took the form of two separate incidents that took place in two countries half a world apart:

In order to advertise a sale of British marine paintings in their salesrooms at Knightsbridge, Bonhams had chosen a delightful little painting by James E. Buttersworth consigned by an American woman, which was reproduced for a promotional postcard sent to their clients all over the world. And out on the West Coast of the United States, a failed actor posing as a decorator and would-be relation to the royal family (as in Windsor) was pulling off handsome scores by selling some "family treasures" (as in oil paintings).

The problem was that the Buttersworth had a striking resemblance to another that had sold at Sotheby's a few years previously, and the British paintings being peddled by Queen Elizabeth's "nephew" were just a little too good to be true—so someone alerted the authorities.

It didn't take long for the feds, and whoever was helping them, to connect the dots and round up the culprits. However, this time

not only would they discover that the paintings had come directly or indirectly from me, but that I was the artist as well. Nevertheless, the feds would have to prove that a conspiracy existed between me and the scoundrels who had sold those paintings in order to have a case against me.

No matter what the feds found out, they still faced a dilemma. Conspiracies are easy to suspect but difficult to prove. The testimony of cooperating witnesses is not enough. Usually they will lie in order to get themselves off the hook. Incriminating statements made by the target of the investigation and gathered by either wiretaps or hidden recording devices are needed to make a case strong enough to stand up in court.

They were also aware that it's not illegal to create or sell fake paintings, as long as they're sold as such. So instead of raiding my house with a search warrant, which would only have yielded more paintings for their growing collection but prove nothing, the feds—either convinced that I was part of a conspiracy or in an attempt to create one where none existed—chose instead to rely on tricks everybody's seen on TV a million times.

When I got a call from someone who had purchased paintings from me some months previously and was in cahoots with the Royal Decorator, I assumed that he wanted to buy more pictures. But when he nervously said, "There was some trouble over those paintings," I was immediately on my guard. The FBI, he went on to explain, had contacted him and wanted to talk about some paintings. He then asked, "What should I tell them?" I knew at once that this was a setup. "Tell them the truth," I said, and added, "I hope you didn't defraud anyone with those pictures."

As for the "Buttersworth" that wound up on the Bonhams postcard, I had the girl I'd stayed with in New York to thank for

that one. Some time back, I had given her the painting, a dupli-
cate of one I had sold at Sotheby's. Then, when she took a trip to
London, she decided to take the piece along and, unbeknownst to
me, consigned it to Bonhams. When the postcards were circulated,
the match was made.

Now that I had stopped spending time in New York, the feds
sent her down to me. Pretending to just "happen to be in the
neighborhood," she showed up at my door, wearing a preposterous-
looking hat. Before I knew it, she launched into a contrived con-
versation, obviously cooked up by the feds, in order to get me to
make an incriminating admission. It didn't work. First of all, I was
on the Bonhams mailing list too. I had already received a postcard
inviting me to attend the sale. Recognizing the painting and real-
izing what she had done, I was on my guard. And, secondly, every
time I said something to her, she aimed the hat at my face. I knew
at once that there was a fucking tape recorder in that hat!

Having failed in their initial attempts to nail me, the feds didn't
take long to make their next move. Instead of sending the men in
black to visit me, this time they dispatched a sweet-natured woman
who turned up at my door and politely showed me her badge. She
was no doubt hoping, like the agents who had preceded her, to be
invited into my home for tea and a nice little chat. Unfortunately,
all she got was my lawyers' card and a door slammed in her face. I
had engaged two of the best legal brains in town, and, only a few
days after Miss Marple's visit, I got a call to come down to their
office. When I got there, we sat down in a conference room and,
without mincing any words, they told me what was going on.

"There's an investigation being run by the US attorney's office,
Southern District of New York," one of them began. "Apparently
they have a number of paintings, fakes, sold by your 'friends,'

and they want to know your connection to them. The FBI agent handling the investigation is a James Wynne. His office is in the Queens Bureau."

Holy shit! I thought.

"I spoke with him a few days ago," the attorney explained. "He runs the FBI's art investigation department."

"I know," I said. "I've read about him. He's the country's top Art Cop."

This was not good news, and, for openers, Special Agent Wynne had lots of paintings and lots of questions. But before we addressed that issue, and before my attorneys could begin a dialogue with Agent Wynne, we had to decide what position I should take.

The best course of action, we agreed, would be to tell the truth. At that point, trying to deny that I painted pictures wasn't an option. True, I'd been painting and selling fakes for decades, but not all the sales were fraudulent. In fact, the more we thought about it, perhaps none of them were. After all, apart from my youthful exploits, which were no longer relevant, I had no idea that selling my paintings at auction could get me in trouble, and it wasn't my fault that Christie's, Phillips, Sotheby's, and Bonhams sold them.

"Besides," I said to my lawyers, "I never told them the paintings were for real. And what business did Wynne have looking into those 'Buttersworths' sold in London? It's outside the FBI's jurisdiction!"

My lawyers agreed completely and immediately sent off a letter to Wynne explaining that "Mr. Perenyi is a respected member of the art community. He has been creating high-quality reproductions for years and never misrepresents them." The letter also stated that not only was I not involved in any conspiracies to defraud collectors, but that I was a victim myself. Furthermore, I

would be available as a witness to help prosecute those who committed fraud and put them behind bars where they belonged.

Fat chance Wynne will buy that one! I thought after leaving my lawyers' office. At least the response we had decided on would put me in a defensible position, and it would let Wynne know that I wasn't rolling over. If he didn't believe in my innocence, he would just have to prove otherwise.

I didn't have to wait long before I got another call from my lawyers. As expected, the Feds weren't buying my story. They were convinced that I was involved in conspiracies—indeed, that I ran, according to them, an "international network." Waiting for me at my lawyers' office was a stack of photos. Discovering my identity as the forger must have been for Special Agent Wynne like finding the Rosetta Stone. The photos submitted for my consideration were part of the federal collection of Perenyis accumulated over the years and awaiting identification. Indeed, Inspector Wynne fully expected me to look at them and be so kind as to authenticate them as the work of my hand.

"Holy shit!" was all I could say as my lawyers spread a retrospective of my work out upon the desk. The collection of photos came with a personal invitation from Special Agent Wynne to come up to his offices in Queens and "talk things over."

This was Wynne's first big shot at me. He knew damn well that I had painted all the pictures in the photos, but the problem for him was still the same: none of the paintings had been sold directly by me. Obviously, his invitation was meant as an intimidation tactic. But as far as my running up to New York to make a confession was concerned, I was afraid he was in for a disappointment. My reply would be based on an important fact. If they had proof of these so-called "conspiracies," instead of sending down a bunch of photographs for me to look at,

they'd have sent federal marshals with handcuffs. For the moment, I either had to reply or simply refuse to answer.

I reminded my lawyers that if Hillary Clinton could get away with being unable to remember anything when questioned by federal investigators about Whitewater, a legal case she had been involved in for years, then why should I be expected to remember any pictures that I might have painted?

That settled it. We composed a letter that took up an entire page, explaining with perfect logic to Special Agent Wynne that "Mr. Perenyi has painted many pictures through the years and can't remember if these are his."

Now it was my turn to wait and see what Wynne's reaction would be. The following week, I had trouble sleeping at night, worried that the feds might come knocking at my door at four in the morning with a warrant. However, time passed and nothing happened. They have a bunch of paintings, I reasoned, but evidently they can't make a case. At least not yet.

The ominous silence dragged on, and in time my lawyers agreed that the case might have been closed—that is, until I discovered that my phones were tapped and the feds had been visiting people I knew both in Florida and in London, their names gleaned, no doubt, from phone records or the two "conspirators" they already had on the hook.

Mob watching and following the lives of hoodlums in the newspapers is a favorite New York pastime. Often, reading about them, I had wondered: How do these guys live with the FBI breathing down their necks? I learned that the answer is *conditioning*. After the initial fear wears off, it's just another nuisance you have to put up with.

Even as the sword of Damocles was dangling over my head, I managed to develop a new business model. Through word of

mouth, I had a growing number of people eager to buy my paintings as "reproductions." These included doctors, lawyers, Palm Beach decorators, antique dealers, three CEOs, private collectors, and more. In fact, a new phenomenon was developing: people were beginning to collect my fakes. The investigation, instead of producing the arrest Special Agent Wynne so desperately wanted, only served to launch me into a new phase of my career, in which hundreds of new fakes of the highest quality were going out into the world—and where they'd end up, no one could tell.

The millennium came and went, and still I was being called to my lawyer's office to reply to Wynne's latest discoveries. Whether they concerned paintings or people I'd once had business with, I always cooperated—that is, to the best of my ability—which invariably meant "I can't remember."

Even the attack of 9/11 didn't slow down Special Agent Wynne, except that now the investigation passed into another phase. No doubt convinced that he wasn't going to prove his conspiracy theories, Wynne changed tactics and moved on to other issues: sales I had made in the auction houses. I couldn't depend on the catalog disclaimers to protect me. "All they have to do," my lawyers informed me, "is to establish a pattern with an intent to defraud" and they could bury me.

With suspicious regularity, I began to receive telephone calls from people I'd known or done business with years ago. The common denominator was that they had all purchased fakes from me legitimately—and most probably had sold them as originals. The callers all followed a distinct script. After they began with a hearty good-natured greeting, they wanted to know if they could buy some "Buttersworths" or "Heades" and wanted to reminisce about paintings I had sold them in the past.

It was just another of Wynne's clumsy attempts to use people his investigation had turned up who were either intimidated or compromised into cooperating to try to catch me in an incriminating statement. Where Wynne was going with this, I couldn't tell, but what he didn't figure on was that one of his "informants" was a double agent.

Special Agent Wynne's puzzling yet unflagging devotion to seeing me behind bars for the rest of my life may have been explained when I got an unexpected visit. I was hanging the laundry outside one day when, like an apparition from the past, my old friend Mr. X, the picker, materialized between the blowing bedsheets. Instantly I knew this had to be about the investigation. Although I was constantly on guard about calls or visits from people from the past, I could not believe that my old buddy, a stand-up guy, could be a stooge for the FBI, so when he whispered that he had some information for me, we sat down at the table near the seawall.

His involvement with the fake Buttersworth in 1980, on file with the FBI, combined with the current investigation also involving fake Buttersworths, created a connection, and my friend found himself caught in Special Agent Wynne's dragnet. The feds suspected that we were in cahoots. Fortunately that wasn't the case, at least in the present circumstances. Even if the feds had now figured out the truth about the picker's involvement in 1980, it was too late to do anything about it. My friend had nothing to fear from Special Agent Wynne.

Two agents, who my friend believed were from the New York office, had showed up at his house one day. Following the same routine they'd once tried on me, they began by assuring him that he "wasn't in any trouble" and that he "hadn't done anything wrong." All they had, they assured him, were "some questions."

Unfortunately for the G-men, Mr. X, a past master in the art of subtlety, found it child's play to glean information from his interrogators while giving them nothing.

"I knew at once it had something to do with your paintings," he said with great amusement. In fact, he'd been following my movements, recognizing my work in auction catalogs, and picking up gossip through the dealers' grapevine. "They say," he said, that "Stebbins has been beside himself ever since the fakes turned up in 1980. He installed that fancy million-dollar forensic lab in the Boston Museum just because of *you*."

"I'm flattered," I replied, but apparently the lab hadn't done Stebbins much good, because my old friend brought along something he wanted to show me. Theodore Stebbins's long-awaited *Catalogue Raisonné* of Heade's work had recently been published. Not only did my friend point out a couple of works in the *Catalogue* that he rightly believed to be mine, but, most surprising of all, the professor had devoted a couple of pages in the book to the problem of fakes. Stebbins described in detail the work of two forgers whose work had "deceived some of the leading dealers in the field." He may have been right about that, but he was wrong about the two different forgers. All the paintings described and illustrated were clearly mine.

But what my friend really wanted to give me was a heads-up about what was going on. "By the questions they asked me," he went on, "they know you've been selling fake Heades and Buttersworths and that you must be the author of the 1980 fakes as well."

"No wonder Wynne's on the warpath," I said. "And, on top of that, he had two of his agents sitting right in my house questioning me about fake Buttersworths."

"I'll bet they had to scrape him off the ceiling," my friend said, "when he finally realized the truth."

After all their questions, all the agents had to show for their interview with the picker was "I haven't seen Ken in years and I don't know what you're talking about." Nevertheless, they advised him that he could be called as a witness in the future, and they hinted that any communication with me could be viewed as "interference in a federal investigation." He waited two days to be safe and then made a beeline to my house.

Incredibly, four and a half years had passed and still Special Agent Wynne, my nemesis, wouldn't give up or make an arrest. Something just doesn't add up, I often thought. Why hasn't he gotten a search warrant by now and raided my house? Especially since he'd been gathering new information. And why, I puzzled, hadn't he ever charged the two people who were first caught fraudulently selling my pictures with a crime? Perhaps the answer would become evident in Wynne's next move.

One afternoon, I received an urgent call on my cell phone. It was my lawyers' office. They wanted to see me first thing the following morning. I knew something serious was up. After a sleepless night, I was back in their office the next morning. Judging from their grim expressions, I was certain that they had been informed by Wynne of my imminent indictment.

Instead, they had received another list of Wynne's latest discoveries accompanied by supporting documents, more questions for me to answer, and a final ultimatum.

Submitted for my consideration were copies of my London bank accounts, copies of wire-transfer deposits made by auction houses, copies of auction-house catalog covers, copies of auction-house

contracts, and copies of the "Big Bucks Birdies" article that had once appeared in the *New York Post*.

Then Wynne asked if I had indeed painted pictures in the manner of a list of American and British artists that included James E. Buttersworth, Martin Johnson Heade, Antonio Jacobsen, Thomas Spencer, John F. Herring, and more, and whether I had sold them as originals in the auction houses. He ended by reminding me that I had also lied to his investigators in 1998.

"Wynne wants you to come up to New York," one of my lawyers said. "He probably wants to offer you a deal for a confession. Curious thing, though: in a slip of the tongue, he let it out that the statute of limitations is about to expire." My lawyer thought the slip was, for some reason, deliberate. "But then he warned," my lawyer continued, "that this would be Mr. Perenyi's last chance." He'd be calling back soon for an answer.

At five years per count, Wynne was letting me know that he had enough here to put me away for the next century and beyond. Indeed, even my lawyers hinted that I might consider moving to an island in the Caribbean. But as intimidating as this communication was, it raised several questions. If Wynn was intent on obtaining my confession, why didn't he simply start by charging me with a lesser crime, such as lying to the FBI? "If he's discovered all these so-called crimes," I asked my lawyers, "and he obviously knows the answers to the questions he's asking, then what does he want my confession for?" That question brought us to one conclusion: "He's not getting cooperation from the big boys," one of my attorneys concluded.

Is it possible, I thought, that my "friends" in New York could be obstructing the investigation in hopes that I would not be indicted? The idea was absurd. Yet I knew the feds had been to the

auction houses, and I asked myself: For what other reason could Wynne need my confession? And, most suspicious of all, why had Wynne not included Fat Boy in his catalog of crimes? Was there a calculated reason behind that omission?

Although I wanted to consider the idea of going to New York and finding out what Wynne had in mind, my lawyers wouldn't hear of it. "Talking to the feds is never a good idea," they said. "They promise deals and double-cross people all the time." Besides, they didn't feel it could benefit me at all. In fact, they suspected that Special Agent Wynne, nearing the expiration of the statute, was about to indict before it was too late and wanted to save himself the trouble of coming to Florida to arrest me. I, on the other hand, hung on to the hope that he still was unable to make his case. And if that was true, I reasoned, he'd have to offer me a pretty sweet deal to get me to confess. With the statute about to expire, jail time would have to be off the table. Perhaps, I hypothesized, a confession from me might give him what he needed to make a case of obstruction against people in high places. What a coup that would be for Special Agent Wynne! Not only could he claim that he'd caught an international art forger, but he could indict the auction houses as well!

However, there was a problem with that, I thought. If his investigation was being obstructed by the auction houses, there was certainly more than one way he could persuade them to cooperate. All he would have to do would be to inform them of his intention to publicly charge the two "conspirators" he already had on the hook. The resulting trial would not only expose my activities in the art market, but it would also reveal that the auction houses had sold my fakes and, worse yet, were protecting me from prosecution as well. Was there something else going on here? I wondered.

I deferred to my lawyers and accepted their advice, but still I had misgivings that an opportunity might be slipping by. If only Roy were still alive, I lamented. He'd know how to handle things.

Whatever the case, I wouldn't have to wait long for Special Agent Wynne to finally show his hand. Two days after he delivered his ultimatum, he was on the phone to my lawyers demanding my answer. In no uncertain terms, Agent Wynne was informed that Mr. Perenyi:

A) Had no intention of coming to New York,
B) Had no further statements to make, and
C) Was prepared to fight an indictment.

It would be an understatement to say that Agent Wynne's response to our reply left my lawyers and me bewildered. "He said that he had no intention of indicting Mr. Perenyi," my lawyer said. "Then he thanked me for my help and said good-bye." Was Wynne just being sarcastic, we wondered, as he was rounding up a posse to arrest me? Only time would tell.

In the end, after a five-year investigation and a mountain of evidence collected, no one, neither the two "conspirators" nor I, was ever charged with a crime or indicted.

Was the investigation a charade, I asked myself, compromised in some way after it led investigators to the big boys? Had it been planned to let the statute expire without an indictment? Whatever the case, it was over. And now at last I was free to concentrate on the next project.

Postscript

Ken Perenyi continues to paint his fakes. After a number
of requests to acquire his FBI file under the Freedom of
Information Act, it remains exempt from disclosure.

Acknowledgments

I f he were still with us, I would sincerely thank Tom Daly, who introduced me to the world of art and made me believe that anything is possible. And of course my thanks to Tony Masaccio and the chance meeting that changed my life. And to Barbara R. and the influence she had on my psyche.

My thanks always to my parents for the love and good home they provided.

My indebtedness to my friend Denis Donovan, whose indefatigable work on his computer helped make this book posible.

Many thanks to my agent, Don Fehr of Trident Media, who, after missing his train stop while reading my manuscript, found the perfect publisher, Claiborne Hancock of Pegasus Books, and whose enthusiasm for my story has been very much appreciated.

Thanks to my editors, Blair Kenny and Phil Gaskill, whose patience and skill have made working with them a true pleasure. Also, much gratitude goes to Maria Fernandez, designer and typesetter extraordinaire, and to the entire team at Pegasus Books who worked on this project.

Lastly, my gratitude to the Underwood Typewriter Company and their superb desktop model number 5, still working after all these years.